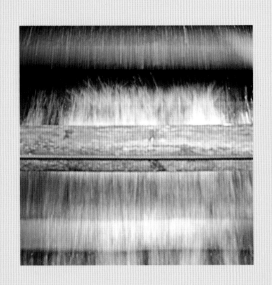

Ontario's
Historic
Mills

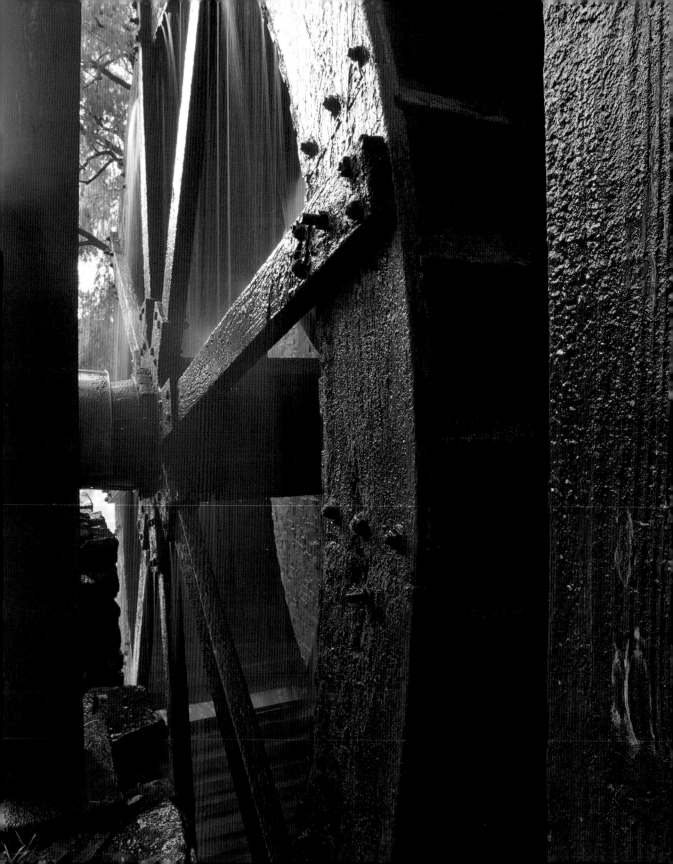

ONTARIO'S
HISTORIC
MILLS

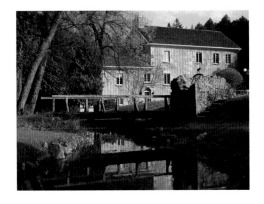

GEORGE FISCHER AND MARK HARRIS

The BOSTON
MILLS PRESS

A Boston Mills Press Book

Photographs copyright © 2007 George Fischer
Text copyright © 2007 Mark Harris

Library and Archives Canada Cataloguing in Publication

Fischer, George, 1954-
Ontario's historic mills / photography by George Fischer ;
text by Mark Harris.

Includes bibliographical references and index.
ISBN-13: 978-1-55046-480-1
ISBN-10: 1-55046-480-9

1. Mills and mill-work--Ontario--History.
2. Mills and mill-work--Ontario--Pictorial works.
3. Historic sites--Ontario.
4. Historic sites--Ontario--Pictorial works.
5. Ontario--History. I. Harris, Mark, 1970- II. Title.

NA6403.C3F57 2007 725'.409713 C2006-906846-1

Publisher Cataloging-in-Publication Data (U.S.)

Fischer, George, 1954-
 Ontario's historic mills / photography by George Fischer ;
text by Mark Harris.
[224] p. : col. photos. ; cm.
Includes bibliographical references and index.
Summary: Guide to Ontario's historic mills, including travel
instructions, a history of the mill's use, and vital statistics on
age, operation, architecture and location.

ISBN-13: 978-1-55046-480-1
ISBN-10: 1-55046-480-9

1. Mills and mill-work—Ontario -- History. 2. Mills and
mill-work – Ontario -- Pictorial works. 3. Historic sites --
Ontario. 4. Historic sites – Ontario -- Pictorial works.
5. Ontario -- History. I. Harris, Mark, 1970- II. Title.

725.4097/13 dc22 NA6403.C3F5734

Published by
Boston Mills Press, 2007
132 Main Street, Erin, Ontario N0B 1T0
Tel 519-833-2407 • Fax 519-833-2195

In Canada:
Distributed by Firefly Books Ltd.
66 Leek Crescent, Richmond Hill, Ontario
Canada L4B 1H1

In the United States:
Distributed by Firefly Books (U.S.) Inc.
P.O. Box 1338, Ellicott Station, Buffalo, New York
USA 14205

Cover design by Gillian Stead
Design: Gillian Stead, and Chris McCorkindale and Sue Breen of McCorkindale Advertising & Design

Printed in China

*The publisher gratefully acknowledges the financial support for our publishing program
by the Canada Council for the Arts, the Ontario Arts Council and the Government of Canada
through the Book Publishing Industry Development Program.*

Private Property and Trespassing
Remember that this book does not give permission to visit any of the buildings or properties featured within.
Each site is owned by an individual or by an organization, and the reader is responsible for ensuring that it
is both lawful and safe to visit any of the sites mentioned in this book. This is especially true for mills that have been
converted to private residences — please be respectful and avoid interfering with the privacy of the owner.
While we have attempted to provide up-to-date information on access,
each building is a piece of property that can be bought and sold, and any of the sites mentioned in the book
could subsequently change hands and no longer be accessible to the public. This book does not give you
permission to trespass on any privately-owned lands, and so if in doubt, please ask.

Contents

This book is dedicated to Lisa, Owen and Isaac and to Kathy and Ervin Gardos

Authors' Acknowledgments

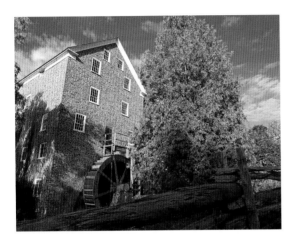

I would like to thank the following individuals who shared their mill stories with me over the past year: Ken Danby, Armstrong Mill; Art Shaw, Delta Mill; Derek Cooke and Rino Roncadin, Roblin Mill; Lain and Gail Ainsworth, Cedar Lane Mill; Jeff Scott, Birge Mill; Charles Simon, Eden Mill. Thanks also to Artak Tadevosyan for use of his beautiful oil painting. A big thanks as well to my good friend and assistant Jean Lepage, who travelled with me to the four corners of Ontario to produce this beautiful book. Finally, thanks to my co-author, Mark Harris, who provided me with information and precise driving directions to all of the mills in this book. Bravo!

– GEORGE FISCHER

It quickly became clear during my research was that there was no shortage of people willing to contribute ideas and information to this book. Most of the mills featured here are the pet projects of enthusiastic "mill fans" who were always eager to tell me everything about "their" mill. There are far too many such people to thank individually in such short space, but thank you, one and all! (You know who you are.) One person who deserves special mention is Maryanne Szuck, a member of the Society for the Preservation of Old Mills, who provided a wealth of information, ideas and useful contacts. Thanks also to Noel Hudson at Boston Mills Press for answering 1,726 of my emails without once admitting that I was becoming annoying. And, of course, thanks to photographer George Fischer for asking me to work with him once again. Lastly, and most importantly, I must thank my wife, Lisa, and my two wonderful little boys, Owen and Isaac. On many a late night, I gave up my chance to change diapers in order to complete the text. Lisa assures me that I'll be able to make up for these missed opportunities in the months to come.

– MARK HARRIS

Introduction

Ontario's historic mills are special places! Once a magnet for settlement and an icon of optimism, the mill was a vital ingredient for the development of our modern society. By automating the cutting of lumber, grinding of grain or preparation of cloth, it finally relieved the burden of completing these mundane tasks by hand. But despite the mill's crucial importance to Ontario's history, most have become a casualty of progress, either disappearing altogether, or slowly crumbling at the mercy of the elements or vandals.

Of those that remain, many have now come full circle, returning to their roots as the nucleus of their community. This time around though, instead of functioning as a centre of commerce and industry, the old buildings now serve a myriad of new purposes. Some have been lovingly and painstakingly restored to working order to serve as living examples of yesteryear. Others have been converted to upscale restaurants, unique office spaces, exclusive inns and even one-of-a-kind residences. Still others await redevelopment, held back only by a temporary lack of financing or a

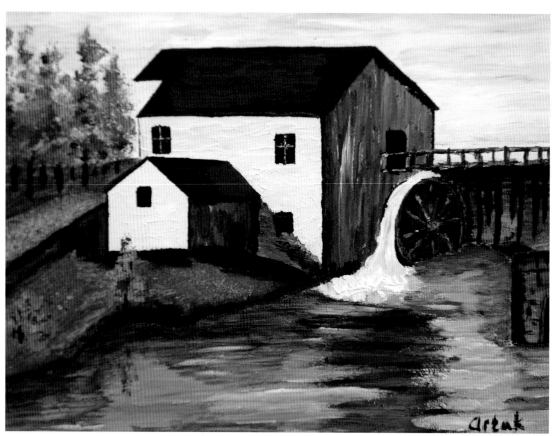

Oil painting by Artak Tadevosyan. (Right) McDougall Mill.

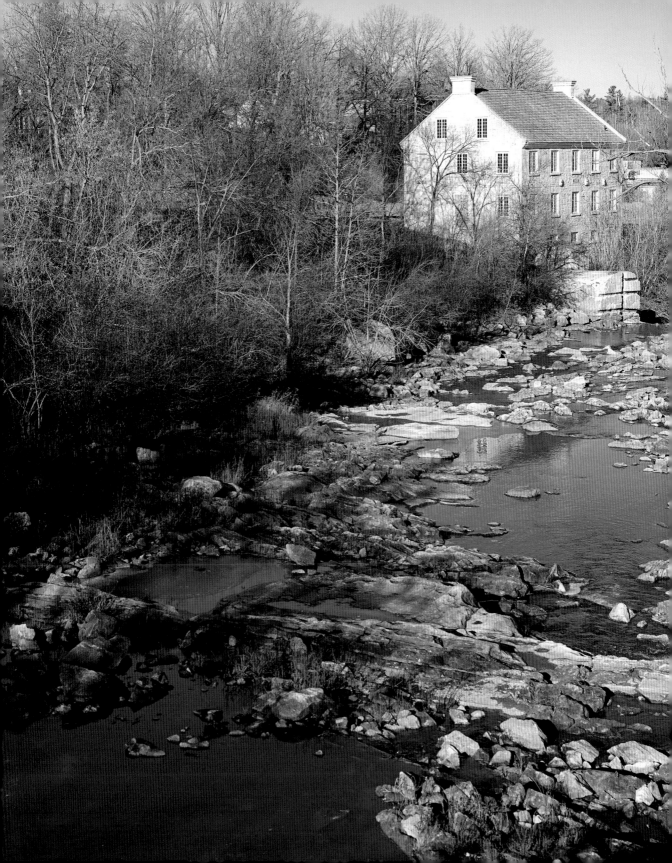

firm vision. But why the attraction to the old building? What makes them so special?

From the outside the old mill can be magnificent, often visually dominating its landscape. Even the crumbling stone ruins can be attractive, ranging in appearance from rustic to nearly castle-like. With massive timber-frame construction or beautiful stone masonry, they just don't build em like this anymore. Inside, the rudimentary, yet sophisticated workings charm those with a love for all things mechanical. With the turn of a crank, water is hurtled at the blades of a turbine and, presto!, power to move a saw, turn a stone or brush a fibre. No electricity or internal combustion required!

Another attraction is the mill's physical link to the past; offer the one constant in a community through a century or more of change. Many local groups interested in preserving and promoting local heritage have turned to "their" mill as a material outlet for their efforts. Often occupying choice locations in our cultural landscape, their long tradition as "people places" is easily understood and exploited. Who wouldn't want to live, work, shop, dine or wed here?

The old mill has long been a romantic element of our landscape. Those that look much as they did a century before have been the subject of countless paintings, photographs, poems and stories. There is something magical about a building that symbolizes fundamental relationships between the natural environment and the basic needs of society.

There is so much that can be known about historic mills, and it is impossible for a book of this scope to thoroughly educate the reader about all the intricate details of milling history and technology. This is not our goal. Instead, it is our intention here to provide

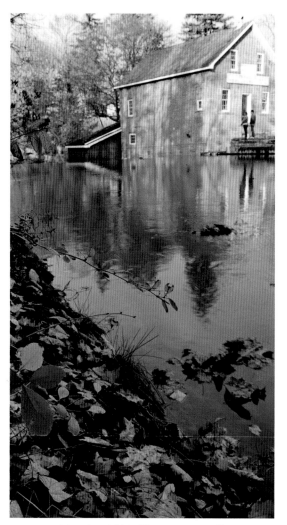

Morningside Mill at Decew Falls

a contemporary glimpse of Ontario's milling heritage as it appears today. With the growing trend towards eco- and heritage-based tourism, more and more people

1750 2 3 4 5 6 7 8 9 **1760** 2 3 4 5 6 7 8 9 **1770** 2 3

are seeking an appreciation of natural or historical treasures in their own backyard. With this book as your guide we hope that you will explore many of these grand (and not-so-grand) old buildings, either from your car or from your armchair.

History and Technology of Ontario's Historic Mills

Ontario's historic mills developed in response to a need to provide for three basic necessities of life: food, shelter and clothing. Each of these three basic necessities could be met by manual labour. But the cutting of wood, grinding of grain or spinning of yarn were tedious to complete by hand, and in order to progress economically, society needed to automate certain tasks.

Enter the mill: a way to mechanize the tiresome task of processing raw materials into useable commodities such as lumber, flour or cloth. To fully appreciate the historic mills featured in this book, it is important to understand something about where they were built and how they worked. Therefore, we've tried here to provide a brief, non-technical overview of the development and technology of waterpower, sawmills, gristmills and textile mills. And since the vast majority of the mills featured in this book are gristmills, we unapologetically provide a disproportionate review of this type of mill.

Power from Water

Ontario's old mills were constructed before the days of electricity; that reliable, transportable and versatile power source we all now take for granted. Many were also constructed before the days of steam, which, though crude, afforded many of the same benefits as

electricity. The miller instead had to rely on the natural elements for power, and with a few exceptions, the mills featured in this book were powered entirely by water. Many eventually supplemented or even replaced waterpower with steam, gas, diesel, and later, electricity.

The amount of power available to a mill depended on the flow of water that could be diverted to the mill and the "head" or height from which the water could be allowed to drop. Multiply the flow by the head and divide by 59 and you have horsepower. It's no surprise that some of the most coveted settings for mills during the initial settlement of Ontario were next to waterfalls, where a good head of water was instantly available. Today, a number of historic mills remain perched beside beautiful waterfalls, as at Elora, Ancaster, Almonte and at Decew Falls (see table below).

But where head from a waterfall was not available, the miller had to create his own, usually by damming a

Some Mills Located Beside Picturesque Waterfalls

MILL	WATERFALL
Ancaster Mill	Mill Falls, Ancaster
Balls Mill	Balls Falls
Darnley Gristmill	Darnley Cascade
Deagle's Mill Ruins	The Cataract (Church's Falls)
Elora Mill	Elora Cascade
Hilton Sawmill Ruins	Hilton Falls
McDougal Mill	Second Chute
Morningstar Mill	Decew Falls
Rosamond Mills	Mill Falls, Almonte
Victoria Mill	Grand Falls, Almonte

King's Mill, Cataraqui (gone) ⌐
King's Mill, Secord ⌐
⌐ King's Mill, Napanee (gone)
⌐ King's Mill, Toronto (gone) ⌐
Backhouse Mill ⌐

| 6 | 7 | 8 | 9 | **1780** | 2 | 3 | 4 | 5 | 6 | 7 | 8 | 9 | **1790** | 2 | 3 | 4 | 5 | 6 | 7 | 8 | 9 |

~10,000 UE Loyalists in Ontario ⌐ Upper Canada formed ⌐ Oliver Evans' first "automatic mills"

stream to create a millpond. As the water level in the pond rose, so too did the amount of head available to power a mill. Early dams were short-lived, constructed of any combination of earth, rock and brush. Later dams were constructed of more solid timber cribwork. Though most remaining mill dams were reinforced with concrete years ago, a few rustic wooden ones still exist (for now), like the little wooden dam at O'Hara's mill.

A millpond could be created almost anywhere, and hundreds, if not thousands, were created, most of them outlasting the mills for which they were built. Even today, few Ontario communities are without their "millpond," and even where no trace of the mill remains, the pond usually serves as a coveted feature of the town park.

In order to operate his machinery the early miller had to divert water to the mill. Sometimes water could enter the mill right from the millpond, but usually a short channel called a "headrace" or "mill race" was constructed to bring water to the mill from the pond.

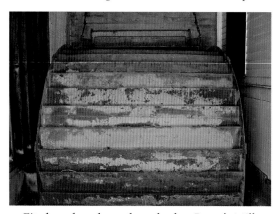

Fitz brand steel overshot wheel at Bruce's Mill.

The "headrace" was most often simply an open ditch, though large-diameter wooden or steel pipes called penstocks were also popular (see Welbeck Sawmill and Bruce's Mill). Occasionally, due to the lay of the land, an elevated wooden trough known as a flume was required, with excellent examples still visible at the Backus Mill and Roblin's Mill. Still others seem to be somewhat isolated from the water, their mill race being filled in with earth long ago (see Nicholston Mill, Molson Mill, etc).

With the twist of a crank, water was allowed to flow from the headrace and strike the mill's waterwheel or turbine, converting the water's kinetic energy to rotary power. Waterwheels came in three principle configurations, illustrated by the figure at right. The undershot wheel was the least sophisticated and least efficient, relying entirely on the force of the water directed against wooden paddles around the circumference of the wheel.

An improvement on the undershot was the overshot wheel, which worked more efficiently by capturing not only the force of the water, but also its weight, which was temporarily held in bucket-like appendages in place of paddles. Overshot wheels as large as 9 m in diameter were found at sites like Balls Falls. A third type, the breast wheel (and its cousin, the pitch-back wheel), was similar to the overshot, but water struck the buckets prior to the top of the wheel, causing the wheel to turn in the opposite direction.

The wheel was normally connected via a horizontal shaft to a large gear inside the mill called a "face wheel." Large pegs protruding from the surface of the face wheel interlocked with bars on a gear called a lantern wheel that spun on a vertical axis. Vertical power could then be transferred to the millstones via

	Ball's Gristmill		Delta Mill	Darnley Mill	Asselstine Woollen Factory

Van Alstine's Mill, Glenora

1800 2 3 4 5 6 7 8 9 **1810** 2 3 4 5 6 7 8 9 **1820** 2 3

(War with USA) ~100,000 people in Ontario

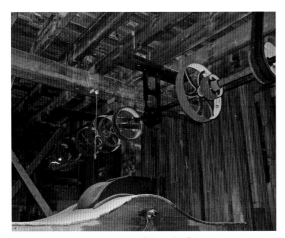

Remnants of lineshafting

simple spur gearing. The basement level of the Roblin Mill in Toronto is one of the best places to observe the gearing of a wheel-driven mill.

The beauty of the mill was that rotary power could be used to drive not only a millstone or saw blade, but also a multitude of different machines. The secret was "lineshafting," a collection of pulleys that connected shafts to the machines by means of endless belts or straps made of leather, gut or canvas. Rotary power could be used to run machines five floors above or almost 100 m away. The remnants of lineshafting are commonly seen at old mills across the province, varying from fully operational masterpieces (e.g., Lang Mill, Bellamy Mill) to piles of junk hidden out back and overgrown by weeds.

Mention the phrase "old mill" and most people instantly envision the creaky old waterwheel, romantically turning away on the outside of the building. But of all the historic buildings featured in this book, only three sites feature a wheel. So what happened?

One reason for their near-complete absence is that Ontario can get cold in winter. Really cold! The early miller found himself wasting far too much time repairing exterior wheels and other external equipment that was constantly battered by ice or splintered by countless cycles of freeze and thaw. Some mills (e.g., Delta Mill) incorporated the wheel into a deep "wheel pit" within the structure of the mill, which afforded some protection against freezing conditions. But perhaps a more significant reason for the absence of the familiar old waterwheel is that most mills, were in fact, powered by turbines. Historical accounts usually reveal that external wheels were indeed installed first, but, starting in the 1850s, were discarded in favour of the turbine.

Though arguably not as rustic or photogenic as the waterwheel, the turbine works in very much the same way. A set of curved blades or "vanes" is set horizontally around a vertical shaft and encased within an enclosed steel tub. Water entered the top, bottom or sides (depending on the model) and was forced against the "vanes," causing the shaft to rotate much like a breeze turns the blades of a windmill. The tub was filled with water at all times maintaining extra pressure on the blades to increase efficiency.

A vertical driveshaft protruding from the top of the turbine normally terminated at a horizontal crown wheel. Visible at many old mills, the crown wheel is a large "bevel gear"; one in which the top surface of the gear is much smaller than the bottom surface. This allowed the teeth to mesh with those of another bevel gear turning on a perpendicular axis. Two bevel gears could thus be used to transfer power from the vertical to the horizontal and back again. Crown wheels were usually constructed of cast-iron with slots to hold

Mill of Kintail				Coldwater Mill				Scott's Mill / Hope Mill		Dickson Mill / Roblin's Mill		Lang Mill		Red Fife wheat / O'Hara Mill							
6	7	8	9	**1830**	2	3	4	5	6	7	8	9	**1840**	2	3	4	5	6	7	8	9

250 gristmills in Ontario — Rideau Canal finished — ~450,000 people in Ontario

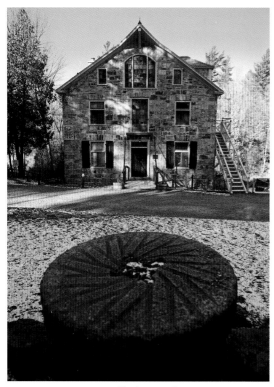

Mill of Kintail

village of Glenora and is located beside Van Alstine's Mill (1806), one of the oldest mills in Ontario (now a private residence). Another common turbine was a model designed by Charles Barber of Meaford. His "Barber Turbine" won an award for the best turbine on exhibit at the International Exhibition in Philadelphia in 1876, and was soon installed at many sites in the province.

Compared to the waterwheel, the turbine was more efficient, less prone to freezing conditions and more durable. Mills could be designed to accept multiple turbines, with four installed at the Goldie Mill, and six at Watson's Mill. Thus, while the artist or photographer of the twenty-first century laments the absence of the familiar waterwheel, the miller merely saw the wheel as a dying technology, begging to be replaced by more efficient methods as quickly as possible. And for those with a love for all things mechanical, a rusty old turbine is a source of interest, providing an opening for discussion of various facts and figures.

In addition to water, steam generated from the burning of wood or coal was also used to power early mills in the province. Though more expensive to operate, it allowed the miller to keep things running even when the water supply dropped to an unusable level. In fact, the miller trying steam soon discovered that he didn't even need a stream at all! And since steam machines could be built to eclipse the power supply of all but the largest of rivers, they were partly responsible for the progression of industry from the little country mill to the larger industrial factory.

The Sawmill

When the first European settlers arrived in Ontario, there was no way for them to obtain sawn lumber to

replaceable hardwood teeth, which were used to reduce noise, vibration and sparks.

While the wooden waterwheel was constructed *in-situ*, the turbine was mass-produced, and several Canadian manufacturers supplied models to Ontario's mills. In the early 1870s James C. Wilson founded "Little Giant Water Wheel Works" to manufacture (you guessed it) "Little Giant Turbines." The firm's old foundry, now used for a field office of the Ministry of Natural Resources, still stands at the picturesque

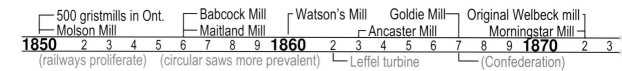

	500 gristmills in Ont.	Babcock Mill	Watson's Mill	Goldie Mill	Original Welbeck mill
	Molson Mill	Maitland Mill		Ancaster Mill	Morningstar Mill
1850 2 3 4 5 6 7 8 9 **1860** 2 3 4 5 6 7 8 9 **1870** 2 3					
(railways proliferate)	(circular saws more prevalent)	Leffel turbine		(Confederation)	

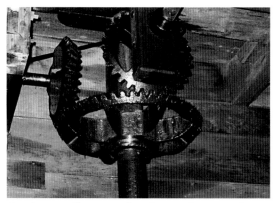

Bevel gears allow transfer of power between planes.

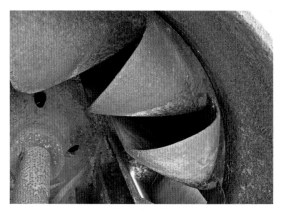

Interior view of turbine vanes.

build houses, barns or other structures. As a result, most early buildings were constructed of logs. Erected with little more than an axe, these dominated the built environment for the first several decades. A trip along the county roads of Renfrew, Lanark or Grey County can reveal a few original buildings still standing, though most are abandoned and slowly rotting away.

Though log homes would continue to be constructed until the mid-nineteenth century, the emergent pioneer society needed sawn lumber for barn boards, wagons, barrels, furniture, etc. Unfortunately, prior to the construction of a sawmill, this involved the slow, exhausting use of a "pit saw," which had a straight blade about 2 m long and wooden handles at either end. The log was placed lengthwise on two long pieces of wood called "side strakes" which were separated by a narrow notch. One man worked the saw from above, while the other, affectionately known as the "pitman" worked the saw from a pit below the side strakes.

Usually the first mill to appear at a new settlement, the early sawmill was constructed to automate the sawing process, and often served as a magnet for growth to the community in which it was located. The first ones were frame saws, comprising a straight blade held rigidly a wooden frame known as a gate or sash. Rotary power turned a crank called a "pitman arm," which in turn caused the entire frame to rise and fall, much like a sash window. The gearing was like the reverse of the automotive crankshaft, where the up-and-down motion of the piston is converted to the rotary motion of the wheel. The saw blade would cut the wood on the down stroke only. The only known example of an operating frame saw in Ontario can be observed at O'Hara's Mill near Madoc.

In addition to providing the up-and-down motion of the saw, waterpower was also utilized to move the "carriage" on which the log rested. Each time the frame was raised, it turned a large gear called a "rag wheel," which caused the carriage to move forward and ready the log for the next cut. Once the end of the log reached the saw blade, the carriage had to be returned to the starting position to cut the next board.

				1034 Gristmills in Ontario					Stark's Mill			Rollers at Coldwater Mill					Turnbull Knitting Mill				
	First rollers in Ontario																				
6	7	8	9	**1880**	2	3	4	5	6	7	8	9	**1890**	2	3	4	5	6	7	8	9
				(turbines become prevalent)				(rollers prevalent)			(rise of prairie wheat industry)										

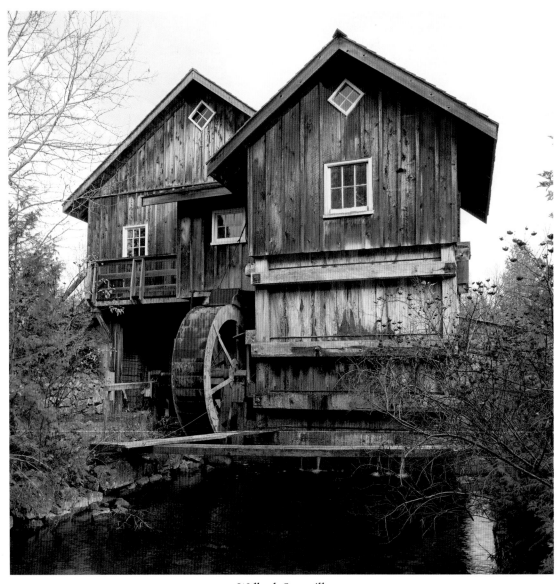

Welbeck Sawmill

Nicolston Mill ⌐ ⌐ O'Hara Mill closes Coldwater Mill as feed mill ⌐
Bell Mill ⌐ baskets at Babcock Mill ⌐ ⌐ Thoburn Mill

1900 2 3 4 5 6 7 8 9 **1910** 2 3 4 5 6 7 8 9 **1920** 2 3

(electricity to rural areas) (World War I) (small gristmills to feed)

An improvement upon the frame saw was the muley saw. This too involved a single vertical blade, but by dispensing with the heavy frame or sash, allowed the saw to cut about twice as quickly. The carriage worked in much the same way as with a frame saw. A fine operating example of the muley saw can be found at Beach's Mill at Upper Canada Village.

The first circular saw blades were brought to Ontario around 1820, though they did not become common until the 1850s and 1860s when they were finally of sufficient quality so as not to bend or warp when cutting larger logs. But once the design was perfected, due to their speed and much reduced vibration, the circular blades all but did away with the reciprocating or up-and-down varieties. Circular saws can be seen in operation at several historic mills, such as the Hope Mill, Dean Sawmill and the operating replica mill at the Welbeck Sawmill.

Though the early focus was solely on local supply, by the first few decades of the nineteenth century the vast lumber export potential of the Ontario forest was realized. This led to the birth of one of the great Canadian icons: the lumberjack. These burly men, worked all winter in the woods to cut timber for an industry that would dominate the Canadian economy for a century. Some, like the legendary Big Joe Mufferaw are rumoured to have been tough enough to paddle the Ottawa River "all the way from Mattawa in just one day!"

Trees were cut in winter as they could be more easily "skidded" out of the woods over the ice. As the snow pack melted, the logs were floated or "driven" down the fast-flowing streams to large milling centres in counties from Muskoka to the Ottawa River. Bytown (now Ottawa) was the undisputed Lumber King.

Compared to the little water-powered village sawmill, the commercial sawmills were giant steam-belching monsters! Where the biggest community muley saw might have cut a few thousand feet of lumber per day, the large lumber mill of the mid-nineteenth century might have been disappointed with 50,000. And when the band saws arrived in the 1890s, the output easily increased by another order of magnitude.

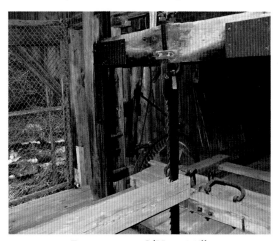

Frame saw at O'Hara Mill.

The Gristmill

Wheat, rice and corn have long been staple foods for most of the world's population, together accounting for 60% of the world's food energy intake. Wheat consists of three primary components: the bran, which is the protective outer layer of the seed; the germ, which is the part of the seed that would sprout if it was planted; and the endosperm, the 83% of the wheat kernel that when ground to a powder makes flour. The white flour that we know today has been milled to remove the bran and the germ, whereas brown or "whole wheat" flours

Mill of Kintail as house
Darnley Mill burns
Delta Mill closes as feed mill
Chaffey's Mill as house

| 6 | 7 | 8 | 9 | **1930** | 2 | 3 | 4 | 5 | 6 | 7 | 8 | 9 | **1940** | 2 | 3 | 4 | 5 | 6 | 7 | 8 | 9 |

(Great Depression) (World War II)

include the germ and the bran, which are excellent sources of fibre.

Humans have milled grains for millennia. By roughly 1000 BC, "quern mills" were developed to crush grain between a flat stone turned on top of another. First operated by hand, larger examples exploited animal power. As civilization progressed, humans learned to replace muscle power with the power supplied by the natural elements. Water-powered mills probably appeared in the first few centuries BC in Greece, while wind power was mastered in Europe, about a millennium later.

Fast-forward to the eighteenth century. European immigrants to Ontario intended on farming and most would rely on wheat as a staple for diet and income. The first few measly harvests were likely ground by hand, or with the aid of simple tools like the plumping mill. But for the farmer to make any real profit, he needed to be able to turn large quantities of wheat into flour.

The government of the day saw the desperate need to stimulate agriculture and built some of the very first gristmills in the province. These first "King's Mills" were constructed at Kingston, St. David's, Napanee and the Six Nations along the Grand River. The mill at St. David's (northwest of Niagara Falls) was constructed in 1783 by Peter and James Secord, and was quite possibly the first mill in Ontario. Located along Four Mile Creek, it still stands, but from the outside, it looks like just another rural frame house.

Not long after, privately-run mills sprang up anywhere there was a source of waterpower and a supply of grain. Instead of painstakingly grinding his grain by muscle power, the farmer could now bring his harvest to the mill and have it processed to flour in a matter of hours. The miller was usually paid by toll, keeping

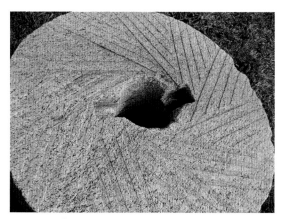

Millstone showing dressing and "eye."

one-twelfth of the grain brought to the mill. As you can imagine, the mill soon became an important focal point of the farming community, as farmers from many kilometres away in all directions would meet and mingle while waiting for their grain to be milled.

The first mills operated as custom mills, with the ground product returned to the farmer, less the miller's toll. They were also termed gristmills, because they could also ground many kinds of grain to a variety of products besides flour, most notably animal feed. The gristmill was usually relatively small and operated by only a miller and a few assistants. As agricultural production increased and the supply of grain exceeded the local demand, merchant mills began to develop. Here, the miller purchased the grain from the farmer outright, and then marketed and shipped the flour to markets, often over great distances. Merchant Mills (also called "flourmills") were considerably larger, but might still do some local custom work for the farmer.

Between the time of construction of the King's Mills and that of most of the gristmills featured in this

| 1950 | | | | | | | | Goldie Mill burns → | Roblin's Mill moved to Toronto ⌐
Dod's Mill (Millcroft) closes ⌐ | 1960 | | | | | Aberfoyle Mill as restaurant ⌐
Nicolston Mill closes ⌐ | | | | 1970 | | |

1950 2 3 4 5 6 7 8 9 1960 2 3 4 5 6 7 8 9 1970 2 3
└ Hurricane Hazel – severe floods

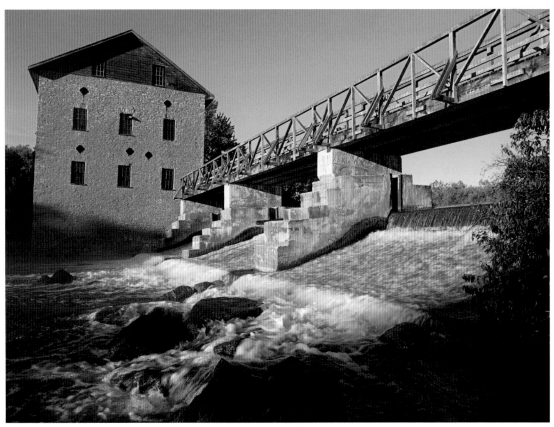

Lang Mill

book, a significant evolution was made in milling technology. In 1791, an American millwright named Oliver Evans (1755-1818) developed the first "automatic mill," which used waterpower to perform just about every task in the milling process. Almost all of the gristmills featured in this book incorporated this newer technology, and a review of the main processes will enhance your appreciation of the old gristmill.

Once the farmer delivered his grain to the mill, it was weighed on a scale and then loaded into an open tub called a hopper and allowed to fall to the basement level. The grain was then brought to the top floor using a bucket elevator, one of Evans' greatest inventions, which consisted of an endless belt of leather to which were attached little metal cups. Functioning bucket elevators in various states of repair can be seen at many mills, with good examples at the Lang Mill, Spencerville Mill and the Otterville Mill.

| Dickson Mill as restaurant | Otterville Mill closes | Fowld's Mill as house | Hope Mill restoration |
| | c. Rosamond Mill closes | | Code's Mill closes |
| 6 7 8 9 **1980** 2 3 4 5 6 7 8 9 **1990** 2 3 4 5 6 7 8 9 |
| Ancaster Mill as restaurant | | | SPOOM Canada formed |

Williamsford Mill

The elevator would empty the grain at the third or even fourth floor of the mill. Here it was passed through a revolving screen to separate large foreign objects like weeds or leaves from the grain. The grain would then pass into a smutter, which cleaned the grain of finer foreign objects like fungus or dust by spinning it at high speeds in a mesh drum, much like a salad spinner removes the water from lettuce leaves. From here, the grain was conveyed to one of several holding bins known as a garner bins. These were often constructed entirely of interlocking 2 by 4 boards stacked one atop of another, with good examples remaining at the Williamsford Mill and the Neustadt Mill.

When the grain had to be transferred vertically from one floor down to another, it was simply moved by gravity. But when it had to be transferred horizontally from one spot to another it was usually moved by an auger or conveyor. This was a long wooden shaft to which were attached inclined wooden plates, transporting grain through a wooden trough much like water moved by Archimedes screw (see Otterville Mill). Once the miller was ready to process the grain, it would be dropped by gravity through the grain chute from the garner bin to the ground floor, and placed into a millstone hopper located above the millstones.

The millstones were the heart of the mill; its raison d'etre. Each disk-like stone was circular in shape, usually about a meter or so in diameter, and about 15-20 cm in thickness. Two millstones were always stacked vertically to form a "run of stone." Small mills might only have one run of stone, while larger ones, like the now ruined Allan's Mill in Guelph had as

Bucket elevators at the Lang Mill.

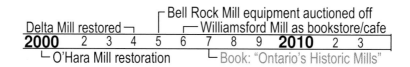

Delta Mill restored ⌐
⌐ Bell Rock Mill equipment auctioned off
⌐ Williamsford Mill as bookstore/cafe
2000 2 3 4 5 6 7 8 9 **2010** 2 3
└ O'Hara Mill restoration └ Book: "Ontario's Historic Mills"

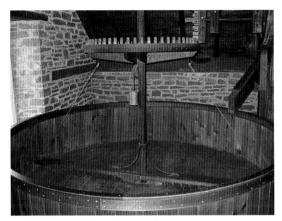

Hopper boy

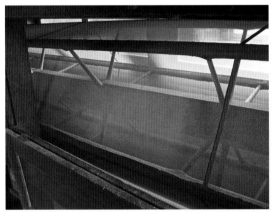

Bolter at Roblin's Mill

each stone ensured that the grain could be ground effectively and moved towards the perimeter of the stones. A round wooden tub encasing the two stones was referred to as a "vat" or "tun," and served to catch the ground product as it spilled over the outside edge of the bed stone.

To ensure a proper working surface, millstones had to be periodically resurfaced and balanced. This process was known as "dressing," and was either conducted by the miller himself or by a specialized "stone dresser" contracted by the miller. Dressing could take dozens of hours per stone, involving meticulous work with a hammer and chisel. And in a busy mill, dressing might be required every several weeks. At many old gristmills you can see the heavy duty "stone crane" that was used to lift the runner stone to facilitate dressing (e.g., Tyrone Mill).

It was generally accepted that the best stones were made of "buhrstone," a specific type of hard quartzite only available from northern France that allowed the miller to obtain exceptionally fine flour. It was normally obtained as a number of smaller pieces and then carefully assembled into a circular shape and bound by a metal band. Other types of stone were also used, some of which could be obtained as solid disks. Canadian-sourced stones of acceptable quality were obtained from quarries in New Brunswick, Nova Scotia, and the Saguenay region of Quebec.

Once the flour or grist left the vat, it descended again to the basement level of the mill, where it was picked up by a different bucket elevator and brought to the uppermost floor to a "hopper boy," a round, shallow tub in which a horizontal rake slowly rotated to cool the flour. Few intact hopper boys remain, with the specimen at Roblin's Mill probably the best kept.

Flour was then transferred to the "bolting reel" or "bolter." This was a large wooden machine in which the flour was sifted into different grades through a rotating drum covered in a fine mesh. Flour that was too coarse to pass through the mesh would be

many as seven. The bottom stone or "bed stone" was kept stationary while a spindle running through its centre transferred rotary power to the "runner stone" mounted on top. The runner would typically rotate between about 100 and 150 revolutions per minute, never touching the bed stone, but instead being carefully balanced to turn 1-2 mm above it.

The whole purpose of the mill was for grain to be ground into flour or grist in the thin space between the bed stone and the runner. Grain was loaded through a small hole in the centre of the runner called the "eye." Patterns of grooves cut into the working faces of

discarded, sent back for a second grind, or used as animal feed. Larger operations might include a bolting chest, which though similar to bolting reel, contained several meshes of progressively finer texture, sort of like a modern coin sorter. This allowed the bolting chest to separate the product by grade. This might include two grades of fine flour, the middlings or medium-coarse flour, and finally the shorts and bran, which was the coarsest product to leave the stones. Many bolters were constructed with great attention to aesthetic detail, being constructed of finely finished wood and often prominently displaying the logo of the manufacturer.

After bolting, the flour was sent to the ground floor through a packing chute to barrels below. The barrels were normally sized to hold 196 pounds of flour. Output from the "average" country gristmill might have been 10-50 barrels per day. The larger

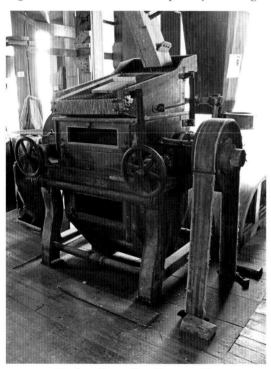

Single roller mill at Spencerville.

mills might have targeted 100 barrels per day, while the largest, like Welland Mills, could approach 300 barrels per day. Of course, the smaller country gristmills might only have produced a fraction of this amount during slow times.

Examples of all of the components mentioned here can be observed at select historic mills in Ontario. In some cases, the entire process is operational. In others, only a few select pieces are preserved, sometimes beyond repair, or, as at Starks Mill, converted to pop art.

In the 1880s, milling technology underwent a revolutionary shift from stone-based technology to roller-based technology. Rollers had been in use in central Europe (originating in Hungary) for several decades, but did not make their way to Ontario until they were imported and implemented in 1875 by E.W.B. Snider at his mill in St. Jacobs. Within about a decade, most other mills followed suit, though some smaller establishments of limited means couldn't afford to retool their operations and simply closed. Rollers required less maintenance, less power and less floor space. These factors combined to allow some existing mills to install multiple rollers where they once had only 2 or 3 run of stone: Snider's Mill had 10 roller mills operating by 1885.

The roller mill processed grain by passing it vertically between several porcelain or steel cylinders housed within a stand, maybe a square metre in area and a little over a metre high. Each roll was typically 15 to 25 cm in diameter, 50 to 90 cm long and rotated at about 450 to 600 revolutions per minute. The grain was broken apart as it passed between two successive rolls. Many mills utilized several rollers to pass the wheat through several "breaks." This was an extension of the "gradual reduction" system of milling that had already been implemented, where instead of aiming for the finest flour on the first grind, the product was passed through the stones (or rollers) in several runs, each time producing a progressively finer product.

Arva Mill, with retail store at far left.

Most of the grist and flourmills that are featured in this book utilized rollers in later years. However, the millstone is typically viewed as being far more romantic than the roller, and it is no surprise that most mill restorations (with the notable exception of the Spencerville Mill) have focused on maintaining the mill in its "stone age." Nevertheless, you can still see roller technology in operation at the Arva Mill north of London. And if you buy flour at the grocery store, it has in fact been milled using rollers, though at mammoth mills slightly more modern than those included here.

Today, only a few small independent mills like the Arva Flourmill still operate using waterpower. Modern milling in Ontario is now limited to about a dozen modern flourmills, all computer controlled and all using electricity to run armies of rollers. Though Montreal is the primary milling centre, large modern mills are found in Ontario in centres such as Blyth, Cambridge, Port Colborne and Woodbridge.

Many Ontario millers obtained their milling and transmission equipment from the Wm. and J.G. Greey Mill Furnishings Firm. Operating out of a building at 70 The Esplanade in Toronto (the building itself is now a designated heritage property), the firm provided almost every possible piece of equipment needed to millers across Canada. Look for the company logo on equipment such as bolting reels. A catalogue released in 1888 became an invaluable resource for the flour miller. As part of efforts to raise funds for the Harrington Gristmill and a digital copy of the catalogue may still be available from the mill's website.

The Textile Mill

The manufacture of cloth from wool (or other fibres like cotton, flax or hemp) has always required a number of major steps. In the early days of European settlement in Ontario, the process of making clothing from sheep's wool or flax was completed entirely by hand. It involved painstaking tasks like carding, where wool had to be straightened, spinning, where fibres had to be "spun" into thread on the spinning wheel, and weaving on simple though inefficient hand looms.

The early woollen mills automated the same processes that were once conducted by hand. All early mills focused on just one or perhaps two particular steps in the overall process. Clean wool had to be "carded," which meant that the individual fibres had to be straightened and then aligned into the same orientation. As this was perhaps the most time-consuming process to perform by hand, carding mills became widespread in a hurry. These mills directed wool through a series of cylinders each covered with protruding bent iron wires. The wires would take hold of the wool as the cylinder turned, orient it in the same direction, and release it. The wool was then twisted and drawn out into a long rope-like appearance called the "sliver" or "roving."

Roving could be "spun" into yarn onto a bobbin. Individual yarns were "warped" together from numerous bobbins and wound closely together on a beam. The beam was then loaded onto the weaving machine. Weaving then interlinked individual yarns with each other at ninety-degree angles to producing cloth.

Once the cloth had been woven, it was still not considered ready, because it was not very tight and still might have a high grease and oil content. The final step in the production process was called fulling, which resulted in a more compact, cleaner and "fuller" cloth. Cloth would be beat and cleaned in soapy water, which caused the fibres to shrink and be stripped of their oil and grease content.

The early carding or fulling mills eventually gave way to woollen "factories" where many or all of the processes could be completed under one roof. An excellent example is the Asselstine Woollen Factory, which is believed to be the only operational nineteenth-century woollen mill in North America. Admittedly, these large textile factories really stretch our normal definition of "historic mill." We have include them here, though, because very few, if any, of the small carding or fulling mills that once dotted the province still exist. And even though the mammoth and often overwhelming woollen factories dwarf the quaint little country gristmills featuring prominently in this book, their value as heritage buildings is increasingly being recognized and exploited.

As the local mill disappeared, the woollen industry began to cluster in select locations. Almonte became known as the "Manchester of Canada" by the late

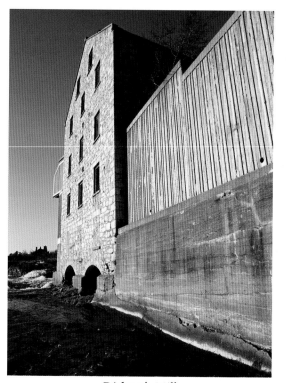

Dickson's Mill

1880s (see the Mills at Almonte). This was a bit of a stretch, but the little town of 4,000 had a dozen woollen firms employing over half of the population. There were several other important milling centres, most notably Galt (see Turnbull Knitting Mill Ruins), and Hespeler, where even as late as 1950 almost ¾ of the workforce was employed at the Dominion Woollens and Worsteds plant. Remaining examples of the large textile factory include Rosamond Mills, the Woollen Mill in Kingston, and Merritton Cotton Mills, which has recently been occupied by the Keg restaurant.

Where Did They Go?

We will never know exactly how many mills were established in Ontario. Many have disappeared into the woods, leaving, at most, perhaps a small heap of stones overlooked by all but the most discerning industrial archeologist. Others were demolished to make way for other structures. Even some of those that still exist are the third or fourth mill constructed on the same spot; a fire being no reason to abandon a prime location.

One thing is for certain: the number of historic mills remaining today pales in comparison to those that once crowded Ontario's industrial landscape. A census of "Mills, Manufactories, etc" taken for Upper Canada in 1861, counted approximately 1,162 sawmills, 501 flour and gristmills, 62 carding and fulling mills and 85 woollen factories.

The availability of cheap lumber from the large mills, the province's improved transportation network, and the dearth of remaining timber led to the downfall of the small community sawmill in southern Ontario. Today, the industry is dominated by the giant mills of northern Ontario, though a few local sawmills still exist in southern Ontario, as well as a relatively recent addition, the portable sawmill.

The downfall of the little country gristmill can be blamed on several factors. The development of the railway system in Ontario played a large role, with entire communities all but disappearing if they were

Traverston Mill

bypassed by the railway route. Mills in communities like Balls Falls, Bedford Mills and Traverston simply couldn't compete without easy access to the railway network. In addition, different varieties of wheat were always being developed, with two notable strains, "Red Fife" (see Lang Mill) and its successor, "Marquis," developed right here in Ontario. In an ironic twist, these hardy strains of wheat developed in Ontario allowed the western provinces to gain dominance in Canada's wheat industry in the late nineteenth century. Thus, while at one time a much more widespread crop in Ontario, wheat was slowly replaced by mixed farming and dairying, and the demand for local milling dropped significantly.

The benefits of scale and mechanization realized at the large textile factories eventually eliminated the need for home textile production, and so too the need for the local carding or fulling mill. Not surprisingly, very few, if any, little country textile mills have survived.

Information about the historical presence of mills in a particular area can often be obtained from the old Ontario County Atlases. These were a well-known set of detailed atlases produced in the late 1870s for most counties in southern Ontario. In addition to showing lot ownership, they indicate the location of hundreds of schools, churches and mills. The maps

have been digitized and are available online at digital.library.mcgill.ca/countyatlas.

Perhaps the best record of mills can be found with knowledgeable residents of former milling communities. Research efforts focused on a particular community or watershed can provide surprising results. In "Mills and Mill Villages of Severn Township," author James T. Angus documents no fewer than 73 former mill sites — in a single township! It has been reported that close to 90 mills operated on the Credit River near Toronto before 1890. Further east, the Friends of the Tay Watershed Association and the Lanark Camera Club were, at the time of writing, working to document the history of mills along the Tay River in Eastern Ontario, with the intent to develop a photographic series of the mills and mill sites of the Tay watershed.

Mill Construction and Architecture

Ranging from the near-ostentatious to purely utilitarian, Ontario's heritage mills exhibit a wide variety of construction methods and architectural details. While a full treatment of the architectural form is beyond the scope of this book, there are a few construction techniques and basic architectural details that you can look for when visiting an old mill.

Most mills were built using the timber-framing technique, which utilized a large skeleton of large wooden vertical posts and horizontal beams. Some of the timbers used to support the mills' structure are nothing short of mammoth! And what is even more remarkable is that many of the beams were squared by hand, simply out of necessity because there were no nearby sawmills available for the job. Posts and beams were connected together by hammering wooden tenons (pegs) into mortises (holes) in the wood. Posts were usually chamfered, meaning that they were beveled along the edges, and each was normally topped by a "capital"; a short horizontal timber to help support the weight of the overlying floor.

Board and batten exterior

The exterior of timber-framed mills can be covered by a variety of materials. Clapboard is composed of horizontal boards, the bottom of each board overlapping the top of the one below it. Board and batten is normally constructed using vertical planks abutting each other, with a narrow strip of wood covering the crack between planks. When the covering was for a small sawmill, barn boards were usually employed, hammered on with great haste and little effort to seal the cracks between them (see Beach's Mill or Scott's Mill).

Horizontal Plank construction is a rare method that we found only at the Schomberg Mill. Here, horizontal 2 by 4 (or perhaps 2 by 6) planks were laid one on top of each other to form both exterior and interior walls. Even the rooms now used as washrooms are constructed this way! We suspect that this construction may in fact hide a timber-frame skeleton, as the ceiling in the restaurant section of the mill is quite expansive. It was not uncommon for grain storage bins to be constructed this way, with visible examples at the Williamsford Mill and the Neustadt Mill (and currently hidden on the upper floors of the Caledonia Mill and Coldwater Mill).

While the old wooden mill can certainly be rustic, those built of stone are usually nothing short of

charming. Prohibitively expensive for all but the most costly contemporary construction projects, old stone mills represent perhaps the most striking and romantic examples of mill architecture. They usually dominate the landscape in which they are found, and are both the most commonly photographed and painted, and most highly sought-after for restoration projects.

Clapboard exterior at Bruce's Mill.

Stone mills could be constructed using several different techniques. The stones that supported the weight of the building also served as the exterior finish for the building. Thus, the mason often had to give consideration for the visual appearance of his work in addition to its ability to stand up. When the stones were stacked in rows of uniform height, the appearance was termed "coursed"; "broken course" being used to describe blocks of varying height in a row; and "un-coursed" used to describe walls with an absence of consistent horizontal rows.

Ashlar masonry, also known as "cut-and-dressed stone," refers to a construction method where the stones are meticulously cut to rectangular blocks for easy stacking (see Snowball Gristmill and Wood's Mill). It was the most expensive method and was usually reserved for more pretentious buildings, and certainly never wasted on sawmills or smaller country gristmills. Rubble-stone masonry referred to walls that were built using just about any kind of stone, provided

enough mortar was available to bind it all together (see the ruins at Lindsey). And where no quarry was nearby, "field stones" were the only stone supply, but could be used to interesting effect, as seen in the multi-coloured walls of the Mill of Kintail.

Brick was used at a number of mills, though usually as a veneer over a timber frame skeleton, as is easily seen at the Nicholston Mill. It is more often found at the slightly newer buildings included in this book like the Thamesford Mill, Thoburn Mill and Cream of Barley Mill, all constructed very early in the twentieth century. Arguably less impressive than stone, a few mills using brick were still able to incorporate little details, like the construction date (1848) that was tastefully incorporated into the brick pattern under the eaves at the Brooklin Mill.

Finally, you may encounter mills that have been covered in metal sheeting. This is a newer, functional material that can serve much the same way as a dentist's crown to sheath a damaged tooth. Considered somewhat unsightly by many, metal also exhibits its own rustic (!) quality, with nice examples at Arva, Bluevale and Wellesley. Concrete also appears in a few historic mill buildings, but is only normally associated with more recent renovations or repairs, as it did not

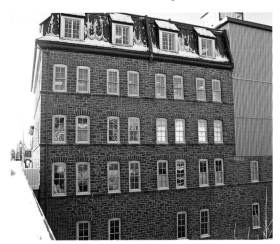

Wood's Mills

become widespread until the early twentieth century. A notable exception is the Logan Mill, which was constructed of poured cement in 1911.

The choice of material used in construction depended primarily on the availability of a particular material, the availability of skilled labour, and of course, cost. Where stone would have had to be transported a great distance, wood was the economical choice. And nobody would expend the effort to construct a sawmill out of stone or brick, as business was sure to fizzle out once local timber supplies were exhausted. But where the entrepreneur wanted to make a statement, stone was the way to go!

In addition to the construction materials used to build the mill, a number of little details can often be seen. In mills constructed of stone, look for the "quoins,"

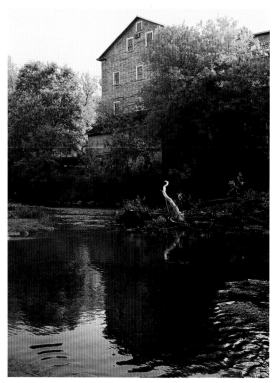

Vanstone Mill

or cornerstones, which were large rectangular stones placed all the way up the corners to protect against damage and stress generated by the structure. It is not uncommon to see cut-and-dressed stones used as quoins even where the rest of the building was constructed of broken-coursed rubble (see Martintown Mill). Windows and doors at stone mills were either topped by a row of vertically positioned cut stones, or by one long solid stone called a lintel.

Perhaps the best hint that an old building in Ontario was at one time a mill is the presence of a millrace arch. This feature is almost always found outside a stone mill or one with a stone foundation. It supported the weight of the building above the large opening where water would enter and exit the building. And owing to the natural strength of its form, the millrace arch is occasionally the only remnant of a structure left standing, with good examples still hidden in the woods at Limehouse and Everton. But where the mill only featured an external waterwheel (e.g., Roblin Mill), this structure was absent.

A curious feature of many mills is the door(s) that open from the upper floors into thin air (see the photographs of the Delta Mill and Otterville Mill). In earlier days these could have been used to haul sacks of grain to upper floors. Once the mill implemented the automatic process however, the doors were still used for additional light and ventilation, as well as for the installation of new equipment.

Windows are often of double-hung sash construction, allowing one or both of the frames to vertically slide open. These can be described by the number of panes: "12 over 8" meaning that the upper frame showed 12 panes while the lower showed 8. The Hope Mill has a "12 over 12" configuration; the Vanstone Mill features "12 over 8"; and the Ancaster Mill has "9 over 9." Of course, buildings featuring large panes spanning half or all of the window opening have had their original windows completely replaced, like those at the Rosamond Mill or Snowball Mill.

Cream of Barley Mill

Other mills featured "casement windows," where two frames would open like French doors. Excellent examples are found at the Spencerville Mill, Watson's Mill and Bedford Mills. And very rarely, the uppermost windows could be part of a "mansard roof," as seen at Wood's Mill, the Beaumont Knitting Mill in Glen Huron and Penman's Mill in Paris. Here the exterior wall on the uppermost floor sloped inwards slightly, but maintained shallow dormer-type windows.

Several buildings exhibit a long clerestory or "monitor roof," which was a narrow upper floor with nothing but additional windows to allow more light and ventilation into the building (see the Thamesford Mill and the Cream of Barley Mill). Similar functions were performed by the much smaller cupola or belvedere, found rarely but notably at the Caledonia Mill and Chisholm's Mill.

The Old Mill in the Contemporary Ontario Landscape

Only a fraction of the nearly 2,000 mills that were counted in the census of 1861 still exist today. Our research revealed very approximately 150 intact or mostly intact old mill buildings, but this of course depends greatly upon what one considers to be an "old mill." Our count excludes probably hundreds of little ruins and dozens of slightly more modern feedmills. Why were some able to survive while the majority disappeared? Did only the best-constructed buildings endure? Or was it simply luck?

Longevity probably had more to do with the ability of an owner to adapt to changing economics and technologies. The mill that was able to supplement waterpower with steam would have a competitive advantage over those left susceptible to unreliable water supply in summer. The flourmill that was quick to embrace roller technology after the 1870s bought itself several more decades of relevance.

The adaptability of the building to be used for a completely different purpose was another key to permanence. The Dickson Mill was used for nearly 40 years for auto supply and repair businesses before being retrofitted as a restaurant. The Babcock Mill in Odessa was designed and built to be used as a flourmill, but never received a bushel, instead being used for many years to construct boxes and baskets.

Of the historic mills that are left standing, and of those that we feature in this collection, the large majority were once gristmills. For the most part, these could easily be converted to feedmills, and to this day remain a necessary component of the rural landscape. Old sawmills are probably rare due to their ephemeral nature — the mill need only have been built to last until the supply of local timber was exhausted. Finally, the local carding and fulling mills were made obsolete by the large woollen factories, which in turn were made outmoded themselves by synthetics and inexpensive imports.

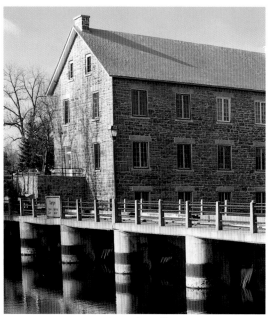

Watson's Mills

But perhaps the most important factor in the preservation of historic mills is the effort expended by dozens of community groups each with a passionate interest in the preservation and restoration of "their" mill. For some time people have sought to protect and restore historically significant buildings, and old mills are no exception. Some, like Watson's Mill, have enjoyed longstanding community backing, while support for others ebbs and flows, with periods of intense activity separated by lulls of neglect. We fully expect that some of the buildings that stood idle at the time of writing will be brought to life in some new capacity. Funding or community interest for others may dry up, a private one may change hands, or a formerly derelict site may be renovated into a completely new structure.

Though the potential uses of old mill buildings are many, they can be grouped into one of six main categories. Each category offers a different experience to the mill enthusiast.

Museums

Of primary interest to many readers are those historic mills that have been restored to living museums. A number of fully operational, museum-quality mills are found throughout the province. Some, like Asselstine's Woollen Mill, Roblin's Mill or the Dean Sawmill, have been incorporated as part of a larger "pioneer village," while others, like the Delta Mill or the Morningstar Mill are stand-alone tourist attractions. Most tend to be open for visiting seasonally, and usually require an admission. If your interest lies in technology, local history, or finding a nearly unspoiled historic landscape for artistic expression, these are the mills for you.

Hospitality

Though small in number, those mills that have been renovated into restaurants or inns are often best-known to the general public. Who hasn't had dinner or attended a wedding at "The Old Mill"? Some of Ontario's finest old stone mills, like those in Elora or Alton, have been converted to classy inns, providing a unique atmosphere for upscale accommodations. Others, like Pratt's Mill, Dickson's Mill or the Aberfoyle Mill, have been converted to restaurants, offering unique experiences for both the budget-conscious and high-end diner alike.

Most of these buildings have been substantially renovated to support the businesses that they now house. The interior of some have been completely gutted, while others, like the Ancaster Old Mill or the Café at the Coldwater Mill, have incorporated the original chamfered posts into the interior decor. The Elora Mill even integrated the steel penstock into its bar, aptly named, the Penstock Lounge.

Retail Establishments

Many old mills continue to serve the public as centres for commerce, though in place of flour and lumber, they now sell products from crafts to chainsaws. Some, like Codes Mill or the River Mill in Kingston, are

multi-purpose facilities housing a range of retailers and offices. In most cases the retailer understands that the preservation of a heritage building can only help to bring customers back again and again.

Perhaps the most romantic of all old mills are those that still sell products prepared on site. These are rare, but there is something gratifying about purchasing locally ground flour or split cedar shingles. The table below lists products that can currently be purchased at existing old mills. Several operational museum-type mills, such as the Morningstar Mill and the Lang Mill produce flour, but do so on an irregular or semi-regular basis and do not have a regular retail operation.

Products Still Produced for Purchase at Specific Mills

PRODUCT	MILL
Apple Cider	Tyrone Mill
Bird Seed	Nicolston Gristmill
Cedar Shingles	Welback Sawmill
Flour	Arva Flourmill
	Bellamy's Mill
	Tyrone Mill
Lumber	Chisholms Mill
	Tyrone Mill

Private Residences and Businesses

With oodles of nooks and crannies and a prominent location in the community, perhaps no building is more unique for use as a home than an old mill. A significant number have been converted to private residences, often snapped up in a derelict state and painstakingly restored to something just barely passing the building code. A recent phenomenon has been the conversion of old mills to condominium complexes. Beautiful examples can be found in Almonte and Fergus, with several more in the planning stages.

This book features a number of old mills that are now used as private residences. Most are located beside a public thoroughfare, and you should normally limit your enjoyment to what you can take in from the road. *All are on private property, and this book does not give you permission to visit any of them.* Please exercise the same respect that you would expect of someone around your home.

A few sites are also used for private businesses that do not have a regular retail store open to the public. These should be treated with the same respect afforded to mills used as private residences. A few, like Molson's Mill or the old Turbine Foundry at Glenora, are occasionally open to the public at special events such as the annual "Doors Open" series.

Derelict Buildings / Ruins

Without a lot of tender love and care, no old building can last forever, no matter how solid the construction. Mills are no exception, and hundreds of old buildings that once occupied prominent positions in the community have long since vanished. Many were torn down to make way for more modern land uses, while others were torn down following a fire or flood. Ruins can be lots of fun to seek out. They range from the near-majestic like at Rockwood, to the near-invisible, like the pile of stones that is all that remains of Morden's

Balaclava Mill

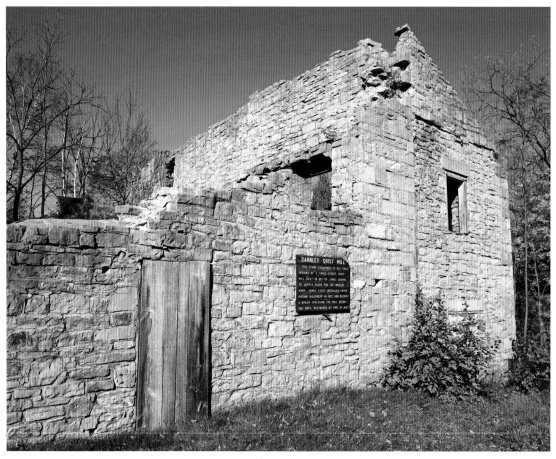

Darnley Gristmill

Mill at Crook's Hollow. Some are completely forgotten, while others, like the Watchorn Mill at Merrickville, are carefully preserved and promoted as a reminder of a community's industrial past.

As with any abandoned building, you should always use caution when exploring a ruined or derelict site. The safety fences surrounding sites like the Darnley Mill were installed for a reason! After a century of neglect, nobody can be sure just how much longer some of these buildings will stand. Inclusion of a building in this book does not guarantee that it will always be safe or lawful to visit.

"Limbo"

A number of fine old buildings currently sit silent, inaccessible to all but the owner. While this can be a major disappointment to the curious explorer, it is just a normal part of the life cycle of an old mill. Many buildings currently used as restaurants or museums had an uncertain future at one point, just as those that currently appear to be going nowhere may someday represent first-rate attractions. Sometimes it is a lack of funds that keeps the buildings closed, while in other cases, restoration efforts, though invisible to the casual visitor, are indeed well underway.

Using This Book

Aside from reading this book, your best bet for truly appreciating these wonderful pieces of our heritage is to explore them for yourself. And by talking to the locals, who are far more knowledgeable about the neighbourhood mill that we could ever be, you can gain an even greater appreciation of the site's rich history and anticipated future (and almost certainly find a fact or two of ours to dispute!).

A word of caution, however: It is no secret that some of these buildings are much more interesting and/or accessible than others. While the true mill fanatic or genealogist may be thrilled to find a crumbling stone foundation hidden in the woods, others may be disappointed at even some of the more historically or structurally interesting mills. We freely admit that a fair number do not represent tourist destinations in and of themselves. But just as the mills served as the spark to light settlement of an entire region, so too can they justify a reason to visit a new town, or serve as waypoints for an interesting day trip through a previously unexplored part of the countryside.

It is always a good idea to travel with a good road map. Several companies provide "town and country" maps, which label most county and township roads in the province. Such maps are indispensable, should you take a wrong turn, should the name of road change, or in the unlikely event that our directions prove to be wrong. These maps also provide a high degree of detail, locating many tiny communities, streams and lakes that wouldn't be allocated ink on most province-wide maps.

More serious adventurers may utilize GPS receivers to find faint ruins hidden in the woods. Armchair adventurers may enjoy the challenge of locating the mills and their surroundings on some of the high-quality satellite or aerial imagery recently made available via the internet (e.g., maps.google.ca). We have included latitude and longitude information that may not be accurate enough to direct you to a mill's front door, but should easily put you within sight of the building. We are even aware of "geocaches" hidden on the grounds of a few mills.

And of utmost importance, remember that this book does not give permission to visit any of the buildings or properties featured within. *Each site is owned by an individual or by an organization, and the reader is*

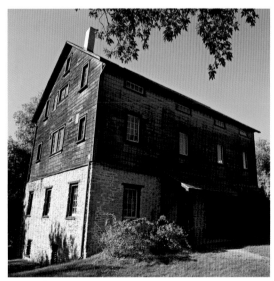

Molson Mill

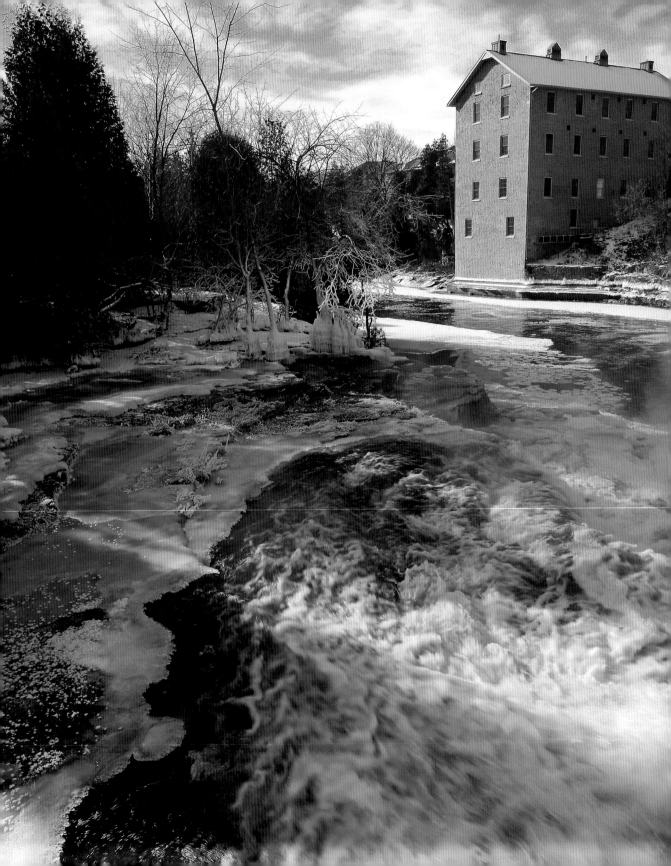

responsible for ensuring that it is both lawful and safe to visit any of the sites mentioned in this book. This is especially true for mills that have been converted to private residences. Please be respectful and avoid interfering with the privacy of the owner. While we have attempted to provide up-to-date information on access, each building is a piece of property that can be bought and sold, and any of the sites mentioned in the book could subsequently change hands and no longer be accessible to the public. This book does not give you permission to trespass on any privately owned lands, and so if in doubt, please ask.

To help you to determine whether a particular mill site is of interest, a short "fact box" accompanies each mill featured in the book. It contains some basic information (eg., date of construction), but also some purely subjective comments. It's impossible to rate a mill like a movie or a fine wine, as the enjoyment (or lack thereof) afforded by a particular mill is as varied as the people looking to visit. Nevertheless, a few purely subjective descriptors that have been used are explained below:

Interior Access if and when the interior of the mill can typically be explored.

Exterior Access the ability to explore the exterior and grounds of the mill on foot.

Artifacts the degree to which milling equipment or other related paraphernalia can be observed.

Photography A subjective assessment of the opportunities for photography or other means of artistic expression.

Setting the primary land use surrounding the mill.

Finally, if you thoroughly enjoy the subject of mills, you may wish to join the Society for the Preservation Of Old Mills, or "SPOOM." The Canadian Chapter is a non-profit organization initiated in 1999 that promotes interest in old mills, their history, function and preservation. Membership affords the opportunity to network, meet and share interests in old Canadian mills. Each year, the SPOOM holds both a "Spring Millers' Day" and "Fall Millers' Day," where a mill is selected for tours and seminars given in a friendly, relaxed format. Though a national organization, most of our meetings are held in Ontario, where the majority of members reside. Membership is varied and includes mill owners, artists, museum curators, writers, photographers, teachers and other mill enthusiasts. The inexpensive annual dues include a subscription to the "Millstone News," a twice-annual publication that served as a valuable source of information during the production of this book. More information is available at www.hips.com/spoom-canada.

And of the many local community groups involved in mill preservation, restoration, and promotion projects, we have yet to meet one that was not anxious for more volunteers to help with their efforts. Contact information for some are included with the information accompanying the mills featured in this book.

(Left) Mill on the Grand River at Fergus.

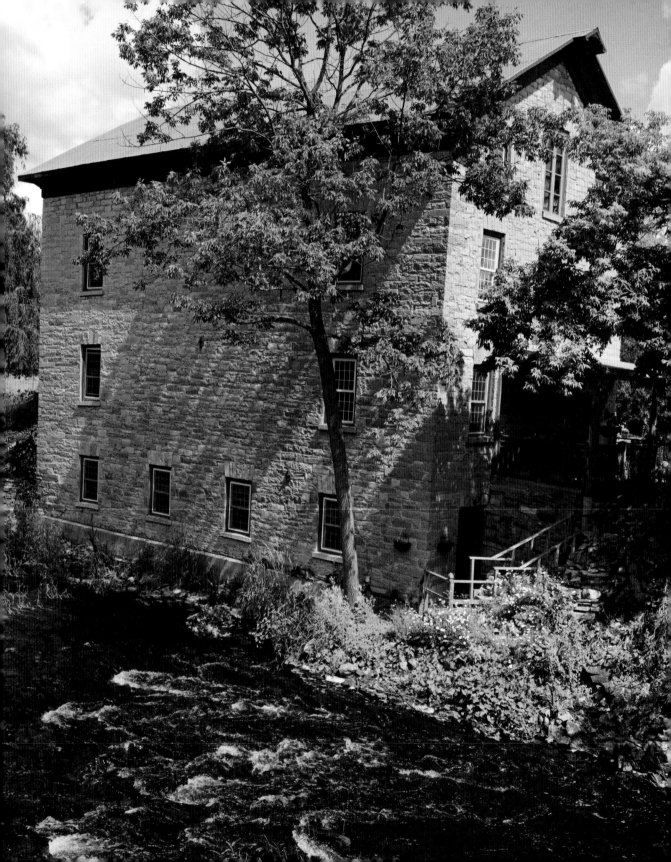

CENTRAL ONTARIO
REGION

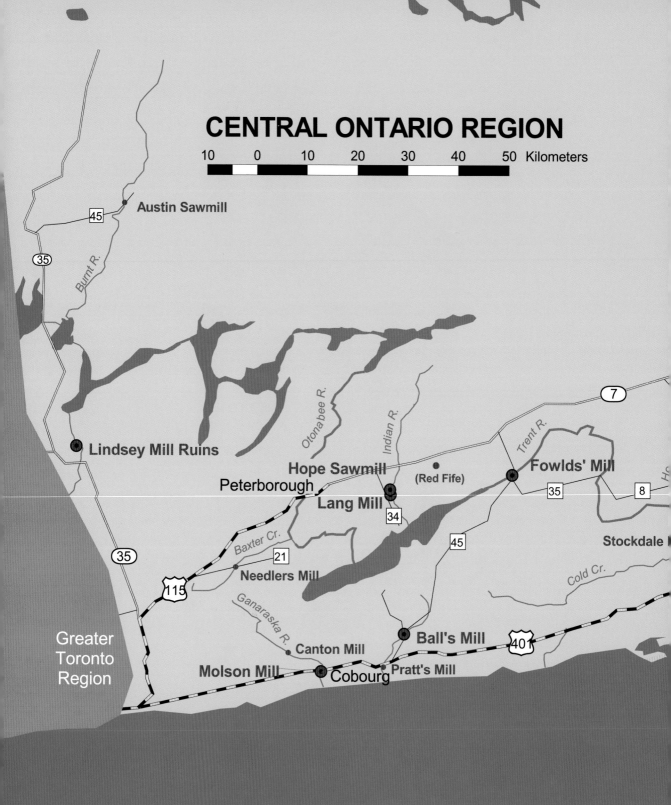

CENTRAL ONTARIO REGION

10 0 10 20 30 40 50 Kilometers

Austin Sawmill

Burnt R.

Lindsey Mill Ruins

Otonabee R.

Indian R.

Trent R.

Hope Sawmill

(Red Fife)

Fowlds' Mill

Peterborough

Lang Mill

34

Stockdale

Baxter Cr.

21

45

Needlers Mill

Cold Cr.

Ganaraska R.

115

Greater
Toronto
Region

Ball's Mill

401

Canton Mill

Molson Mill

Cobourg

Pratt's Mill

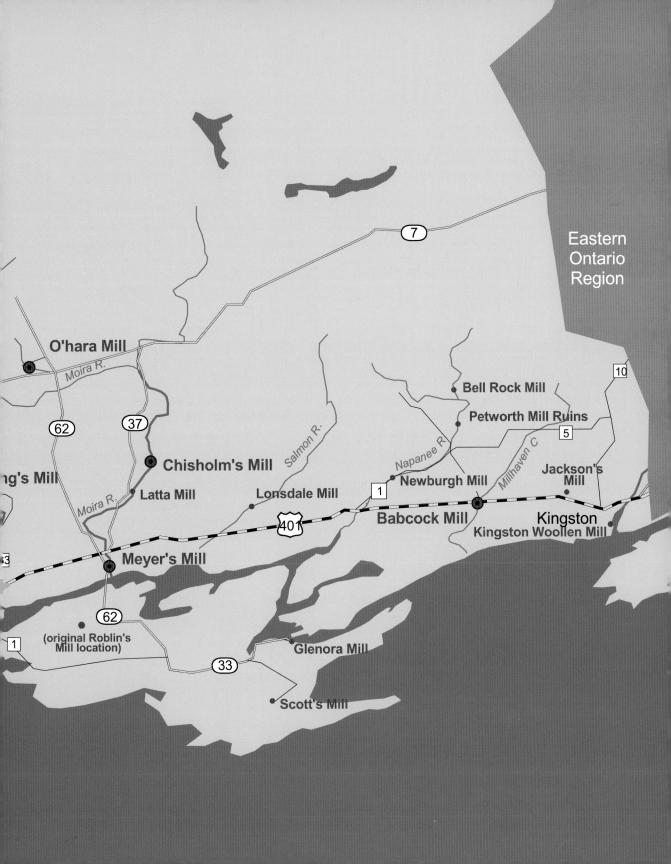

Babcock Mill

Likely the only remaining "basket mill" in Ontario, the old limestone building at Odessa is a real gem! With three floors of equipment, most of which is in working order, the mill thrills school children and adult visitors alike as it comes to life. Unfortunately, due to funding constraints, it only comes alive a few select times each year. But if you are lucky, you may be able to experience one of the more unusual historic milling operations in the province.

Built in 1856 by John and Phillip Booth, the building was intended for use as a gristmill. The brothers ran out of funds before they could install any equipment, and the building was instead used for box-making and storage. John Herbert Babcock purchased the mill in 1907 and used the building as a sawmill and planing mill. By 1915, Babcock had patented a new basket design and started a long period of basket-making at the mill that continued until 1970. "Better Baskets by Babcock": could they have picked a better jingle? The mill was sold to the municipality in 1977, which hired Don Babcock (a grandson of John) in 1986 to refurbish much of the old equipment. Between 1988 and 1993, the mill operated as a tourist attraction, even producing baskets using the same process patented nearly 80 years earlier. Funds dried up in 1994, however, and at the time of writing, the mill was only open for a few specific days each year.

An open headrace delivers water from the millpond to a turbine shed, an inconspicuous little sheet metal building behind the mill. Inside is a 30-inch vertical shaft turbine built by Chas. Barber & Sons of Meaford. Outside the building, a long, rusting horizontal shaft is partly visible and transmits rotary power to the mill. Inside the mill, an extensive system of lineshafting powers many different machines. On the lower level, the visitor can see the planar, band saw and rip saw, all manufactured by W. B. Ballentine of Preston. In addition, the slat knife and tumbling drum can be examined, as well as the boiler that once heated water to soften the wood for slicing and bending for baskets. Belts transfer power up to still more machines the second floor, including a slat cutoff saw and basket hoop-thinning machine.

Directions

Follow Hwy 401 west from Kingston for about 12 km and exit at Lennox and Addington Rd 6 (Wilton Rd). Drive south to Lennox and Addington Rd 2 (Main St.) and turn right. Drive west for 0.6 km to Bridge St., turn left and continue for about 0.5 km to a parking area across the river from the mill. Information on when the mill is to be open may be obtained by sending an inquiry to babcockmill@yahoo.ca. About 5 km south of Odessa along Millhaven Rd is the original site of the Asselstine Woollen Mill, now located at Upper Canada Village.

Mill Name	Babcock Mill
Settlement	Odessa
Built	1856
Current Use	Undetermined
Original Use	Basket Mill
Interior	Special Occasion
Exterior Access	Anytime
Artifacts	Operational
Photography	Good
Setting	Rural
Latitude	44.27910
Longitude	76.72209

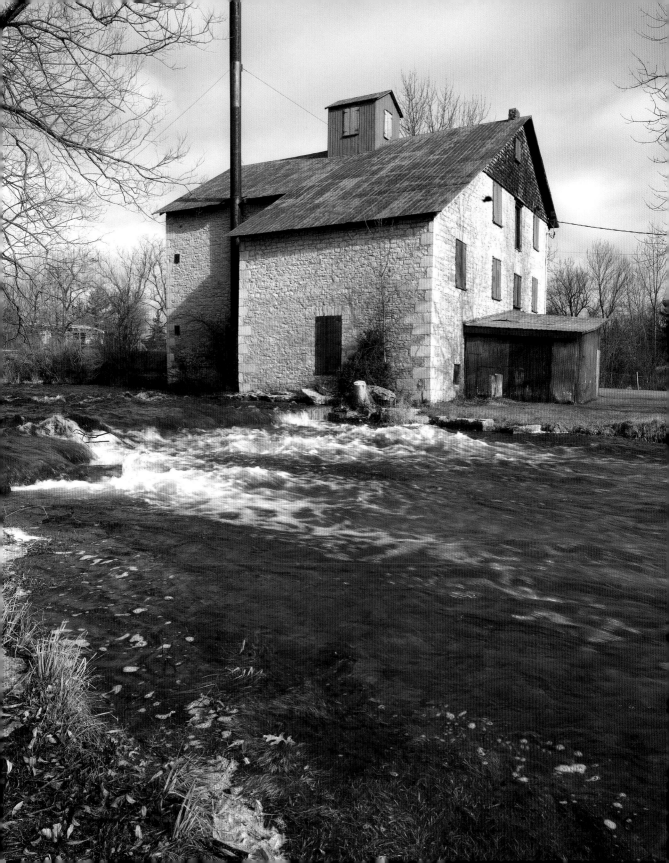

Ball's Mill

Keep your hands inside the car window as you drive by! Ball's Mill is a long, two-and-a-half storey building within reach of McDougall Rd. The mill building is privately owned, but given its proximity to the road, it is easily photographed and examined. The exterior is covered by clapboards, painted white, now heavily peeling, with green trim around the windows and thick cornice. A stone foundation supporting the frame structure is mostly hidden below grade.

Originally built as a carding mill by Lambert Stevens in 1842, William McDougall retooled the mill for grist milling in 1846. John Ball, who had operated another mill nearby, purchased the mill in 1884. Shurflake flour became widely accepted as one of the finest flours in the province, a fact proudly displayed by signage still present at the south end of the mill. Flour production ceased about 1952, though the Ball family continued to operate the building as a feedmill. After ownership for some time by the Ganaraska River Conservation Authority, the building is now a private residence and has been designated as a Heritage Structure by Hamilton Township.

The mill was powered by water diverted from a pond located several hundred metres upstream. Water travelled through a concrete raceway hidden underground, which connected to the bright red steel penstock still visible today at the north end of the building. In 1906, Ball replaced a waterwheel with a more efficient turbine.

Ball's mill is the last of a number of different mills that once stretched along Baltimore Creek. The creek was a dependable power source, not only because it drains an area of about 50 square kilometres, but because it drains parts of the nearby Ganaraska forest. This great woods, set on the Oak Ridges Moraine a few kilometres to the north, would have provided a reliable supply of ground water discharging from the creek. Problems associated with the deforestation of the Ganaraska forest led directly to the formation of Ontario's Conservation Authorities in the 1940s.

Directions

From Toronto, follow Hwy 401 to Northumberland Rd 45 at Cobourg. Go north on Rd 45 for 5 km to the village of Baltimore. Turn left on Northumberland Rd 15 and then make a quick right turn onto McDougall Rd and proceed to the mill. The mill is privately owned, and you should not trespass, but the mill can easily be viewed from the road.

Mill Name	**Ball's Mill**
Settlement	**Baltimore**
Built	**1846**
Current Use	**Private Home**
Original Use	**Carding Mill**
Interior	**Private**
Exterior Access	**Roadside Only**
Artifacts	**Unknown**
Photography	**Good**
Setting	**Rural**
Latitude	**44.03338**
Longitude	**78.14631**

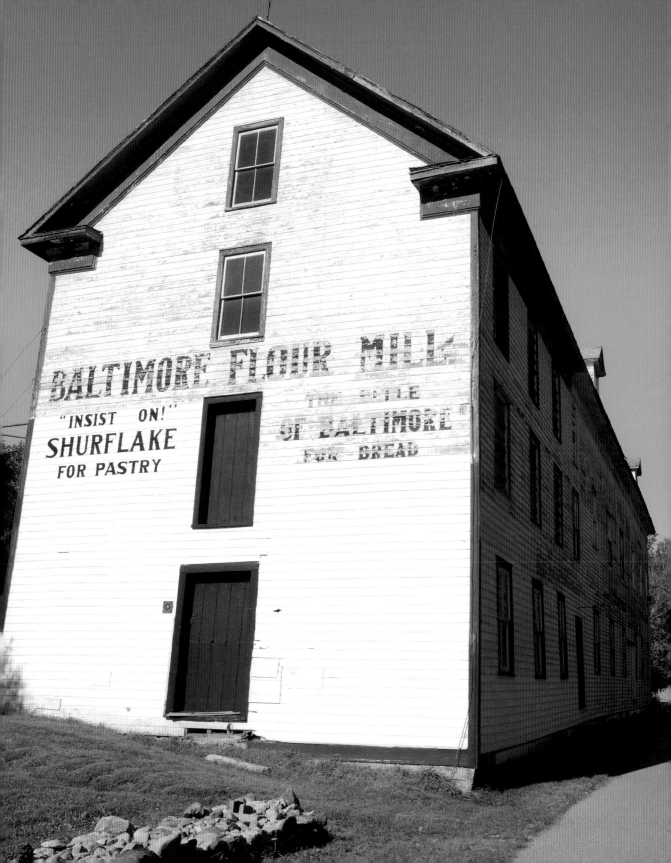

Chisholm's Mill

Chisholm's Mill is a dilapidated little building that has almost been swallowed whole by a sprawling 25-hectare lumberyard. Fortunately, the complex couldn't spread over the river, and the mill is easily viewed from the far banks of the Moira. Clad in shiny sheet metal, topped with a rusty red roof, and set beside a rocky reach of the river, this scene has long been a favourite for painters and photographers. When river levels are moderate to low, you can safely explore the flat limestone bedrock platforms along the far side of the river. But heed the warning sign posted prominently on the mill: "Warning! Many swimmers have died here. Stay away from the dam."

The Shipman family constructed several mills here beside the Moira River. In 1857, the site was purchased by William Fraser Chisholm, who in turn operated several successful milling businesses. Each spring, logs from the forests to the north were floated down the river to Chisholm's mills and several others. Though the log drives ended in 1909, the Chisholm family business has continued for 150 years, and has grown beyond the on-site lumber supply store to include forestry management services, building supplies, and log home construction. A building supply retail outlet is situated beside the mill and is open Monday to Friday and Saturday mornings until noon. Further information about the mill and business is available online at chisholmlumber.com

Directions

Follow Hwy 401 to Belleville, and then go north on Hwy 37 for about 20 km. Turn right on Hastings Rd 7 and drive about 2.5 km. The road will bend to the right and then soon pass the lumber store and the mill. Immediately after crossing the bridge, turn right and park in a small gravel lot beside the edge of the river. Do not trespass on the property of the lumberyard. At Latta, 6 km south on Hwy 37, a 30 m wide but low mill dam spanning the Moira River can be seen from the bridge on Scuttlehole Rd. A private residence has been rebuilt on the remains of an old stone mill foundation located on the west side of the river.

Mill Name	Chisholm's Mill
Settlement	Chisholm's Mill
Built	1857
Current Use	Private Business
Original Use	Sawmill
Interior	Private
Exterior Access	Roadside Only
Artifacts	Unknown
Photography	Good
Setting	Rural
Latitude	44.35325
Longitude	77.30828

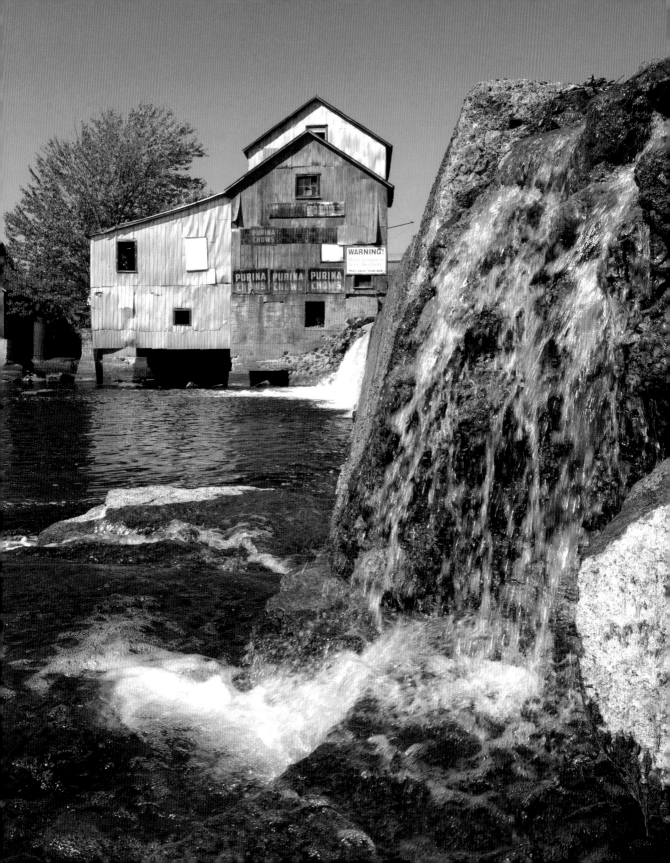

Fowlds' Mill

Fowlds' Mill is another old stone gristmill that has been converted into a private residence. Mostly hidden out of sight from the roadside, the best view (and photograph) of the old building is from a weedy vacant lot across the millpond. The two-and-a-half storey building is constructed of thinly-quarried, coursed limestone and reflects beautifully when the pond in the foreground is calm. Big 16-over-12 sash windows illuminate the second floor.

The first gristmill at Hastings was built in 1828 by James Crooks, who later went on to build much larger mills at Crooks Hollow (see entry for Darnley Mill). Crooks wasn't really interested in developing at Hastings (then known as Crooks Rapids), and it is believed that he only built the mill in order to maintain his milling rights at the site. Henry Fowlds bought the wooden gristmill in 1851, and by 1858 was using three run of stone to produce up to 250 bushels per day. The mill burned in 1869, but was rebuilt by 1871, this time of stone. Fowlds' enterprise expanded to other spheres, and for some time he ran a steamer on Rice Lake that transferred lumber to his sawmill, as well as delivered supplies to lakeside residents.

Between about 1912 and the late 1960s, the building was used to generate hydroelectricity for the Breithaupt Leather Company, a nearby tannery that produced leather for soles and work gloves. Following several years of non-use, the building has been used since 1988 as a beautiful private residence. The village of Hastings is a pleasant little stop along the Trent Canal. Lock 18 is easily visible from the bridge, which when moved to allow boat travel on a summer weekend can generate a traffic jam on Rd 45 worthy of a bigger centre to the south!

Directions

Exit Hwy 401 at Cobourg and follow Hastings Rd 45 north for 43 km to the village of Hastings. As you cross over the bridge over the Trent River, a short laneway leads to a public parking lot behind the buildings fronting Bridge St. The mill is located in the distance at the far end of the pond. By following a short path (or by making your own) through the overgrown field you can take in a very pretty view of the mill. This book does not give you permission to trespass on private property.

Mill Name	**Fowlds' Mill**
Settlement	**Hastings**
Built	**1871**
Current Use	**Private Home**
Original Use	**Gristmill**
Interior	**Private**
Exterior Access	**Roadside Only**
Artifacts	**Unknown**
Photography	**Good**
Setting	**Suburban**
Latitude	**44.30991**
Longitude	**77.95425**

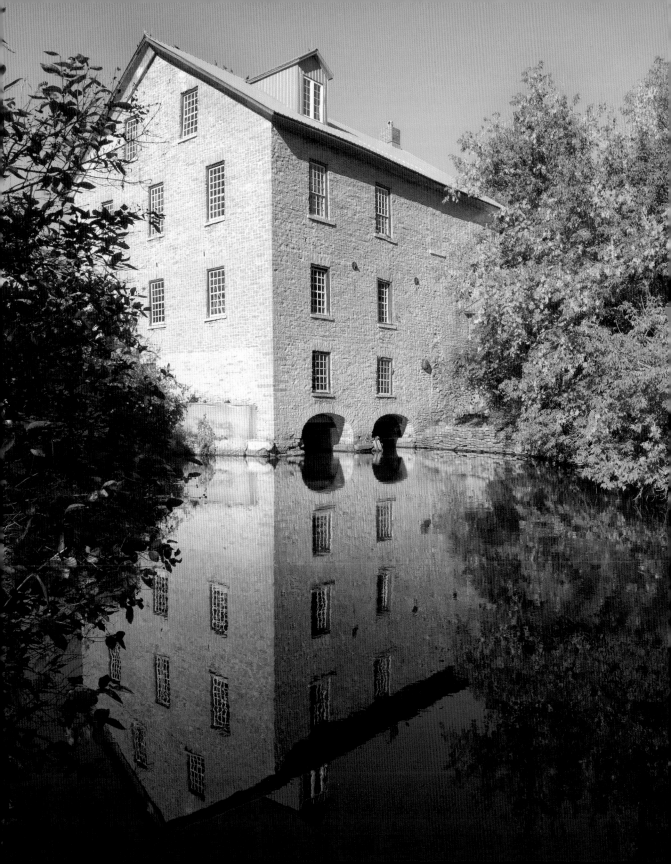

Hope Sawmill

The Hope Mill is located just a kilometre or so upstream from the better-known Lang Mill. Close geographically, the two mills are also related by their history. Constructed in 1836 by William Lang, who had just arrived from Scotland a few years earlier, the mill was originally built as a carding mill to prepare wool for spinning. When Lang's son-in-law, Richard Hope, took over operations in 1873, he added shingle and sawing equipment. The carding equipment was removed in 1892, after which the mill continued only as a sawmill. Lang died in 1898, just a few kilometres downstream at Keene. His mill, was kept alive by his descendants until his great-grandson sold it to the Otonabee Region Conservation Authority in the 1960s. Ironically, the mill built by Lang came to be known by a different name, while Lang actually had little to do with the mill that now bears his name.

The exterior of the building is built partly of stone and partly of wood. A viewing platform runs the length of the building, and from behind a wire safety fence, you can get an unobstructed view of the sawing process from start to finish, even when the mill is not in operation. If you look up, you can see the round cedar beams under the sloping roof. They look like they were simply felled and positioned immediately, without even stripping them of their bark.

In 1999 a collection of volunteers, including history buffs, local businesses and government agencies, began to restore the mill. General Electric Canada in Peterborough completely reconstructed the two mill turbines and associated gearing. One turbine rated at 40 horsepower was used to power the 48-inch circular saw and saw carriage, while another rated at 25 horsepower ran various woodworking tools, including a lathe, table saw and shingle cutter. The circular saw and the carriage apparatus have also been recently restored.

A low dam maintains a quiet swimming pond that doubles as a beautiful reflecting pool on calmer days. A footbridge over the dam connects the mill site with the Hope Mill Conservation Area, offering camping, canoeing, picnicking, and of course, a great view of the mill! Downstream of the dam, the swift-moving Indian River passes over limestone bedrock, just inches from the mill, and then winds past a small, pleasant picnic area.

Directions

From Peterborough, drive east on Hwy 7 for 7 km past the intersection with Hwy 115. Turn right on Peterborough Rd 34, and go south for 5.5 km to Lang Rd. Turn left and drive past the Lang Mill and Pioneer Village for 2 km to Hope Mill Rd. Turn right and park in the gravel lot on the right side of the road. The mill is just a few steps down the road.

Mill Name	Hope Sawmill
Settlement	Lang
Built	1836
Current Use	Museum
Original Use	Carding, Sawmill
Interior	Museum Hours
Exterior Access	Anytime
Artifacts	Operational
Photography	Moderate
Setting	Park
Latitude	44.28404
Longitude	78.17226

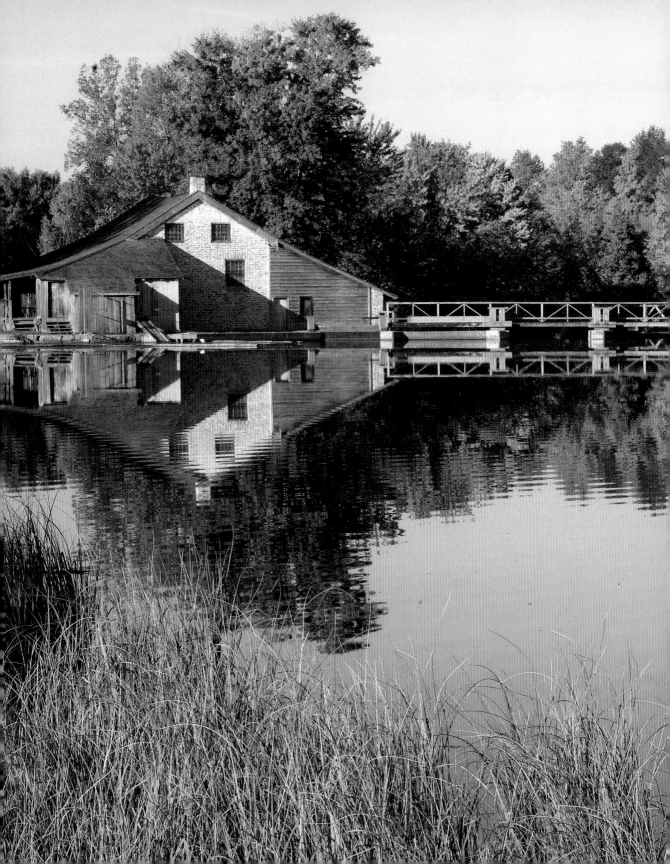

King's Mill

King's Mill is a charming little building that just seems to pop out of nowhere. The exact date of construction of the building is unknown, though it is believed to date between 1820 and 1850. The mill went through a number of owners before being purchased by Frederick King, whose son Lloyd operated the mill until 1963. Shortly after, in 1971, the site was purchased by the Lower Trent River Conservation Authority and now forms the centrepiece of the 25-hectare King's Mill Conservation Area. This passive conservation area offers nothing fancier than good old-fashioned fishing, picnicking and nature enjoyment. At the time of writing, the building was closed to the public, though you can easily explore the exterior.

The little stone building is one-and-a-half storeys in height, not including the ¾-storey basement level. Note the large timber beams incorporated into the stone walls—a feature that we didn't observe anywhere else. With a fresh coat of red paint, the beams contrast beautifully with the off-white limestone walls of the mill. Behind the mill you can examine the stone headrace that delivered water to the lowest level of the mill, as well as the weathered remains of the earthen berm that diverted water to the headrace. The headrace has been closed off with concrete blocks and is now covered with sheet metal. For some time, the Lower Trent Conservation Authority used the building as a workshop. The interior was modified for this purpose, though some of the original milling equipment is reported to be present.

The ruins of an old concrete dam are located immediately south of the mill. Several tens of metres beyond is another small, but intact dam that regulates the waters of Hoards Creek to form a narrow, shallow pond about 700 m in length. Lined with cattails and half-dry during late summer, the pond is a wetland restoration project being undertaken by Ducks Unlimited and the Lower Trent Conservation Authority. There is a tiny parking area a few hundred metres east on King's Mill Rd, from which you can examine the dam and the wetland.

Directions

From Toronto, go east on Hwy 401 to Trenton and go north on Hastings Rd 4 for about 8 km. At Frankford, Hastings Rd 4 ends at Hastings Rd 33. Continue north on Hastings Rd 33 for about 11 km to Stirling. At Stirling, turn left on Hastings Rd 8 (Front St.). Drive west for one block, and then follow Hastings Rd 8 by turning right on Hoards Rd. Follow Hastings Rd 8 for 5.5 km to Hastings Rd 19 (Wellman's Rd). Turn right on to Hastings Rd 19 and drive 3 km north to the mill, which is located at King's Mill Rd. There is a little gravel parking lot on the right, as soon as you cross over the Creek.

Mill Name	**King's Mill**
Settlement	**Wellman**
Built	**c.1840**
Current Use	**Undetermined**
Original Use	**Gristmill**
Interior	**Private**
Exterior Access	**Anytime**
Artifacts	**Unknown**
Photography	**Excellent**
Setting	**Rural**
Latitude	**44.33182**
Longitude	**77.62892**

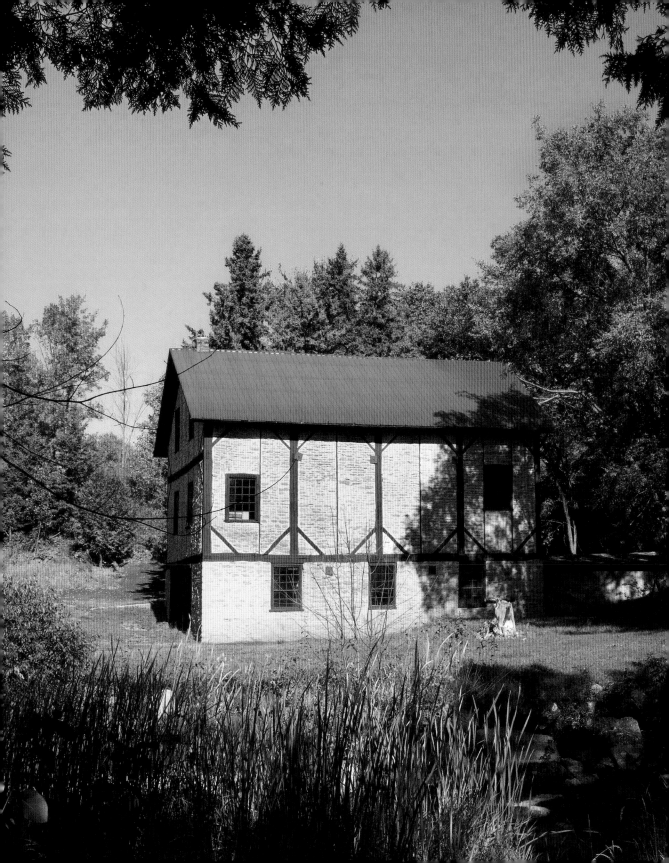

Lang Mill

A tour of the Lang Mill is one of the best ways to understand the gristmilling process. Few other operating gristmills in Ontario are so spacious and well presented. And there is perhaps no clearer working example of Oliver Evans' "automatic mill" in all of Ontario. With the aid of a knowledgeable mill interpreter, the visitor can easily follow the milling process from power source to finished product.

Built in 1846 by Thomas Short, the Lang Mill triggered the development of a small village originally known as Allandale. In prosperous times, Short's mill produced up to 8,000 barrels of flour per year, and he added several other businesses, including a sawmill, barrel factory and foundry. By the early 1870s, however, Short was bankrupt, and the mill entered a long period of changing ownership. The village and mill were soon renamed after William Lang, one of the first settlers in the area who had constructed the nearby Hope Mill several decades earlier. Owing to the good quality of the milling site, flour was produced by a number of owners until 1956. The mill was purchased by the Otonabee Region Conservation Authority in 1965.

The building is constructed of limestone blocks reportedly quarried from the bed of the Indian River.

Mill Name	**Lang Mill**
Settlement	**Lang**
Built	**1846**
Current Use	**Museum**
Original Use	**Flourmill**
Interior	**Park Hours**
Exterior Access	**Anytime**
Artifacts	**Operational**
Photography	**Excellent**
Setting	**Pioneer Village**
Latitude	**44.27505**
Longitude	**78.17099**

The bedrock is hidden by the overlying soil at Lang, and it may have been transported from exposures at the Hope Mill, just 1 km upstream. Two storeys high on one side and three on the other (plus an attic), the mill exhibits a sturdy, though not brawny appearance. The photographer will be delighted to find clean, unobstructed views of the mill from most angles, with two beautiful ponds separated by a low, wide dam covered by a footbridge.

Power from the Indian River is captured by a turbine located out of view in the bowels of the mill. A large cogged crown wheel set immediately above the turbine is visible below a plexiglass window set in the mill's floor. With the turn of a brass hand crank, the mill interpreter can adjust the speed of the turbine. The crown wheel transfers power to a bevel wheel attached to a horizontal shaft located beneath the floor. From here, you can actually follow the power of the river as it is distributed via large belts to working equipment located throughout the mill. You can see, hear and feel the life of the mill as the elaborate, yet well preserved system of belts, pulleys and drive-shafts snakes its way to the top of the mill. A troop of bucket elevators stands guard opposite the stairwell to the second floor. The bolters and sifter are connected to the power train, while other off-line pieces of vintage equipment are also on display.

Today, the mill is the centrepiece of the attractive Lang Pioneer Village. Created by the county of Peterobrough in 1967, the village provides the visitor with an opportunity to transported back in time to the nineteenth century. With the help of the knowledgeable staff, the visitor is to explore almost 30 historic buildings, each dating from between 1820 to 1899. Most buildings fully furnished, and some, like the blacksmith shop, shingle mill and printing press are fully operational.

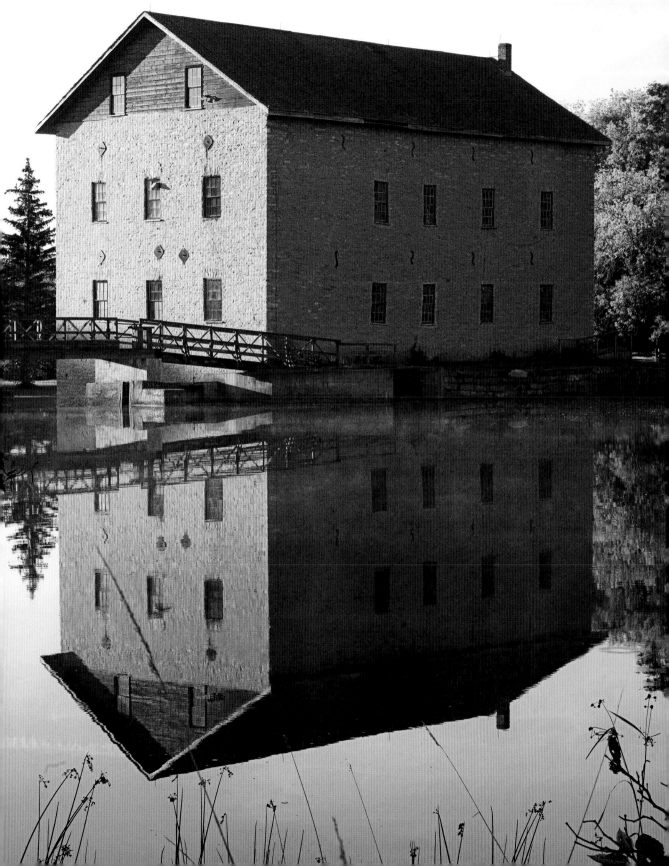

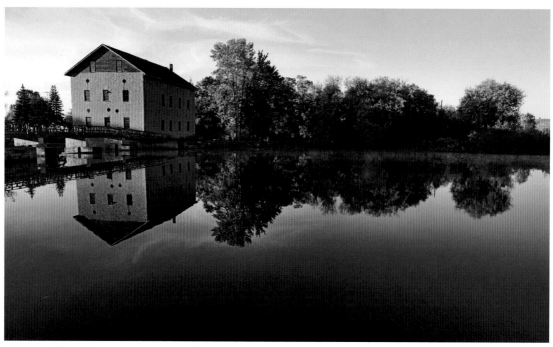

The mill is the centrepiece of the attractive Lang Pioneer Village in Peterborough County.

Of note to milling fans is the 1820s era log cabin built by David Fife, the "founder" of Red Fife wheat. Fife was a farmer from the fourth concession in Otonabee Township, located just a few km to the east of the Lang Mill. Receiving a handful of wheat from a friend in Scotland (who had in turn obtained it from a cargo ship from Poland), Fife planted some of the seeds in spring 1842. Legend has it that a single plant grew. But that one plant was free of rust, a problematic fungus that was widespread among the varieties in use at the time. Within several years, the variety's hardiness became well known in Ontario, and a few decades later became the mainstay of prairie wheat farming. As you may have guessed, Red Fife was ground at the Lang Mill. Fife is commemorated on a plaque outside the mill and another one further east on Hwy 7.

Directions

From Peterborough, go east on Hwy 7 for 7 km past the intersection with Hwy 115. Turn right on Peterborough Rd 34, and go south for 5.5 km to Lang Rd. Turn left and drive for 0.8 km to Lang Pioneer Village. The village is open during late spring to the end of summer, so it is best to call or check the website to ensure that the mill building is open. If the village is closed, the mill is still easily visible (and photographed) from the road. For hours and season of operation, please consult their webpage, langpioneervillage.ca

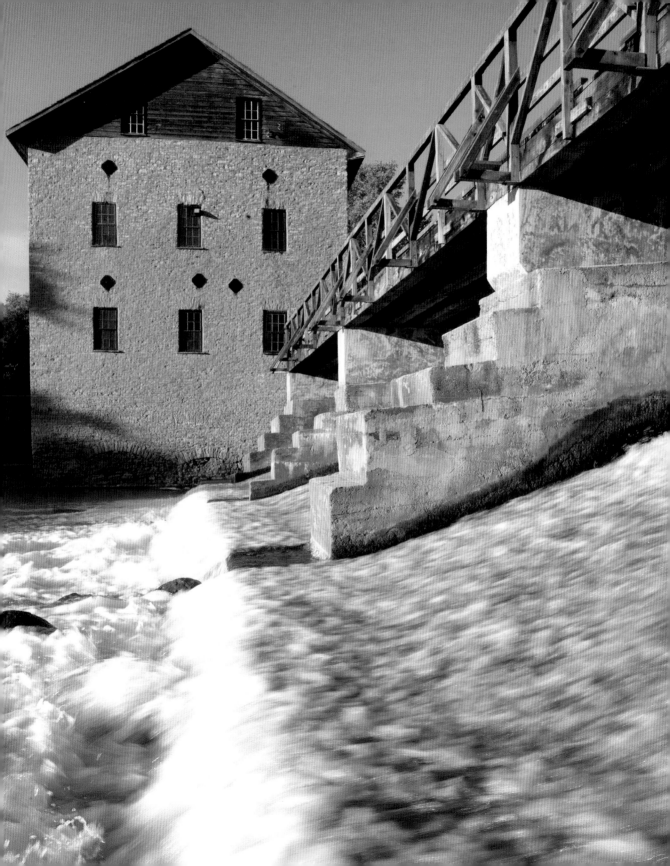

Meyers' Mill

After fleeing from New York State as a United Empire Loyalist, John Walter Meyers founded a settlement at Belleville in 1790. He soon bought land on the first concession of Thurlow Township and built a mill. The existing building is constructed on the site of Meyers' first mill. The small, ivy-covered two-storey stone building, looks somewhat out of place beside the busy four-lane city street. The building now houses the offices of Quinte Construction Association. While the interior has been completely renovated into office space, the exterior of the building has been beautifully preserved, including what appear to be the original 9-over-9 sash windows.

Walk in behind the mill and the scene suddenly changes. An extra storey in the back, the mill's foundation flares gently outwards toward the bed of the Moira River, likely a sort of buttress for additional support. Built just inches from the river's bed, the swift-flowing waters of the Moira must have been a would-be miller's paradise. When stream flows are high, the river blasts its way through the city, dropping over a number of low dams and small rapids. When flows are very low, you can safely walk out onto the flat bedrock along the river's edge for a more inspiring view of the building.

Directions

Follow Hwy 401 to Belleville and exit at Cannifton St. (Hwy 37). Go south on Cannifton St. for 2.3 km to Station St. and turn right. The mill is located on the right, about 0.6 km further south at 54 Station St. After exploring the site around the mill, try a walk along the Parrott Riverfront Trail. Opened in 2002, the paved trail will eventually follow the river's edge from its mouth to Corbyville, located almost 8 km upstream.

Mill Name	Meyers' Mill
Settlement	Belleville
Built	N/A
Current Use	Private Business
Original Use	Gristmill
Interior	Private
Exterior Access	Anytime
Artifacts	None
Photography	Good
Setting	Suburban
Latitude	44.17184
Longitude	77.38266

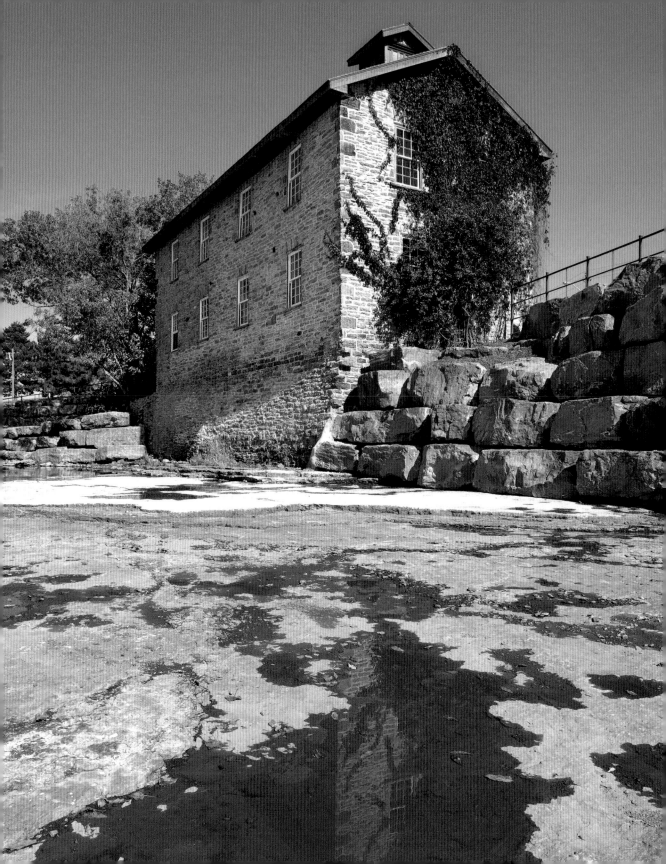

Molson Mill

A beautifully restored stone-and-wood building, the Molson Mill occupies a quiet, yet easily accessible park-like corner of Port Hope. While little is known about the history of milling at the building, we do know that it was built around 1850 by Thomas Molson of the famed brewing family from Montreal. By the 1920s and 1930s, however, the building had already been converted for use as a summer school for the Ontario College of Art. Instruction at the school was headed by J.W. Beatty, a well-known Canadian artist and friend of the legendary Tom Thomson.

Today, the building still serves as a hub for the arts. It is the home base for "Journey Through the Arts," a summer series of weeklong music, art and drama programs for children. The mill is also opened to the general public a few times through the year: usually for "Doors Open Port Hope" in spring, and often in autumn for the Northumberland Studio Tour.

In most Ontario mills, stone was used either for the entire exterior or for just the foundation. Molson's building is fairly unique in that the ground floor and basement level are built of stone, while the upper two floors are built of wood. If you've brought your kids, challenge them to find the fossils embedded in many of the stones used for the west end of the building. While the interior of the building has been modified somewhat for use as the art school, the stone walls and timbers are exposed throughout. The bright, airy main floor is illuminated by a giant picture window at the east end of the building. Recently added by the art school, and though uncharacteristically large for an old mill building, this window provides a beautiful source of natural light for students and visitors alike.

More information on the art school and public access to the mill may be available at www.journeythroughthehearts.com. Just a few steps behind the mill is the Ganaraska River Fishway, a fish ladder built by the Ministry of Natural Resources in 1973. Looking like a tunnel on the far side of Corbett's Dam, the fish ladder allows Rainbow Trout, Chinook Salmon and other species to swim upstream past the dam to spawning grounds.

Directions

Exit Hwy 401 in Port Hope at Northumberland Rd 28 (Ontario St.) and drive south. At the first road (Mitchell St.), turn right and drive 0.7 km west to Hope St. Turn right and park in the gravel lot in front of the mill. If you are coming from the west, you will actually exit Hwy 401 at Rose Glen Rd. Simply turn right and continue along this road until it becomes Mitchell St.

Mill Name	**Molson Mill**
Settlement	**Port Hope**
Built	**c.1850**
Current Use	**Private Art School**
Original Use	**Gristmill**
Interior	**Special Occasion**
Exterior Access	**Anytime**
Artifacts	**Some**
Photography	**Good**
Setting	**Park**
Latitude	**43.96767**
Longitude	**78.29488**

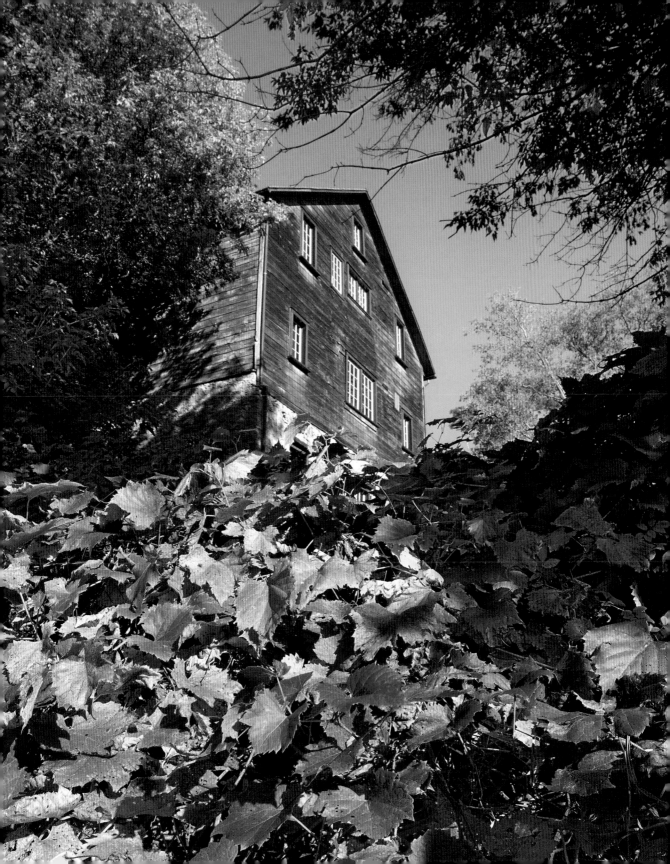

O'Hara Mill

Tucked in the woods beside a pretty little waterfall on Deer Creek, the O'Hara Mill is the smallest mill in this collection. The one-storey wooden building is sheathed with plank walls and a cedar shake roof, and sits atop a small stone foundation built into the side of the creek bank. On the creek side, a steel penstock leads from the little wooden dam to a horizontally mounted turbine at the foot of the building. Above the entrance to the building, look for the vintage wooden eavestrough: they don't build 'em like this anymore! Visitors can enter the building, though they are restricted from exploring the entire ground floor by a wire safety fence.

The mill is unique in that it is felt to be one of the province's last remaining examples of "frame saw" technology. Most remaining sawmills use a circular saw, a technology that superseded the frame saw. In a frame saw, a linear blade is fixed vertically in a heavy wooden frame. The entire frame is raised and lowered like a sash window by power from the turbine. The miller could control the whole mechanism from the ground floor using primitive controls, which here are literally nothing more than a few small-diameter logs, some never even stripped of their bark.

James O'Hara built a house on this property in 1848, and about two years later had built the mill. Regular sawing at the mill is believed to have ceased in 1908. The building sat derelict for some time before a first attempt at restoration was made in the 1950s. In 2000, more extensive restoration work was initiated by the then newly-formed Friends of O'Hara Mill. Much of their early efforts were aimed at ensuring the building didn't slide into the creek. Now it is stabilized, efforts are being made to put the blade back into operation. Upcoming plans also include replacing the precarious dam with a newer, more stable concrete structure. Wood from the existing dam will be used to face the new dam in order to maintain the heritage look, but you may wish to hurry to get a picture with the existing beautiful wooden dam.

The O'Hara Conservation Area is a peaceful little park that is just perfect for a relaxing afternoon with a young family. Short nature trails circle the tranquil millpond and lead to a picturesque footbridge overlooking the mill. In addition to the mill itself, seven other pioneer buildings can be explored, including the original O'Hara homestead and a restored woodworking shop. On the annual Heritage Day, the park can be jammed with hundreds of visitors who experience demonstrations of near-lost crafts, including blacksmithing, spinning and pioneer cooking, and view antiques and other displays set up on the grounds.

Directions

Follow Hwy 7 east from Peterborough (or west from Ottawa) to Madoc. Turn north on Hwy 62 and drive 1.8 km to Mill Rd. Turn left on Mill Rd and drive for 3.4 km to the entrance for the Conservation Area. There is a very small admission fee. Refer to quinteconservation.ca for current hours of operation and upcoming special events.

Mill Name	**O'Hara Mill**
Settlement	**Madoc**
Built	**1850**
Current Use	**Museum**
Original Use	**Sawmill**
Interior	**Museum Hours**
Exterior Access	**Park Hours**
Artifacts	**Operational**
Photography	**Good**
Setting	**Park**
Latitude	**44.51775**
Longitude	**77.52397**

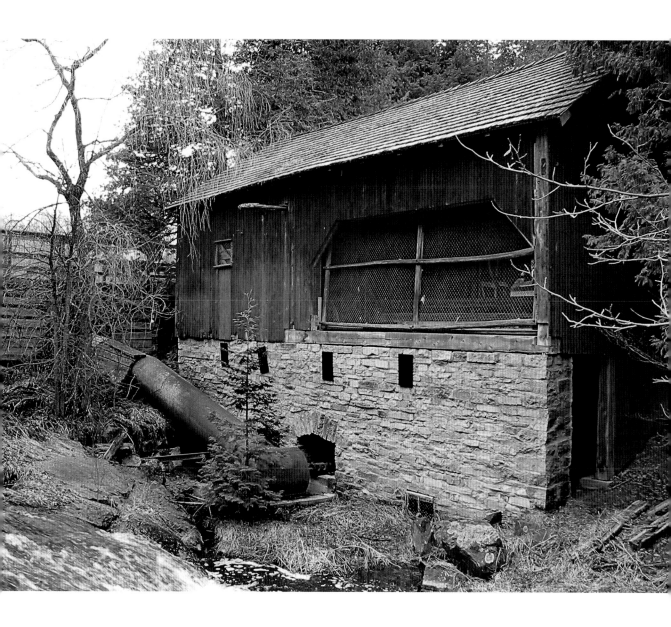

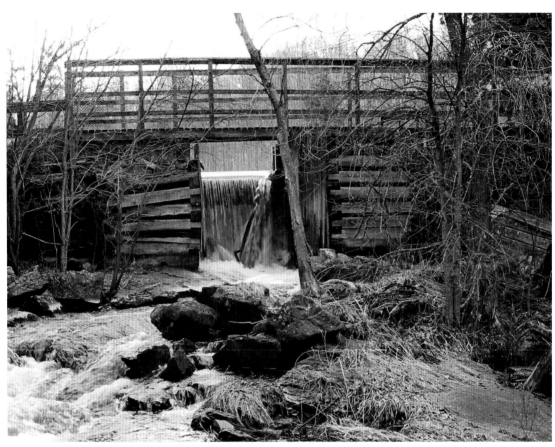

One of the last wooden mill dams in Ontario.

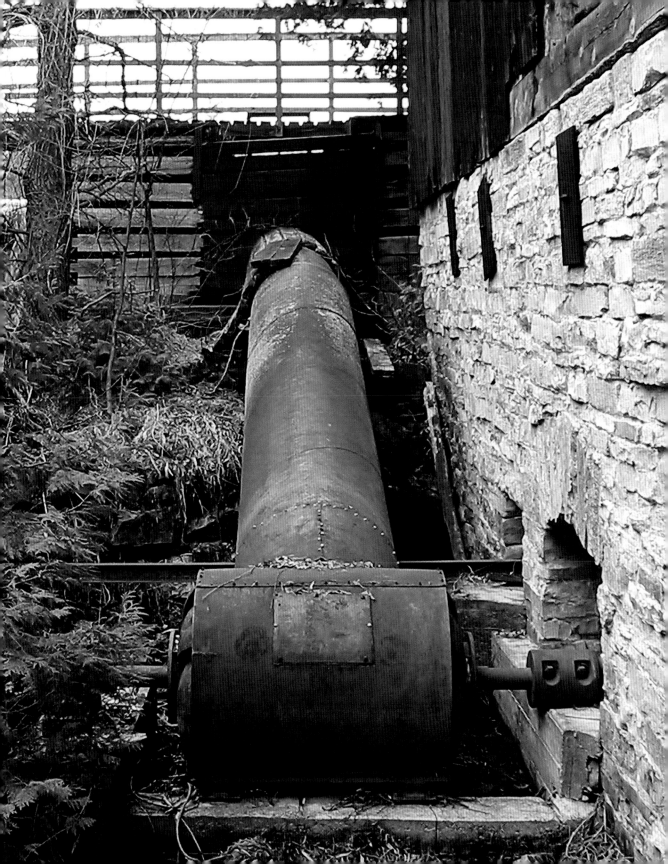

Other Mills: Central Ontario

Bell Rock Mill

This plain, almost barn-like wood building was constructed sometime between 1918 and 1921. Waterpower and steam were used to run a grist and feedmill, plus a saw, shingle and planing mill. The mill also produced cheese boxes until 1969. Until recently, most of the original equipment was still inside the mill. In 2005, an auction was held at the mill, during which many vintage pieces were lost, including a 50-inch circular saw. Though regrettable, this has helped to bolster the collections and displays of several other mills, such as the Delta Mill.

Kingston Woollen Mill

Kingston Woollen Mill

Set right beside the waterfront at the end of Cataraqui St. in Kingston, the big woollen mill is an impressive red-brick building featuring a five-storey tower and double 12-over-12 sash windows. Built by the Kingston Cotton Manufacturing Co. in 1882, the sprawling steam-powered mill closed in 1929, but opened again two years later and accommodated a number of textile-related businesses for the next hundred-odd years. The complex was restored in the 1990s and now houses the *Kingston Whig-Standard*, an upscale restaurant, spa and professional offices. Old photographs and maps are displayed in the foyer and hallways leading to the businesses on the ground floor. A book written in 2002 by Bruce Warmington provides a detailed history of the mill, its workers and the community.

Lonsdale Mill

James Lazier built this little gristmill beside the Salmon River in 1842. It is now a private residence and is not open to the public. A woollen mill built here at a later date burned in 1904, leaving only the stone ruins.

Needler's Mill

The first mill at this site was built in 1824 by John Dyell. The attractive building located here today is actually just the upper portion of a mill that William Needler built and then moved here in 1909 from Cedar Valley, just 6 km downstream. A steel flume delivering water from the millpond is partially buried behind the mill. Though the mill is currently closed to normal visiting, it is surrounded by Millpond Park, an attractive green space with picnic tables and 8 km of trails that follow alongside the millpond and continue into the countryside. Exit

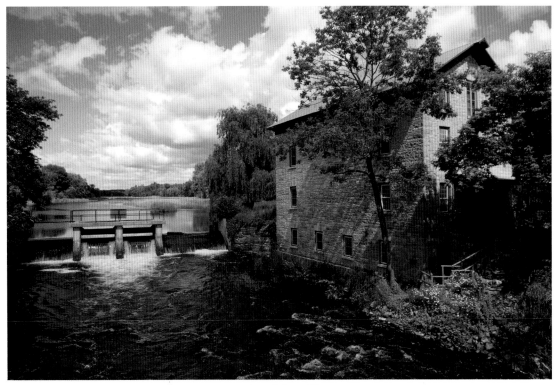

Lonsdale Mill

Needler's Mill

Hwy 115 at Peterborough Rd 10 and drive south for 4.5 km to Milbrook. Cross the main street (King St.), and follow the road around the bend to the mill, just one block behind the historic downtown.

Pratt's Mill

Ebenezer Perry built this yellow-brick gristmill in the 1850s. Alexander Pratt, who also operated Ball's Mill at nearby Baltimore, acquired this mill in 1889, starting an association with the Pratt family that lasted until 1986. The building now houses the Mill Restaurant and Pub, which offers three floors of casual dining in a unique atmosphere. Though extensively renovated, the original post-and-beam structure was preserved, the brick walls are still exposed outside and in, and a small number of

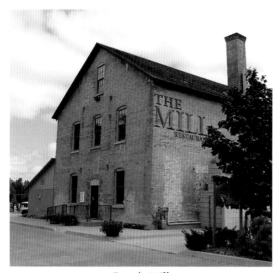

Pratt's Mill

Stockdale Mill

Two mills located on Cold Creek, just outside of Frankford. The gristmill was constructed in 1880 and operated until 1972, used almost exclusively for feed, though it also produced flour during World War II. The Cider mill was built in 1920. In 1999, the mills were purchased and underwent extensive restoration and renovation, including the removal of an ugly concrete loading dock. At the time of writing, the mills were available for sale.

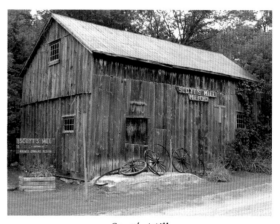

Scott's Mill

artifacts (including the old scale and several legers) were incorporated into the decor. Located at the northeast corner of Ontario St. and Elgin St. in Cobourg. More information is available at themillincobourg.com.

Scott's Mill

James Clapp built this mill in 1836. One of the smallest, quaintest little sawmills left in Ontario, this mill is currently closed to the public. A peek through the cracks between the mill's boards reveals that some equipment is still intact, and hopefully interest and resources will be raised to once again open the little building to tourists. A small turbine is visible beneath a back corner of the mill, encircled by a crumbling half-well of rubblestone. A long-since-vanished wooden flume diverted water to the mill from Black Creek at a point beyond the small hill behind the mill. Located at the western end of Millford on Crowes Rd, just 100 m north of Prince Edward Rd 10. The drive through the scenic Prince Edward County countryside is worth the trip alone.

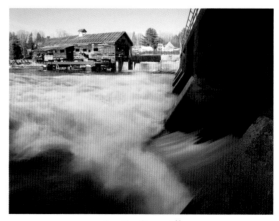

Austin Sawmill

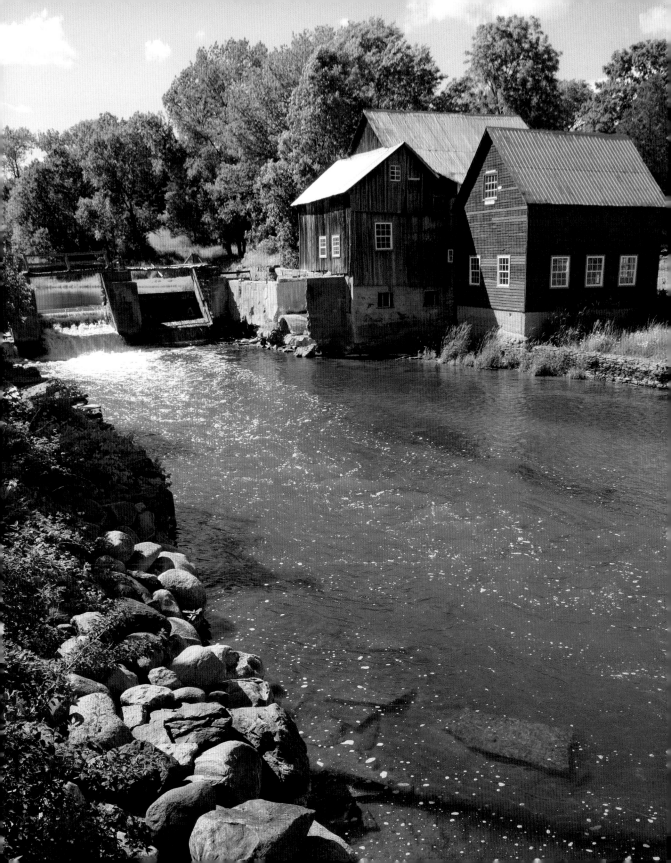

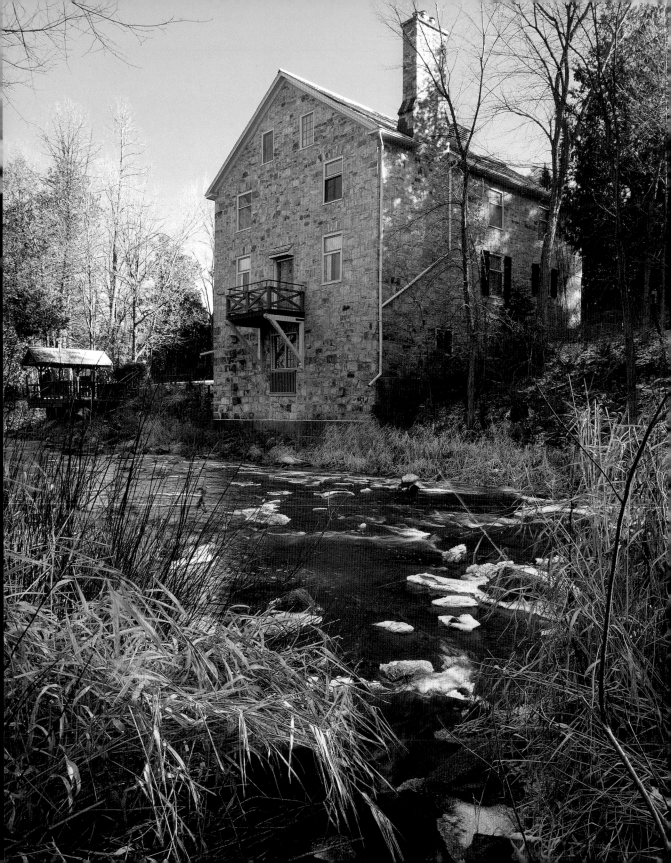

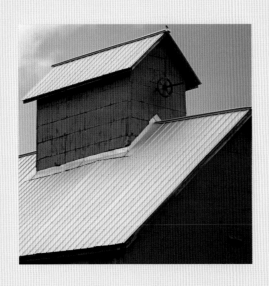

EASTERN ONTARIO

REGION

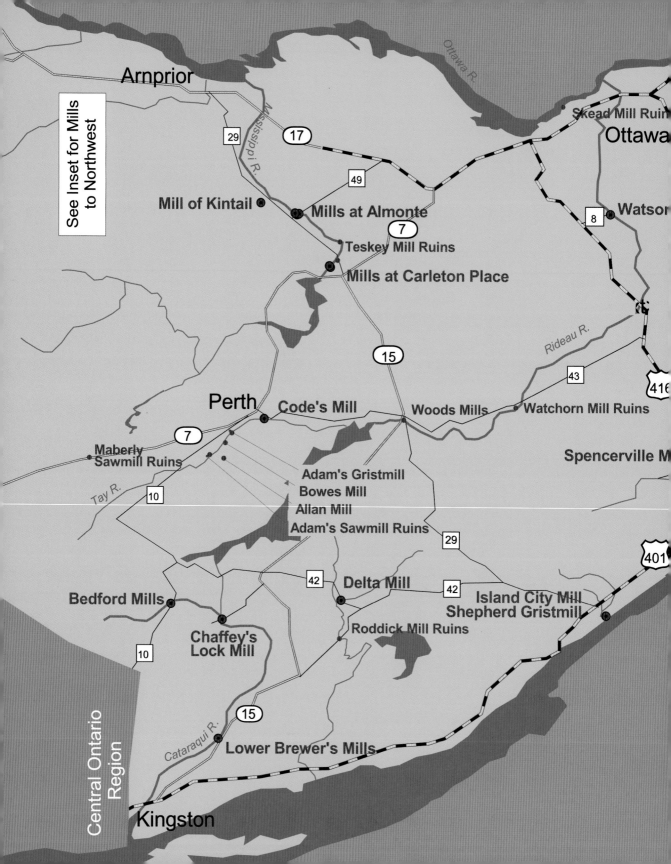

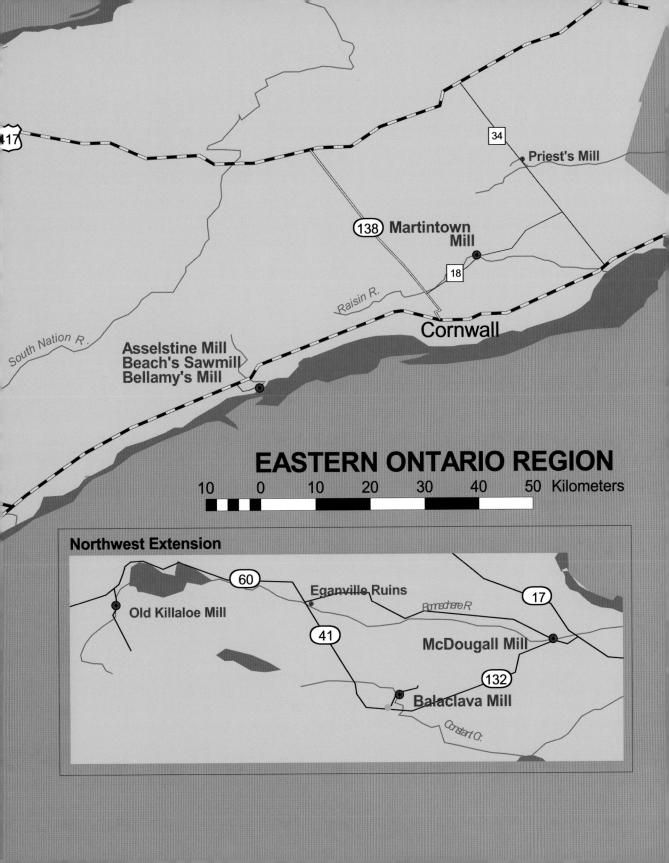

17

34
● Priest's Mill

138 Martintown
Mill
18 ●

Raisin R.

Cornwall

South Nation R.

Asselstine Mill
Beach's Sawmill
Bellamy's Mill ●

EASTERN ONTARIO REGION

10 0 10 20 30 40 50 Kilometers

Northwest Extension

60
Eganville Ruins ●
17

● Old Killaloe Mill Bonnechere R.

41
McDougall Mill ●

132
● Balaclava Mill

Constant Cr.

Asselstine Woollen Mill

Large, rectangular and clad in red clapboard, the mill is perhaps not as quaint or rustic as most of the others shown in this book, but while the exterior is rather plain, the interior is nothing short of amazing! This remains the only operating nineteenth-century woollen mill anywhere in North America, providing a unique experience to watch yarns and blankets produced from raw wool by a waterpowered mill. And when you add the stories of the knowledgeable mill hands to your experience, a visit to this mill should not be missed.

Two of the mill's three floors are packed with a maze of complex textile equipment, most of which is fully operational and can be safely viewed by the visitor on a daily basis. The equipment is considerably more complex than at your typical sawmill or gristmill, but fortunately, only a few machines are normally running at any one time. The drive belts used to run the rest of the equipment continue to turn, though they are slipped onto idler pulleys when a particular machine is not required. By focusing on a few machines at a time, the staff are better able to explain each step of the process.

Raw wool from sheep raised in the village is brought into the mill on the main floor. Here is it is "picked" by the picking machine, which is essentially a large cylindrical metal drum with long steel points. After being washed or "scoured" in vats on the first floor and dried outside, the wool is brought back to the second floor, where it is passed through three carding machines. At this point, the wool is in the form of "roving," sort of like a thick soft rope. The roving is brought to the spinning jack, where it is spun into yarn. The yarn is then transferred to the loom, where it is woven into fabric and, in turn, into blankets.

The mill was constructed by Michael Asselstine in 1828 on Millhaven Creek at Asselstine, 4 km south of Odessa. By 1861, the mill was producing 3,000 yards of flannel and satinet per year, and by 1870 was producing various cloths, yarns and woollen blankets. Business continued until 1947. Eleven years later, the building was purchased by the St. Lawrence Parks Commission and later moved to Upper Canada Village.

Directions

Follow Hwy 401 for 60 km past Brockville to exit 758 at Upper Canada Rd. Go south for 1.8 km to Stormont, Dundas and Glengarry Rd 2. Turn left and drive 2 km to the Upper Canada Village. There is an admission fee, but in addition to three great mills, the first-class park contains a large number of beautifully restored, functional historic buildings, all with knowledgeable staff in period costume. This is one of the best mill sites for a family outing, and you could easily spend the greater part of day enjoying the village. The park webpage outlines the dates and hours of operation, as well as a list of exhibits and activities: uppercanadavillage.com.

Mill Name	Asselstine Woollen Mill
Settlement	Morrisburg
Built	1828
Current Use	Museum
Original Use	Textile Mill
Interior	Museum Hours
Exterior Access	Museum Hours
Artifacts	Operational
Photography	Moderate
Setting	Pioneer Village
Latitude	44.94524
Longitude	75.07036

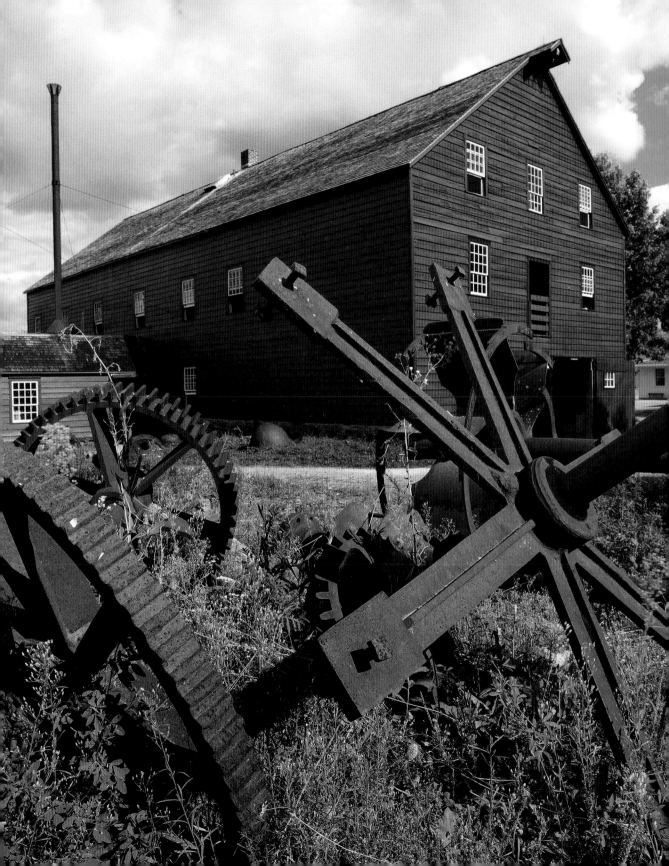

Balaclava Mill

Hurry up — this one may not be around for long! If it isn't soon torn down for safety reasons, it may simply succumb to the elements and collapse into Constant Creek. Miraculously, this two-and-a-half storey structure clothed in rotting vertical planks, and capped with a rusting metal roof still manages to hold itself together. During high flows in spring, the north half of the mill almost seems to float on the waters of Constant Creek, which aggressively digs its way under the building. In places, some of the planks have pulled away from the main structure and now hang on for dear life. It is almost as if the owners woke up one day and simply decided that they would no longer run the mill, leaving it frozen in time. Actually, this is probably exactly what happened!

The mill was constructed in 1855 and was bought by the Richards family in 1868. At its peak, it is said to have cut close to one million board feet per week. That's a lot of sawdust! In the early days the sawdust was simply dumped into the river. In an example of pioneering environmental regulation, the government forced the Richards to find another way to dispose of sawdust, and in about 1903, they constructed a dust burner that still stands today. This small stone-and-

steel tower sits behind the mill on a low concrete slab in the middle of Constant Creek. Though a major fire in 1936 consumed much of the mill, it was quickly rebuilt. The Richards family sold the mill to Donald Dick in 1957, who also owned the general store visible just steps to the north. The mill is believed to have closed in 1966, and as the fortunes of the mill disappeared, so to did those of the village.

Balaclava is one of Ontario's best-known "ghost-towns." A small number of abandoned buildings line the only street through the settlement. In addition to the mill, this includes several abandoned houses and the old general store, all made of wood and each one a little less stable than the next. All of the buildings are posted with "No Trespassing" signs and are dangerously close to collapsing. Fortunately, they are located just inches from the road and can easily be enjoyed on a very short stroll.

Directions

Drive west from Ottawa on Hwy 417 to the end and continue west on Hwy 17 to Renfrew. Follow the signs for Hwy 60 through town and watch for the sign for Hwy 132 at Munroe Ave. About 25 km past Renfrew you will reach the small community of Dacre. Turn right at the general store and follow Scotch Bush Rd for about 3 km to Balaclava. You must not trespass in the mill building: it is private property and certainly very dangerous. Fortunately, the mill and a number of the other buildings are easily visible from the roadside. The drive to Dacre is quite scenic, with the hills of the Madawaska Highlands slowly rising in the distance. By continuing west from Dacre and following Hwy 41, the road enters the rugged highlands, where the scenery is pure Canadian Shield: forests, rock and water.

Mill Name	Balaclava Mill
Settlement	Balaclava
Built	1936
Current Use	Ruins
Original Use	Sawmill
Interior	Private
Exterior Access	Roadside Only
Artifacts	Some
Photography	Good
Setting	Rural
Latitude	45.38940
Longitude	76.94955

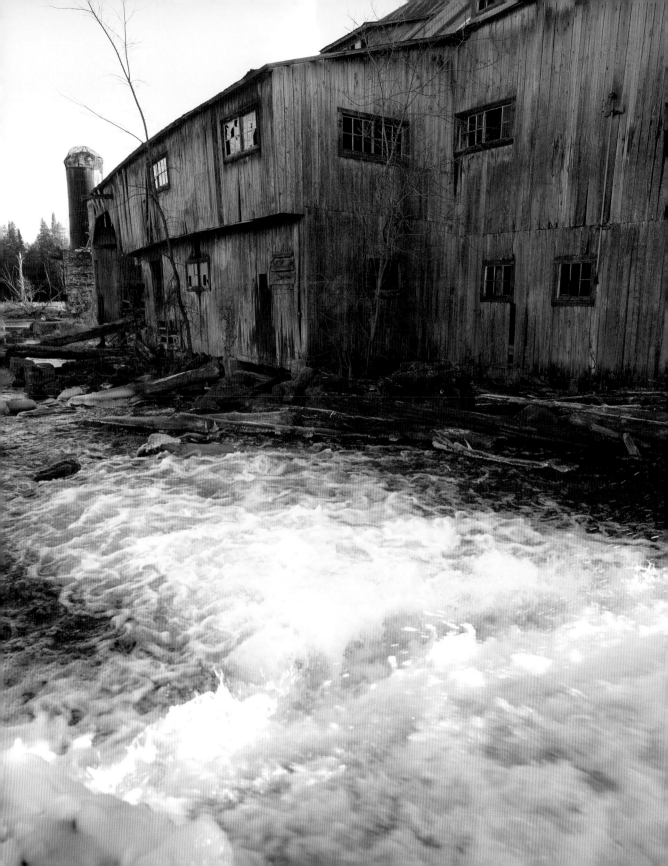

Beach's Sawmill

A little dark and dingy, and enclosed in one of the most primitive mill buildings in this book, the Beach Sawmill is nevertheless a fantastic place to watch and learn about the earlier days of the lumber industry. The mill was built by William and Alvin Beach in 1846 and originally stood beside the South Nation River at Heckston. It is designed around the operation of a "muley" saw, probably the only such saw still in operation in the province. The muley saw was an improvement on the "gate" or "frame" saw seen at the O'Hara Mill, because only the saw blade is moved, instead of the entire heavy wooden frame, allowing for somewhat speedier cutting.

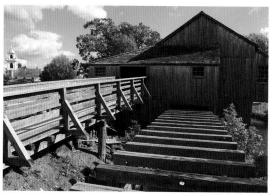

Raceway to channel water to the mill at left; ramp to pull logs into mill at right.

White pine and white oak logs from around eastern Ontario are brought to the mill. They are pulled up a ramp into the second floor of the mill using a pulley system that operates as horses walk away from the mill. From here the logs are rolled onto the carriage. Water is then allowed to flow from the pond into the sluice beneath the mill, where it turns a "barrel-wheel," a kind of primitive horizontal turbine rated at approximately 5 horsepower. The barrel wheel sits just below water but can be seen from the ground floor

of the mill. Once the wheel starts rotating, it turns a gudgeon attached to a pitman arm connected to the sawblade on the upper floor; the whole apparatus working much like a crankshaft that converts the rotary power of the tubwheel to the up-and-down motion of the saw. The blade moves up and down with each revolution of the barrel-wheel.

The barrel-wheel also provides power to the carriage, which slowly moves the log along a track towards the saw. After each pass, the carriage needs to be reset so that the saw can cut off another board. Though the saw is able to cut through a log in about 5 minutes, operations today typically proceed at a much slower rate so that interpretative staff can be heard and respond to visitors' questions. The mill can work with logs up to about 75 cm in diameter, though they must be cut to less than 7 m to fit on the carriage.

The muley saw can be used to cut wood ranging from 1-inch thick planks to 8-by-8-inch posts. Once cut, the lumber is brought out via the ramp over the main door. And the wood isn't just cut for show, as it is routinely used for construction and repairs through-

Mill Name	Beach's Sawmill
Settlement	Morrisburg
Built	1846
Current Use	Museum
Original Use	Sawmill
Interior	Museum Hours
Exterior Access	Park Hours
Artifacts	Operational
Photography	Good
Setting	Pioneer Village
Latitude	44.94524
Longitude	75.07036

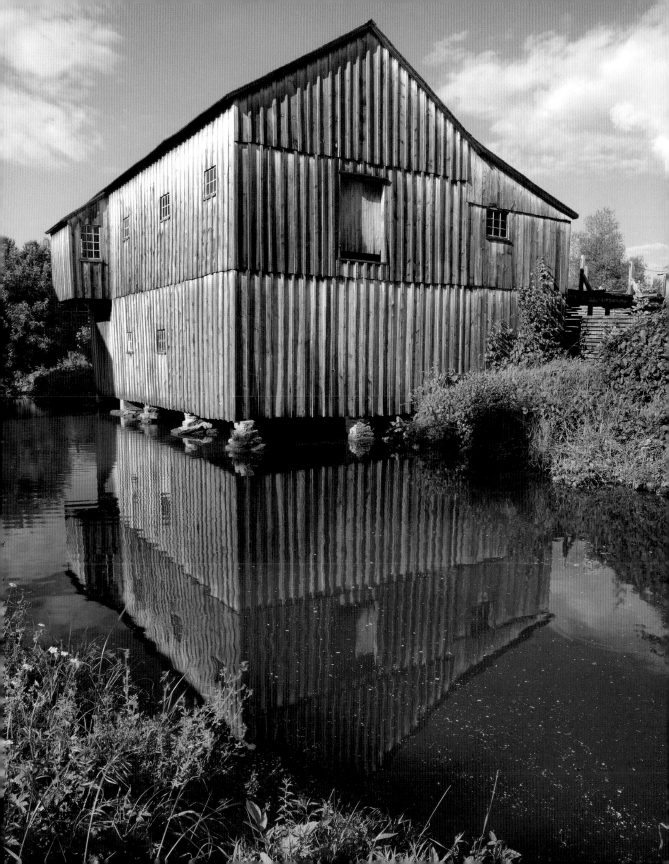

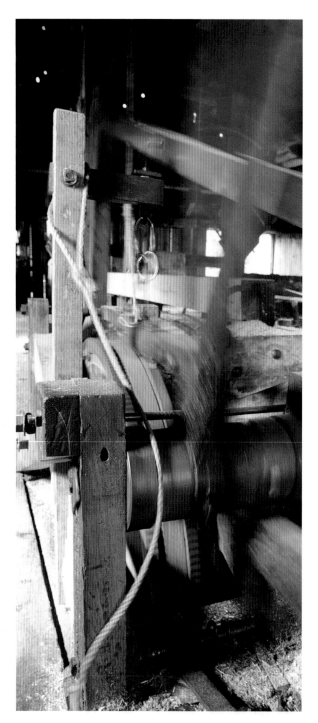

out the village. The mill also houses a large circular saw or shingle mill on the main floor just inside the main entrance. It was used for cutting roof shingles and is operational but not currently used.

Directions

Follow Hwy 401 for 60 km past Brockville to exit 758 at Upper Canada Rd. Go south for 1.8 km to Stormont, Dundas and Glengarry Rd 2. Turn left and drive 2 km to the Upper Canada Village. There is an admission fee, but in addition to three great mills, the first-class park contains a large number of beautifully restored, functional historic buildings, all with knowledgeable staff in period costume. This is one of the best mill sites for a family outing, and you could easily spend the greater part of day enjoying the village. The park webpage outlines the dates and hours of operation, as well as a list of exhibits and activities: uppercanadavillage.com.

Reverse arm of ratchet wheel, moving log back and forth through the saw.

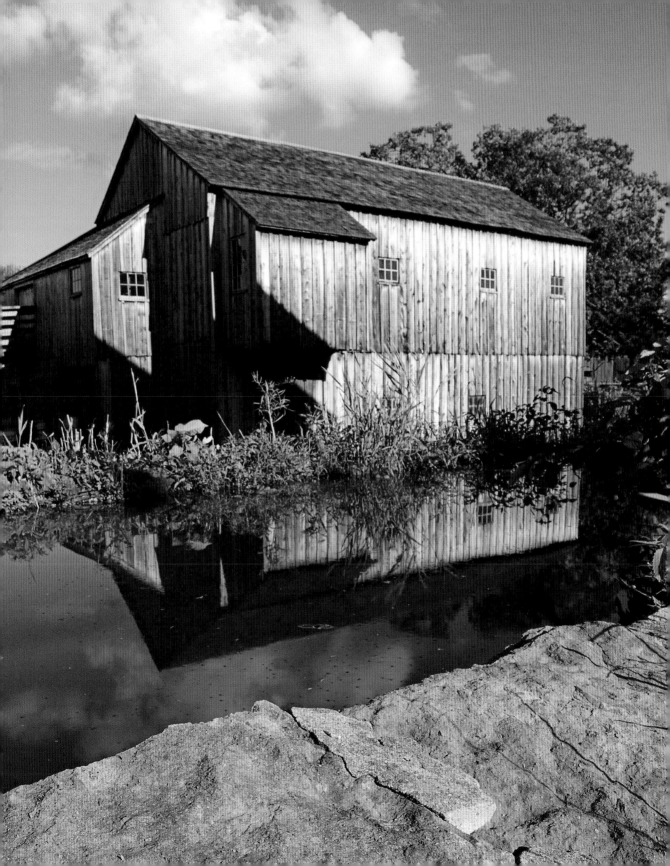

Bedford Mills

The community of Bedford Mills is quiet now, exhibiting a level of indolence certainly unimaginable to residents of the area in the mid-nineteenth century. For Bedford Mills was once a booming industrial centre, with a sawmill once employing 150 workers and shipping goods to Montreal and centres in the northern United States. Today, all that remains of this once-thriving enterprise are the old gristmill building and the old stone powerhouse set beside the easternmost arm of Loon Lake. Both buildings are now used as a private residence, and even though they are within arm's reach of Bedford Mills Rd, respect for the owners' privacy should be exercised at all times.

The first mill at this location was a sawmill constructed in 1829 by Benjamin Tett. A successful local businessman, Tett had many interests, including a lumbering partnership with the Chaffey family (see Chaffey's Mill). His sawmill was constructed near the base of Buttermilk Falls, a small cascade-type waterfall draining water from Devil's Lake, immediately adjacent to the road. The original mill was torn down and replaced by a larger building in 1847. In 1848, the sawmill was joined by a gristmill (the existing green wooden building) built by William Chaffey just below the sawmill. Tett's small empire included three other sawmills, a shipbuilding enterprise and a shingle mill. The business was carried on by his sons John and Benjamin Jr. from 1872 until sometime after Tett's death in 1878. Business at the mills later became unprofitable, as there was no railway, and the community was not located on the main route of the Rideau Canal. Operations ceased early in the twentieth century.

For a short time during the middle of the twentieth century, the powerhouse was used as a general store. The beautiful vine-covered stone building is set just steps from the water's edge and has been used as a unique private residence for some time. The gristmill, admittedly overshadowed by the beautiful powerhouse, is right across the road and is now used as a private workshop. If you look carefully, the remains of what were likely the concrete supports for a flume feeding the gristmill can be seen beside the waterfall.

Directions

Follow Hwy 401 to Kingston and exit at Frontenac Rd 10 (Perth Rd). Drive north for about 42 km and watch for Bedford Mills Rd on the left. If you miss it, don't worry: the little gravel road meets the county road twice. Follow the road for a few hundred metres to the mill and powerhouse. Remember that the mill buildings and grounds are now a private residence and you must not start wandering around the property. Even though excellent photographs of the old powerhouse can be obtained from the road or from across the pond, please use discretion to avoid invading the owners' privacy.

Mill Name	Bedford Mills
Settlement	Bedford Mills
Built	1848
Current Use	Private Home
Original Use	Gristmill
Interior	Private
Exterior Access	Roadside Only
Artifacts	Unknown
Photography	Good
Setting	Rural
Latitude	44.60444
Longitude	76.40561

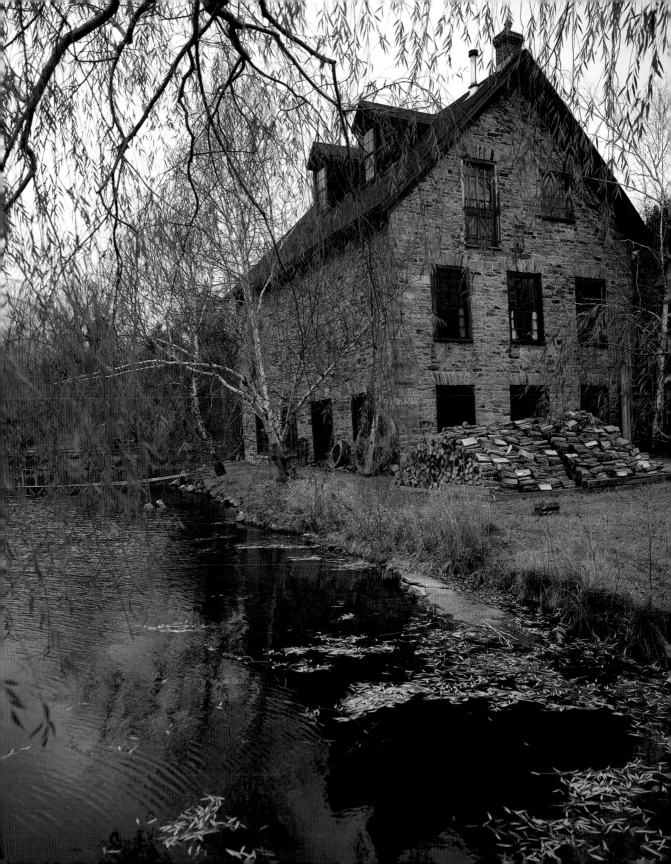

Bellamy's Mills

A modest number of the heritage flourmills in Ontario have been restored to the point where flour can be prepared onsite. Of these, the Bellamy Mill is unique because it is the only such mill that is run by both waterpower and steam. Not that this was always a unique combination, as many mills turned to an auxiliary power source in order to expand or to safeguard against unreliable stream flow. But no other historic mill in the province has preserved a dual power source in working order. Add to this the gorgeous stonework, tidy display and informative staff, and it becomes one of the more rewarding flourmills to visit in this collection.

In 1822, three brothers, Samuel, Chauncey and Hiram Bellamy, constructed this beautiful mill in the tiny village of North Augusta. For the first 40 years, power was obtained from Kemptville Creek (AKA "Mud Creek"). Though the river drains about 100 km upstream from here, for almost 8 months of the year the stream flow was just too low to power the mill. By the 1860s, the need for a longer operating season was answered with the installation of a wood-burning boiler and engine that could power the mill when the head of water was insufficient.

Mill Name	**Bellamy's Mills**
Settlement	**Morrisburg**
Built	**1822**
Current Use	**Museum**
Original Use	**Flourmill**
Interior	**Museum Hours**
Exterior Access	**Park Hours**
Artifacts	**Operational**
Photography	**Excellent**
Setting	**Pioneer Village**
Latitude	**44.94524**
Longitude	**75.07036**

In 1979, the building was carefully dismantled and moved to Upper Canada Village. And unlike the Roblin Mill that was moved to Toronto, here, the original stones were used in the reconstruction. The majority of the equipment in the mill is not from the original site. Over a number of years, many vintage pieces were collected from various sources throughout eastern Canada, though some equipment, like the tube boiler, had to be custom built.

A classic example of the "automatic mill," it is possible for one miller to run the entire operation from the ground floor. Fortunately for the visitor, 3 or 4 interpretive staff are usually on hand to explain the process. Grain is lifted to the upper floor by operational bucket elevators. After the usual cleaning processes, it is transported back to the ground floor for grinding at one of three run of stone. All three sets of stone are operational, two of which are used primarily for wheat, while a third is reserved for oats. Flour is then sent to a small but operational bolter on the second floor, before the finished product is packaged in cotton sacks. Some of the flour is sent to the village bakery, which can use up to 300 lbs on a busy day. The rest is sent to the village store for sale to the public, available as both whole wheat and superfine white.

The first two floors plus the basement are open to exploration. A Leffel turbine, rated about 50-horse-power is hidden below water level in a wooden pressure box in the basement. It is used every day, transferring rotary power throughout the mill via a long vertical iron shaft visible on each floor. On the third floor, the vertical shaft couples to a horizontal lineshaft, which in turn connects to numerous pulleys that distribute power to various machines.

Today, the mill runs for part of the day on steam power. A low addition to the main mill building

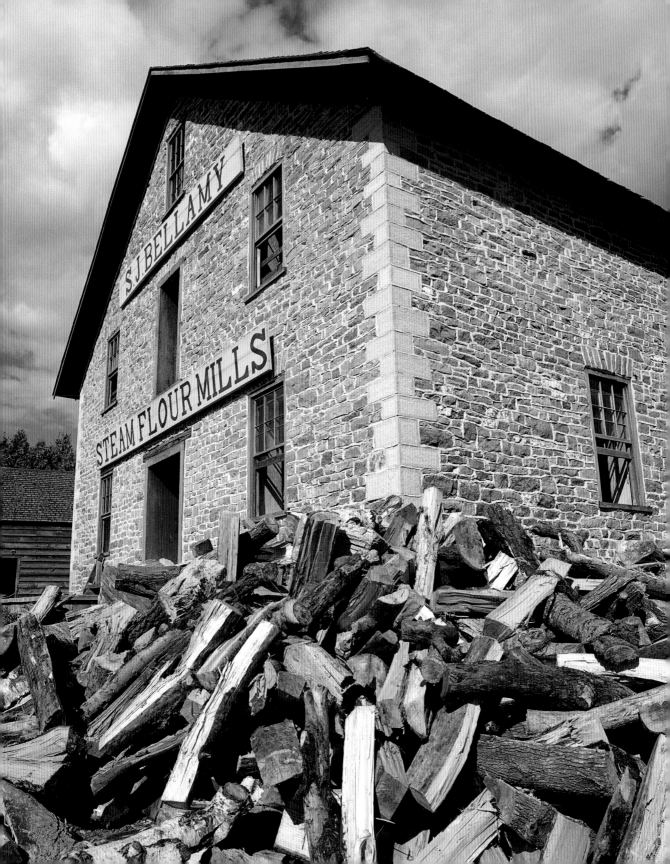

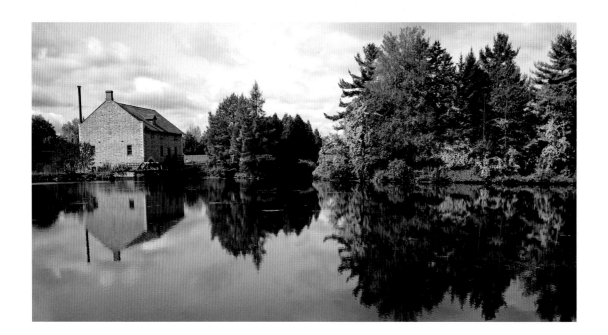

known as the "steam house" contains the 35-horse-power steam engine. Consuming a face cord of wood in two hours, the engine runs most afternoons. Visitors can see the engine and talk to the engineer to learn more about its operation.

Directions

Follow Hwy 401 for 60 km past Brockville to exit 758 at Upper Canada Rd. Go south for 1.8 km to Stormont, Dundas and Glengarry Rd 2. Turn left and drive 2 km to Upper Canada Village. There is an admission fee, but in addition to three great mills, the first-class park contains a large number of beautifully restored, functional historic buildings, all with knowledge-able staff in period costume. This is one of the best mill sites for a family outing, and you could easily spend the greater part of day enjoying the village. The park webpage outlines the dates and hours of operation, as well as a list of the exhibits and activities: uppercanadavillage.com.

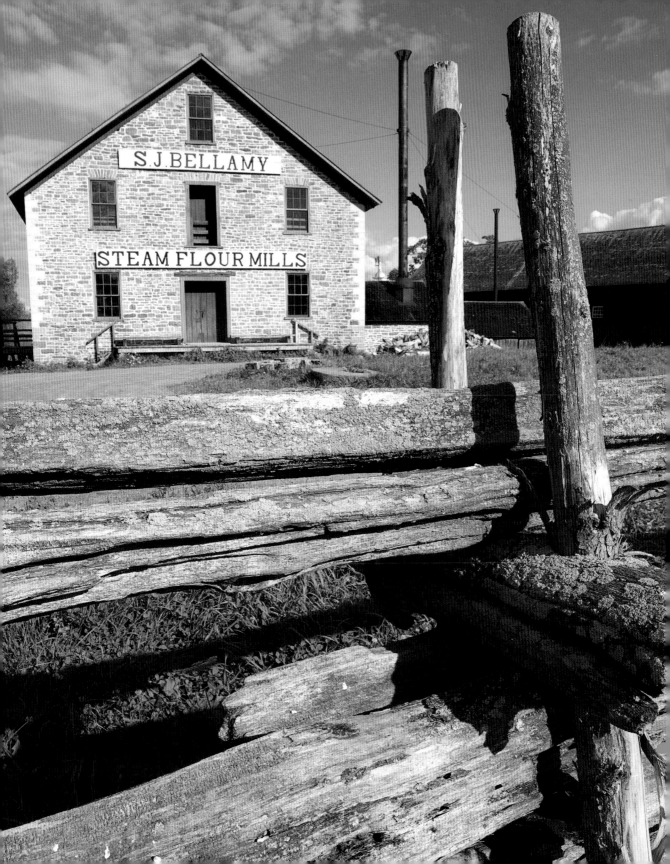

Chaffey's Lock Mill

Perched atop a low, rocky outcrop, Chaffey's Mill has a great view of the picturesque, park-like grounds surrounding Lock 37 of the Rideau Canal. The natural setting of this mill is one of the best in Eastern Ontario. It's a great place for a picnic or to just sit and watch the boats work their way through the locks on a nice summer afternoon. A number of tables line the approaches to the locks, several with a good view of the mill. In addition to the mill, you can also explore the locks, the little swing bridge, and a small museum that now occupies the original lockmaster's house, a one-storey defendable building that was constructed in 1844.

Chaffey's Lock is named after Samuel Chaffey, who was an uncle of John Chaffey. He came to Canada in 1816, and within about 10 years had constructed one of the largest milling complexes in the eastern part of the province. Chaffey died in 1827, falling victim to malaria (not to worry, malaria is no longer encountered in Leeds and Grenville County). While tragic, this prevented the further tragedy of Chaffey seeing all of his mills eventually demolished to make way for the locks of the Rideau Canal a few years later. In an ironic twist of revenge (or perhaps it was Chaffey's curse), construction of the locks (1826 to 1832) was delayed when much of the work crew succumbed to malaria. The 202 km long canal connects Kingston to Ottawa. Though originally planned as a military lifeline to bypass the St. Lawrence River, it helped with colonization of the area, and now serves as one of Ontario's premier pleasure craft routes.

At the time of writing, the mill building housed the Gallery at the Mill which contained an assortment of art, antiques and collectables. Constructed in 1872 as a gristmill by John Chaffey, it was originally built of stone. The portion of the mill facing the canal was restored with now-aging white clapboard after the original stone wall was torn away by flooding in the early 1900s. In 1941, the mill was converted to a private residence by Arthur Phelps, a well-known Canadian journalist and professor of English. Phelps is rumoured to have occasionally cast his fishing line out his kitchen window to the millrace below, which is a long, narrow channel lined with stone blocks.

Directions

At Kingston, exit Hwy 401 at Frontenac Rd 10 (Perth Rd). Drive north for about 50 km (the route becomes Leeds and Grenville Rd 10) to the pretty tourist village of Westport. At Westport, turn right on Leeds and Grenville Rd 42 and drive for 13 km to Hwy 15. Turn right and drive a few kilometres to Leeds and Grenville Rd 9. Chaffey's Lock and the mill are 9 km further down this scenic road, which twists and turns over little hills before ending up at the picturesque settlement. Parking is limited, so you may have to find a spot and walk a few hundred metres to the mill. Before leaving the site, be sure to investigate the Lockmaster's House Museum, located just steps from the locks.

Mill Name	Chaffey's Lock Mill
Settlement	Chaffey's Lock
Built	1872
Current Use	Private Home
Original Use	Gristmill
Interior	Retail Hours
Exterior Access	Anytime
Artifacts	Unknown
Photography	Good
Setting	Park
Latitude	44.57915
Longitude	76.31982

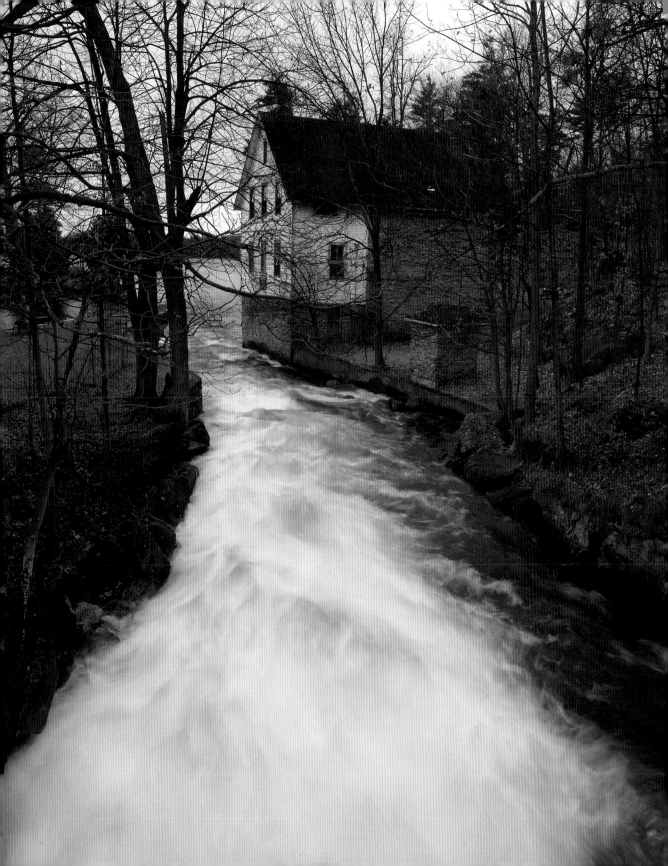

Code's Mill

Code's Mill is strategically located just one block from the main street through Perth. While this wasn't critical to the mill's success as an industrial venture, its location is perfectly suited to its modern use as a multi-purpose retail establishment. The building now houses a small number of interesting shops, offices, a restaurant, coffee shop and an upscale conference and banquet hall. The airy yet cozy atrium in the middle of the building is a great place to enjoy a coffee and a good book about mills! Throughout much of the mill, the original stone walls and ceiling trusses are still exposed.

The first portion of the mill was built by the Kilpatrick family in 1841 as a tannery. About 48 years later, Thomas Code bought the mill and expanded operations to include carding, spinning, fulling, and yarn colouring. Code expanded again in 1896 to produce more value-added products such as socks, gloves, sweaters and mitts, and again in 1899 by adding a felt-making process. The portion of the mill fronting Herriott St. was an addition built in 1903. Right across the street at 50 Herriott St. is Code's home, an impressive stone house built in 1906 that was once heated by steam from the mill. Code's Mill continued to house felt-making operations until the factory finally closed in 1998. The following year, its owner began to convert the building from industrial to commercial use.

Code's Mill is but one of many fine stone buildings in Perth. The compact downtown is the perfect size for a walking tour, and a guide brochure is available from the Tourism Information office two blocks east at 34 Herriott St. The mill is also only one of many that once flourished in the small Tay River watershed. While most are now long gone, a few still exist, the majority no more than ruins. A local community organization in Perth, the Friends of the Tay Watershed Association, are, at the time of writing, documenting the history and developing a photographic series on the mills and mill sites of the Tay. Unlike the book in your hands, their project will represent a different approach by detailing the mill history of one small, concentrated area.

Directions

From Ottawa or from the west, follow Hwy 7 to Perth. Drive south on Lanark Rd 43 (Wilson St.) for about 1.5 km. When you see the road bend to the left, stop! The mill is on your left at 17 Wilson St. E. Park on the road or in the municipal lot behind the mill building. More information about the mill and the businesses that it houses is available at codesmill.ca. Right across the street from the mill is Stewart Park, a town favourite, which offers a pleasant place to take a stroll or a picnic after a walk through the mill. In 2005, a bronze sculpture of Big Ben, one of the most famous show-horses in Canada, was unveiled in the park just across the street from the mill.

Mill Name	Code's Mill
Settlement	Perth
Built	1841
Current Use	Multi/Retail
Original Use	Tannery
Interior	Retail Hours
Exterior Access	Anytime
Artifacts	None
Photography	Good
Setting	Urban
Latitude	44.89961
Longitude	76.25127

Delta Mill

The Delta Mill is often argued to be the best-preserved example of early gristmill architecture remaining in Ontario. Designation as a National Historic Site and restoration efforts by the Delta Mill Society have helped to keep the gorgeous building in excellent condition. This is all the more remarkable considering it is likely the fourth-oldest remaining mill in the province (after Backus Mill, the mill at Glenora, and Ball's Gristmill).

The village of Delta was known as Stevenstown when William Jones began construction of this mill around 1810. As the village is set on a delta-shaped piece of land between Upper and Lower Beverley Lake, it was renamed Delta in 1857. Few visitors are aware that the upper lake is actually the product of a dam constructed by Jones on Plum Hollow Creek, which was originally just one of a number of small creeks draining into the lower lake. Flour-milling ceased in the 1920s, though the mill continued in the feed business until 1949.

The last private owner of the mill deeded it in 1963 to four individuals who would later become the founders of the Delta Mill Society. The mill obtained status as a National Historic Site in 1973. In 2004,

after 5 years and a million dollars in major renovations, the building was reopened as one of the most-visited mill museums in Ontario. Not content with this accomplishment, the Mill Society hopes take things one step further by restoring the mill to operational status in time for its bicentennial, in 2010.

Though currently not in operational condition, the mill is packed with well-designed, professional-quality displays, as well as many examples of mill technology. A self-guided tour leads you past interpretive displays explaining the early history of milling and the development of the automatic mill. One interactive exhibit actually lets you move grain using a miniature bucket elevator and auger conveyer. The tour continues on the second floor, where exhibits concentrate on the grains that would have been ground at the mill. In 2005, a bolter, smutter, roller mill and several other pieces were bought at auction at the Bell Rock mill, and are being incorporated into the displays throughout the mill.

On the ground level, a metal grate in the floor allows you to take a glimpse of two 48-inch turbines installed in the wheel pit, found at the base of the shorter portion of the building adjacent to the creek. Power was initially obtained by means of a breast wheel, but was replaced by the turbines in about 1860. By the early twentieth century, the owner at the time (George Haskin) was able to use the turbines to generate electricity for the village. One of the priorities of the Delta Mill Society is to restore the waterwheel in the wheel pit. Not that there's anything wrong with turbines, but a switch back to wheel technology would help to emphasize the building's earlier years.

Constructed of tan-coloured, cut-and-dressed stone, the quality of craftsmanship is immediately apparent. Large quoin stones anchor the corners of the

Mill Name	Delta Mill
Settlement	Delta
Built	c. 1810
Current Use	Museum
Original Use	Flourmill
Interior	Museum Hours
Exterior Access	Anytime
Artifacts	Lots
Photography	Excellent
Setting	Urban
Latitude	44.60999
Longitude	76.12290

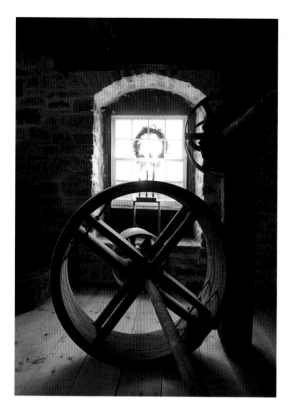

building, and splendid stone arches protect the headrace, tailrace and the 12-over-8 double-hung windows. The beautiful stonework is also exposed inside the mill, as is much of the post-and-beam timber-frame skeleton. Visible from the uppermost floor is the ridge beam, a single 18 m hand-hewn beam into which the roof rafters are pegged.

Directions

Follow Hwy 401 to Kingston and exit at Hwy 15. Drive northeast for about 30 km to Leeds and Grenville Rd 33 and turn right. Drive for 15 km to Leeds and Grenville Rd 42, turn left, and drive 3 km to the village of Delta. The mill is on the left side of the road, just past a parking area in front of the river. The mill is open from Victoria Day to Labour Day, and at the time of writing, there was no admission charge. More details are available at the mill's website, deltamill.org, and the Mill Society sells a more detailed account of the mill, entitled *A History of the Old Stone Mill, Delta, Ontario*, and written in 2000 by Paul S. Fritz. Be sure to take a short walk through the picturesque village, including a stop at the Museum of Industrial Heritage in the old town hall, just around the corner on Court St.

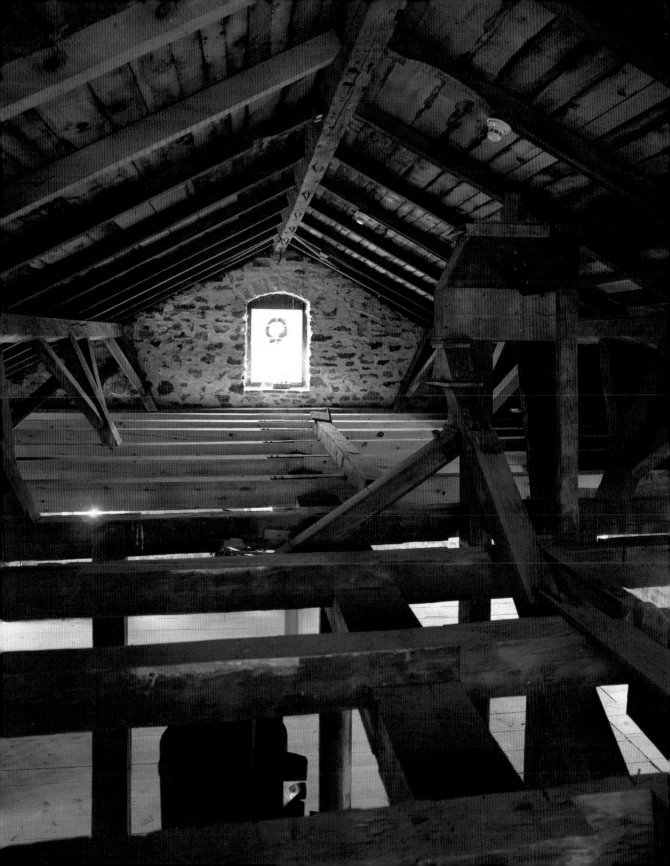

Island City Mill

Shepherd's Gristmill (above), Island City Mills (right)

There are two old mills in Brockville. The more photogenic of the two is currently known as Island City Mills, a fine stone building that dates to about 1903. Built by Archie Cameron, the mill was an addition to Cameron's existing flour and feed business, which he had started about a decade earlier. At its peak, the mill is believed to have employed six millworkers, several drivers, and handle, close to 30 tons of grain per day.

When Cameron died in 1913, the building was sold to Henry Murray, who in turn sold to George Atkinson in 1930. He operated the mill until 1966. A retail outlet for the business was located next door, at 182 King St. W. Herbert Sheridan then purchased the mill and ran an antique store in the building for some time.

Unlike most of the mills in this book, waterpower was never used here. Power was instead generated by a coal-fired steam boiler located in a small brick building at the south end of the mill. The boiler house was torn down in 1973. Shortly after, many of the better pieces of equipment from both the mill and the boiler house were moved to the mill at Wakefield, Quebec, including a corn cracker, plate grinder and a "Stratford Dustless" brand flour sifter. There are also rumours that several pieces made their way to Watson's Mill.

Just a short walk from the Island City Mill is Shepherd's Gristmill, a pretty little stone mill built by Robert Shepherd in 1852. In the early years, the site was a beehive of activity, with upwards of nine mills drawing power from Buell's Creek. Right behind the mill, the creek is lined for some distance with stone masonry walls, a considerable undertaking that we did not observe at any other site. After some detective work, it was discovered that the stone was added around 1906, after the building had ceased operations as a mill. By 1893, the building had been converted for use as a coal oil depot by Imperial Oil and was used for this purpose until 1978. As a result, there are no traces of the original milling equipment. Since 1992, the building has housed the Riverwalk Mill, a family restaurant, pub, and meeting space spread over three floors of the mill.

Directions

Follow Hwy 401 to Brockville and exit at Leeds and Grenville Rd 29 (Stewart Blvd). Drive south, following the route as it becomes William St. and then Courthouse Avenue. At King St., turn right and drive four blocks to Kincaid St. The Island City Mill is located behind 186 King St. W. For Shepherd's Gristmill, drive south on Kincaid St. to Water St. Turn right and drive two blocks to the mill at 123 Water St.

Mill Name	Shepherd Gristmill
Settlement	Brockville
Built	1852
Current Use	Restaurant
Original Use	Gristmill
Interior	Patrons Only
Exterior Access	Anytime
Artifacts	None
Photography	Good
Setting	Suburban
Latitude	44.58630
Longitude	75.68792

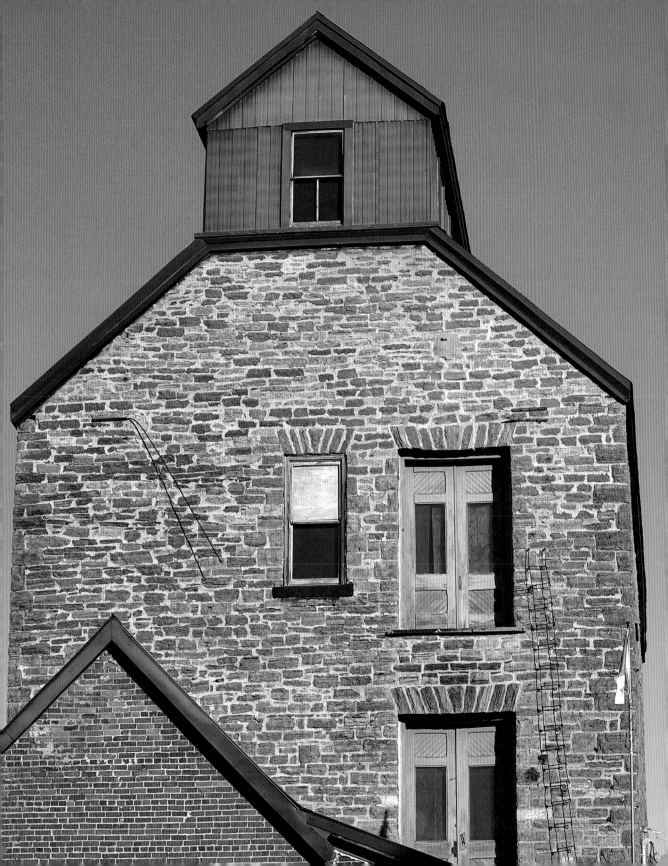

Lower Brewer's Mills

Situated beside Lock 45 along the Rideau Canal, this unassuming former gristmill now houses a small rural art gallery. Though set below a small waterfall, the little building is admittedly far from the prettiest in this collection. And the grounds, though pleasant, are perhaps not as nice as at Chaffey's Lock, further upstream. Nevertheless, the overall scene and surrounding countryside are relaxing and represent a nice pit stop on an afternoon drive out of Kingston. This is a perfect spot to watch pleasure craft pass through one of the little locks of the Rideau Canal. Still operated by hand, the locks are used to raise boats 4 m from the level established by the dam at Kingston Mills, some 15 km to the south.

John Brewer constructed mills both here and 3 km upstream at Upper Brewer's Mills. Ownership of the original mill here at Washburn passed through several hands, before the mill was torn down in 1942 to make way for a small hydroelectric generating station. The power plant was constructed by the Gananoque Light and Power Company, and is still located immediately upstream of the existing mill building, fed by a closed metal penstock. The remaining mill building, built c. 1865, is reported to have once been a storage elevator for the first mill. When the first mill was removed, much of the milling equipment was transferred to the elevator, which operated as a gristmill off and on until the 1960s. The building is set on a stone foundation, but is sheathed in what appear to be square metal plates, which we only observed elsewhere on the Bell Mill at Utopia.

Directions

From Hwy 401, exit at Hwy 15 at Kingston and drive north for 15 km to Washburn Rd. Turn left and drive 0.5 km to the locks. Note that a "swing bridge" is associated with the locks here, and depending on boat traffic, you may have to wait to cross the bridge. Fishing is reportedly good, though we didn't have a rod to test the waters during our visits.

Mill Name	Lower Brewer's Mill
Settlement	Washburn
Built	c.1865
Current Use	Retail
Original Use	Gristmill
Interior	Retail Hours
Exterior Access	Anytime
Artifacts	Unknown
Photography	Moderate
Setting	Rural
Latitude	44.38900
Longitude	76.32600

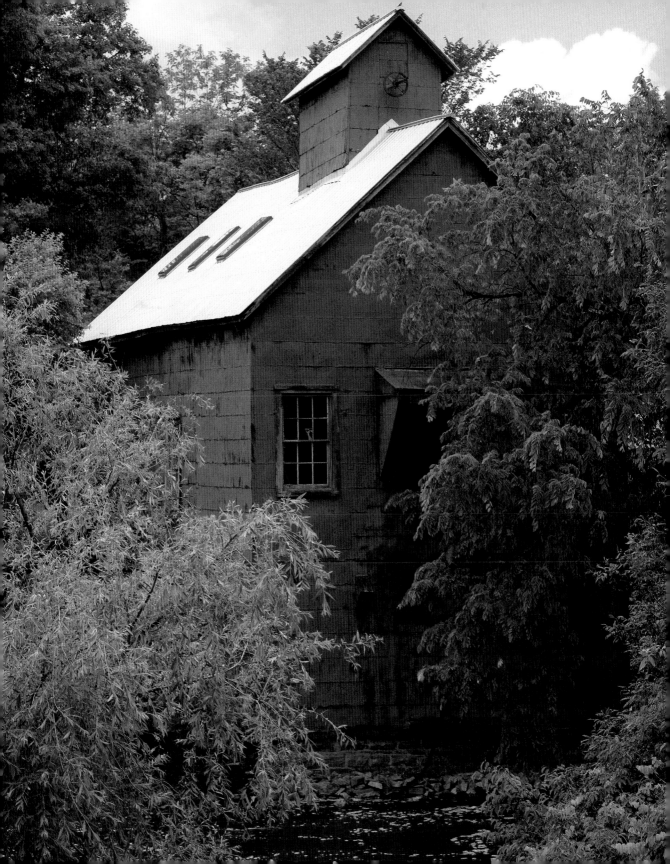

Martintown Mill

A close look at the lintels over the window openings of the Martintown Mill provides a stark reminder of how close this mill came to sinking into the Raisin River. Like some kind of avant-garde architectural experiment, a number of the long stones "droop" towards the river, especially on the southeast-facing side. Fortunately, efforts by a number of groups to save this picturesque little building have been successful, buying time for further restoration of the mill by the Martintown Mill Preservation Society.

Alexander McMartin built this mill in 1846. His saw and carding mills that were also constructed at this site, as well as an earlier mill built by his father, have long since vanished. After McMartin's death in 1853, the mill was operated by a number of different owners. Several additions were made, including installation of a 48-inch turbine that produced about 55-horsepower in about 1881, a roller mill in 1898 and a 40-horsepower gasoline engine installed in 1931 to provide greater reliability. The mill ceased operations in 1951, and it was not until ownership by the Raisin River Conservation Authority in the 1980s and 1990s that any significant restoration efforts were made.

In the mid-1980s, extensive stabilization work was conducted. This included repair of the foundation walls, installation of stable concrete pedestals in the mill's basement and the setting of a low concrete wall along the river's edge. A new wood floor on the ground level was installed out of absolute necessity (the uppermost level needs one too!). The whole structure was stabilized by the addition of tie-rods, the anchors for which are clearly visible on the exterior walls. A pamphlet available from the Society details the history of the mill, with a particular emphasis on the stabilization projects of the 1980s.

In spite of the successes to date, there is still much work left to do, and as always, progress is limited by the availability of funds. Restoration of the building is still very much in progress, and this very process is part of the interest of a visit to the mill. Visitors are able to tour the mill on select occasions during the year, and you should check the website for dates of opening: martintownmill.50webs.org. Though tours are currently limited to the ground floor, the old Leffel turbine set high on a platform in the basement is clearly visible behind a wire safety screen.

Directions

Follow Hwy 401 to Cornwall and exit at Hwy 138. Go north on Hwy 138 and follow the signs as the highway jogs right and then left before heading northwest from the city as St. Andrews Rd. About 6 km along the route beyond Hwy 401, turn right on to Stormont, Dundas and Glengarry Rd 18 and drive for 10 km to the village of Martintown. Immediately after crossing the river in the village, turn into the very small parking lot located beside the mill.

Mill Name	**Martintown Mill**
Settlement	**Martintown**
Built	**1846**
Current Use	**Museum**
Original Use	**Gristmill**
Interior	**Special Occasion**
Exterior Access	**Anytime**
Artifacts	**Lots**
Photography	**Good**
Setting	**Urban**
Latitude	**45.15491**
Longitude	**74.71090**

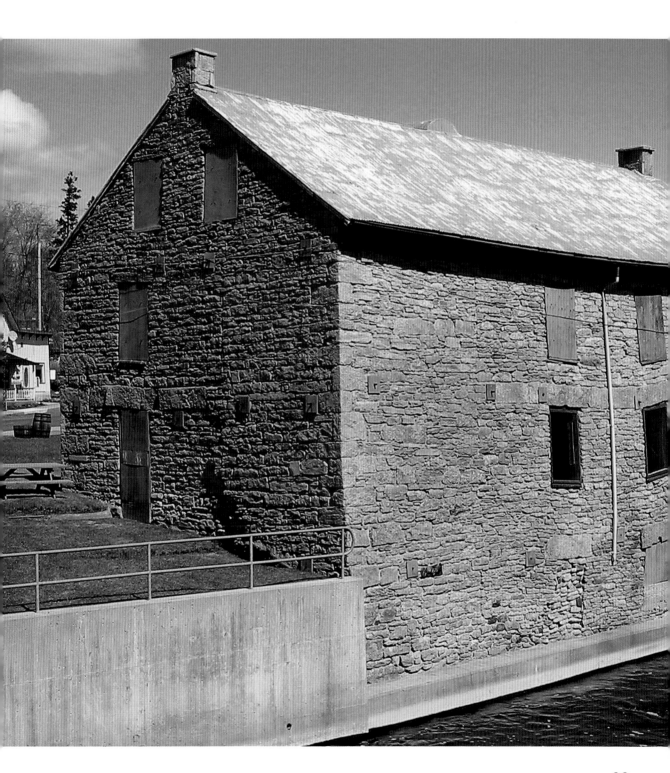

McDougall Mill

Another beautiful stone mill in the Ottawa Valley, the fine building watches over a rocky, scenic stretch of the Bonnechere River. Though a fire in 1972 burned what was left of the milling equipment, the mill is now a museum. It houses three bright levels of historic artifacts, ranging from examples of Renfrew's early industrial output to a large collection of agricultural implements. But as the museum is quick to point out, the mill building itself is the prize exhibit! Some of the stones used in the broken course masonry are the largest among the mills included in this collection. The roof has been fitted with cedar shakes; a less durable, though historically appropriate covering for the building. On the west and south walls of the mill, stone arches that once crowned the entrance and exit for water flowing into and out of the mill are still visible, though they have been sealed shut by concrete. A channel that would have diverted water to the west arch was probably filled in when the museum grounds were prepared.

The mill was constructed in 1855 by John Lorne McDougall. A retired fur-trader and Hudson's Bay Company agent, McDougall had already built Renfrew's first store around 1840 before purchasing part of Lot 13 along the river for a paltry 5 shillings. In addition to an existing sawmill, several other mills eventually crowded this site to take advantage of its milling benefits. After a long succession of different owners, Michael Murray donated the mill to the town in 1963, which in turn opened the McDougall Mill Museum in 1969.

After touring the mill, be sure to take in the picturesque walk across the infamous "swinging bridge." Less than a hundred metres downstream, this wooden suspension footbridge treats you to not only a wobbly ride, but a panoramic view of the mill and its surroundings, including the gentle waterfall and an ugly-turning-rustic hydroelectric generating station built in 1900. When river flow is low, you can safely scramble along the bedrock bed of the river and follow a weak path upstream past the concrete foundations of a long-since-demolished milldam. The falls is known as the Second Chute and is only one of five chutes on the 145 km Bonnechere River. The First Chute is a considerably larger, rugged waterfall hidden in the woods about 13 km downstream, accessible from Thomson Rd.

Directions

Follow Hwy 417 west from Ottawa and continue west as the expressway becomes Hwy 17 at Arnprior. Drive for another 28 km to Renfrew and turn left onto Hwy 60. Follow the signs for Hwy 60 as it snakes through town. Eventually you will pass over a bridge, where the mill is plainly visible across the river to the right. Turn right on Arthur St., stay right and drive two blocks to the mill.

Mill Name	McDougall Mill
Settlement	Renfrew
Built	1855
Current Use	Museum
Original Use	Gristmill
Interior	Museum Hours
Exterior Access	Anytime
Artifacts	None
Photography	Excellent
Setting	Park
Latitude	45.47772
Longitude	76.69312

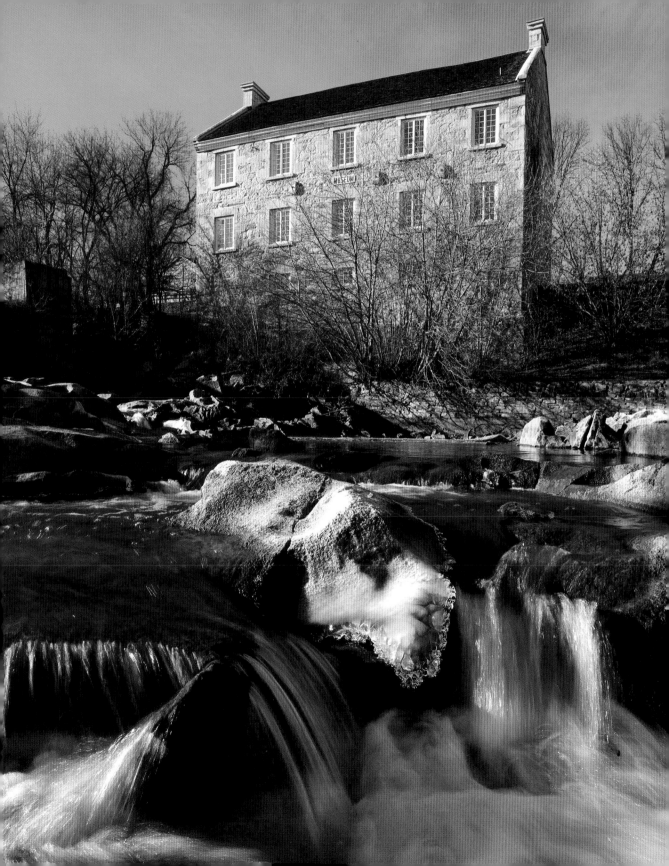

Mill of Kintail

Hidden in the woods on the edge of the idyllic Indian River, this is undoubtedly one of the prettiest stone gristmills in the entire province. The Mill of Kintail is the only reminder of several mills that once drew power from the Indian River. Remnants of the dam used to store the river's power for the mill can be seen just upstream. At one time, waterpowered two run of stones for flour and two more for oatmeal. Today, the building's colourful sandstone walls are a bright and cheery contrast to the dull grey limestone and dolostone blocks used to build so many of Ontario mills. Bright and cheery on the inside too, the building now houses a fine collection of sculptures by a renowned Canadian sculptor, Dr. Robert Tait McKenzie.

Known first as Woodside Mills, the mill was constructed in 1830 by a Scottish pioneer named John Baird. Baird later moved his operations to Almonte, believed to be on the site of the present-day hydroelectric generating station in that town (see the Mills in Almonte). In 1930, Baird's mill, neglected and in need of repair, was purchased and restored by McKenzie, who named the mill after a family fort in the Scottish highlands. A surgeon, athlete, physical educator and sculptor all rolled into one, McKenzie was somewhat of a Canadian legend. He spent his summers at the mill until about 1937, working on sculptures in a sunny studio on the upper floor. His sculptures appear around the world, including Edinburgh, Washington, and, a little closer to home, the War Memorial in his hometown of Almonte.

The Mississippi Valley Conservation Authority now owns the mill and operates it as a museum dedicated to the life of McKenzie, displaying over 70 of his sculptures. It is also used as a base for a wide variety of nature education programs for both students and the general public. A network of nature trails winds through more than 60 hectares of woods and old fields and can be enjoyed any time of year.

Directions

Follow Hwy 417 west from Ottawa to Ottawa Rd 49 (March Rd). Exit west and drive 16 km west to Almonte. Drive through town and turn right on Lanark Rd 29. Drive north for 3 km to Clayton Rd and turn left. Turn right on Ramsay Concession Rd 8 and follow the signs to the parking lot. The mill is located about 500 m in from the sideroad. The museum is open from mid-May to mid-October, though you may walk the grounds any time of year. More information on the mill, special events and hours of operation is available at millofkintail.com.

Mill Name	**Mill of Kintail**
Settlement	**Bennies Corners**
Built	**1830**
Current Use	**Museum**
Original Use	**Gristmill**
Interior	**Museum Hours**
Exterior Access	**Anytime**
Artifacts	**None**
Photography	**Excellent**
Setting	**Wilderness**
Latitude	**45.24450**
Longitude	**76.25787**

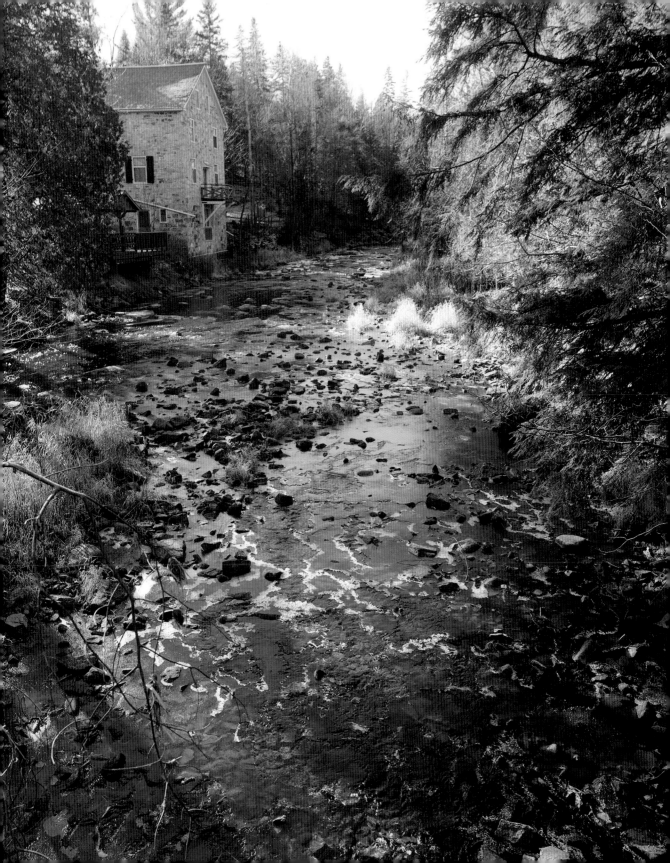

Mills at Almonte

Almonte is a small town in the Ottawa Valley with a big milling history. At one time the nucleus for textile production in Ontario, the town was referred to as the "Manchester of Canada." By the late nineteenth century, nearly half of the town's 4,000 inhabitants worked in woollen mills operated by almost a dozen different firms. Four mill buildings still remain, and each has been converted to a different use. None of the mills is in itself a tourist destination, but their proximity to one another and the heritage value of the old town combine for a great opportunity for a walking tour. So park your car, put on your walking shoes, and explore! The map below highlights the mills and a few other features in the town. The round-trip walk described here is just over a kilometre long.

Located in a former mill warehouse is the small Mississippi Valley Textile Museum, at the corner of Rosamond St. and Mary St. The museum contains informative displays on the textile industry and the everyday life of a millworker, and the knowledgeable staff can answer questions about both the museum's displays and the history of the town. A decent collec-

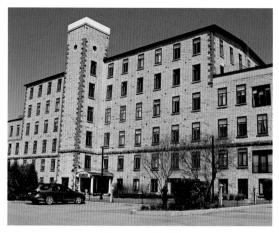

Rosamond Mill

tion of vintage textile machines on exhibit upstairs includes looms, winders, a felt knitting machine, and a bobbin winder. Most of the equipment dates from the early twentieth century, and while not operational, some pieces are undergoing restoration efforts. The museum also houses galleries that display rotating exhibits of contemporary fibre arts and a small giftshop.

Immediately adjacent to the museum, and impossible to miss, is the massive Rosamond Mill complex. Six storeys high in places and occupying the majority of a city block, this was the largest and most technologically advanced woollen mill in Canada for decades, and remains one of the larger industrial heritage buildings in Ontario. It was constructed in 1866 by Bennett and William Rosamond as a means to expand the Rosamond family business established by their father, James Rosamond. The Rosamonds used local wool, but also imported much finer wool from South Africa and Australia. Manufacturing at the building stopped in the early 1980s. The building was soon recognized as a National Historic Site (1990) and was recently

Mill Name	Asselstine Woollen Mill
Settlement	Upper Canada
Built	1828
Current Use	Museum
Original Use	Textile Mill
Interior	Museum Hours
Exterior Access	Museum Hours
Artifacts	Operational
Photography	Moderate
Setting	Pioneer Village
Latitude	44.94524
Longitude	75.07036

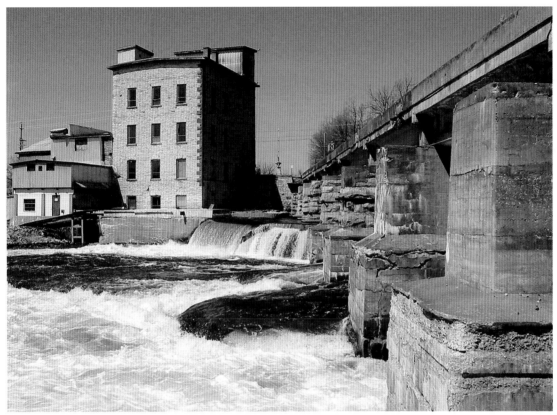

Maple Leaf Mill

restored into a beautiful condominium complex known as "Millfall." The condominium and grounds are private property, though the building can easily be viewed from the roadside or museum parking lot.

Walk south along Mary St. for two blocks to Almonte St. (County Rd 49) and turn right. A bridge takes you over one of the two waterfalls that provided the power for early industry in the town. Waterpower at one falls is still used to generate 2.4 megawatts at the historic Almonte Hydroelectric Generating station, built in 1925 and visible high above the right bank of the river.

After crossing the bridge, turn left on to Almonte's historic main street, fittingly known as "Mill St." To your left is the Victoria Woollen Mill, also once known as the Rosamond No. 2 mill. This building was constructed in 1863 by James Rosamond as an addition to an earlier mill erected in 1857. The mill later received an addition of its own, as evidenced by the different colour stone used for the upper two floors. Shortly after the larger Rosamond Mill had been constructed, the Victoria Woollen Mill was sold and continued to operate under different owners as a woollen mill for many decades. Today, the mill is occupied by a number of businesses, including a restaurant and antique store, each with a brilliant view of the waterfall. Partially hidden beneath a viewing platform beside the waterfall are a few remnant pinion gears and shafts.

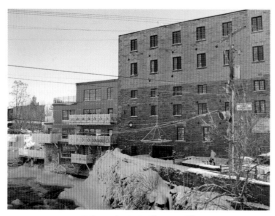

Victoria Woollen Mill

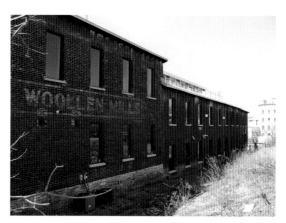

Thoburn Mill

From the Victoria Mill, walk through the parking lot to the gazebo beside the river. Pick up the walking trail along the river's edge, passing the old Mississippi Iron Works, which is now a restaurant. When you reach the railway bridge over the Mississippi, look across to the former Maple Leaf Flourmill. A more modern addition to the original four-storey stone building was being demolished at the time of writing.

Just beyond the railway bridge is Almonte's Town Hall, a magnificent stone building at the corner of Queen St. and Little Bridge St. Turn right onto Little Bridge St. and walk under (you guessed it!) a little bridge to the Thoburn Mill. This red-brick building was constructed by William Thoburn in 1918 to replace his earlier mill that had been destroyed by fire. The mill produced flannels and was still run by water power when it closed in 1956. Water exited the mill via a tailrace at the far end of the building that can be seen from the walking trail. The building has been significantly renovated to house the municipal Chamber of Commerce as well as many other small offices. Return to the museum by walking down Mill St. to Almonte St. and then to Mary St.

Directions

To reach Almonte from Ottawa, follow Hwy 417 to Ottawa-Carleton Rd 49 (March Rd). Exit west and drive 15.5 km west to Almonte. The road becomes known as Almonte St. Cross over the first bridge over the river and watch for Mary St. on the right. Turn right on Mary St. and drive two blocks to the Textile Museum. Be sure to consult the museum's website for operating hours and dates: textilemuseum.mississippimills.com

Rosamond Mill, now a condominium.

Mills at Carleton Place

There are three old mill buildings in Carleton Place, each of which is clearly marked by No Trespassing signs. Though this is somewhat discouraging, all three are easily viewed from the road and their close proximity makes this three-for-one deal a worthwhile trip. First is the Boulton Brown Mill, the oldest part of which was built by Hugh Boulton in 1869. Horace Brown took over the mill in 1870 and shortly after installed the first roller mill in Carleton Place, which he operated until 1929. After a fire in 1970, the mill was left for dead until the late 1980s when it started its new life as the Boulton Brown Condominiums. The front of the building is but inches from Mill St., and you can easily examine the fine broken-course ashlar masonry. The grounds are private, but you can obtain a fine view of the other side of the mill, the dam and upper rapids on the Misssissippi River from a parking lot off Bell St. on the far side of the river.

A short walk along Mill St. leads you under a very low railway bridge and to the old McArthur Woollen Mill. Constructed of Beckwith sandstone in 1871 by Archibald McArthur, the building was first used to manufacture worsteds and tweeds. In 1907, it was purchased by a firm called Bates and Innes and was converted to a knitting factory said to have employed about 150 people. Though textile operations ceased in the 1950s, the durability of the building allowed it to be adapted for use by a firm distributing fibre-optic components. Though surrounded by private property, the impressive building and the old millrace are easily visible from Mill St., and also via a short scramble through the woods along Princess St.

Continuing your walk along Mill St., you will reach a bridge over the lower rapids. Just before crossing the bridge, be sure to take a detour down the short nature path along the river's edge. Stay back from the edge though: a memorial plaque tells of a young girl that drowned here in 1992. Across the bridge you can view the old Gillies Machine Works building. This third building was built by John Gillies and Ferdinand Beyer in 1875 to manufacture heavy machinery. Like the McArthur Mill, it was later purchased by Bates and Innes and converted for use as a felt mill. Once again, like its neighbour, the old building now houses a high-technology firm.

Directions

From Ottawa, go west on Hwy 417 to Hwy 7 and continue west to Carleton Place. Turn right on Franktown Rd and follow this main road into town for 2.2 km, during which it becomes Moore St., then Bridge St. Just before crossing the bridge over the Mississippi River, turn right on Mill St. There is limited parking along the right side of the road, right across from the Boulton Brown Mill. The other two mills are no more than a few blocks' walk further northeast along Mill St.

Mill Name	Boulton Brown Mill/ McArthur Mill
Settlement	Carleton Place
Built	1869/1871
Current Use	Private Business
Original Use	Flourmill/ Woollen Mill
Interior	Private
Exterior Access	Roadside Only
Artifacts	None
Photography	Moderate/Good
Setting	Urban
Latitude	45.14383
Longitude	-76.14332

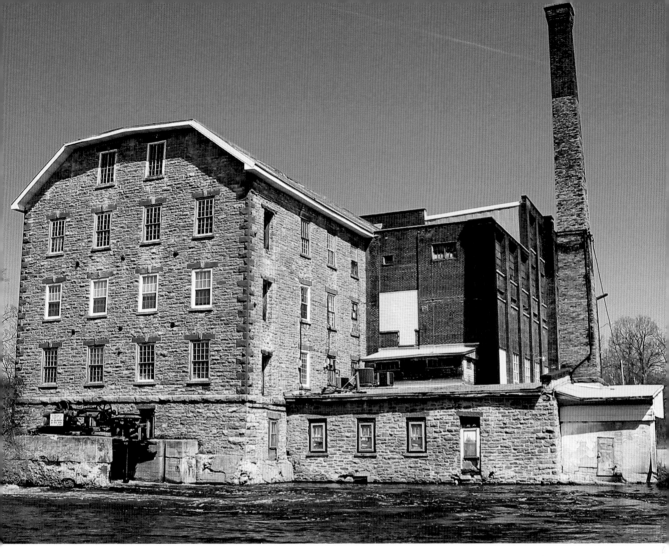

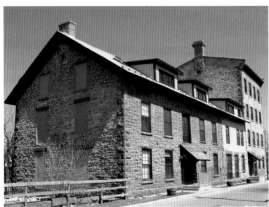

Boulton Brown Mill

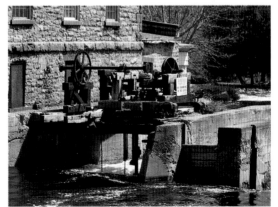

McArthur Mill (top and right)

Spencerville Mill

Unlike the dim, cramped conditions of many of Ontario's heritage mills, the main floor of the Spencerville Mill is refreshingly spacious, tidy and bright. Oh, and by the way, the date here is 1934, not a year earlier nor a year later! If the plans of the Spencerville Mill Foundation progress as intended, the visitor will have a fairly unique opportunity to step back in time to this one particular year in the history of milling in the province. And unlike most other mill restoration projects, there is no millstone at Spencerville. They're actually quite proud of their rollers, thank you very much!

The Foundation has recently conducted major work to restore the structure and rebuild its dam. In 2005, through a grant from the Ontario Trillium Foundation, the group greatly increased the tourism potential of the mill by adding visitor washrooms and a wheelchair access ramp. The group hopes to once again develop power with the recently restored and re-installed 1934 Barber turbine. Power will be used to run some of the machinery, including some of the bucket elevators and the single roller mill. Plans also exist to redevelop the upper floor, an even more spacious, bright room with a high ceiling that would be perfect as an art gallery or meeting hall.

At the time of writing, visitors were only permitted to access the ground floor of the mill. Fortunately, restoration and interpretation efforts to date have focused almost entirely on this level. At the far end of the main floor, behind the bucket elevators and grain chutes, are three large machines, prominently displayed towards the back wall. At left is an 18-inch plate grinder, installed in 1935 and used to grind grain for animal feed. In the centre is a single roller mill, installed in 1905 and used for crushing oats. Furthest to the right is a double roller mill, also installed in 1905 and used for flour milling. As an interesting side project, the Foundation is developing a replica of an old general store, housed in the stone addition on the east end of the mill and accessible through the main building.

This beautiful building was constructed in 1864 by Robert Fairbairn. Fire consumed the mill in 1884, but Fairbairn's son David was able to rebuild using the existing stone exterior. In 1912 the mill was purchased by J.F. Barnard, who soon produced the first registered livestock feed in the country, sold as "Grow or Bust." The mill continued to operate, primarily as a feedmill, until it was closed by Barnard's grandson in 1972.

Mill Name	Spencerville Mill
Settlement	Spencerville
Built	1864
Current Use	Museum
Original Use	Gristmill
Interior	Museum Hours
Exterior Access	Museum Hours
Artifacts	Lots
Photography	Excellent
Setting	Park
Latitude	44.84211
Longitude	75.54500

Directions

From Ottawa or Hwy 401, follow Hwy 416 to Leeds and Grenville Rd 21. Exit at Rd 21 and turn left (west). Drive for about 0.7 km to Leeds and Grenville Rd 44 and turn right. Drive for about 0.4 km and turn left at Water St., the first street after the bridge over the South Nation River. Park in the gravel lot in front of the mill. To find out when the mill is open to the public, visit the Foundation's website at spencervillemill. com. Be sure to bring a picnic lunch, as there are a number of tables in the small but pleasant grassy parkette surrounding the mill.

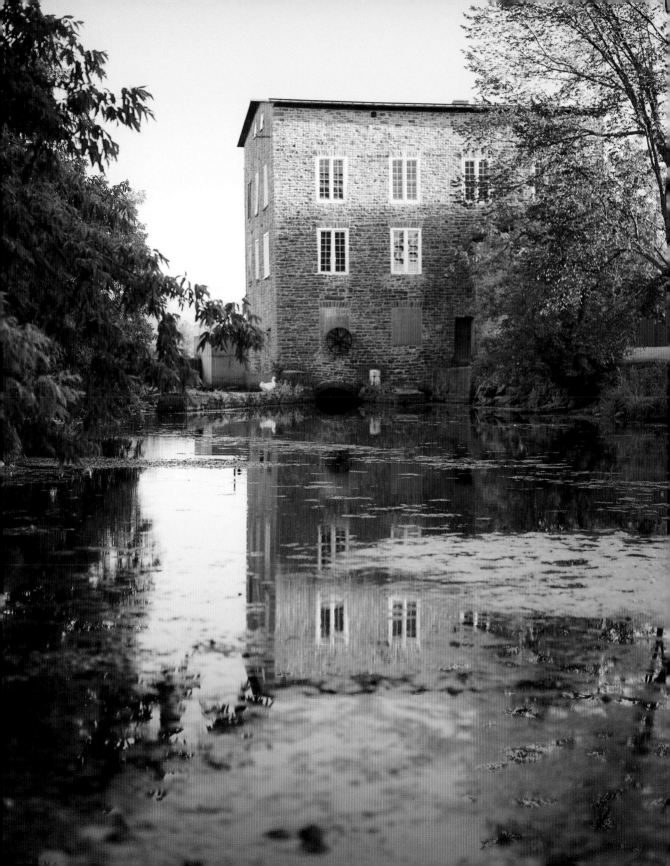

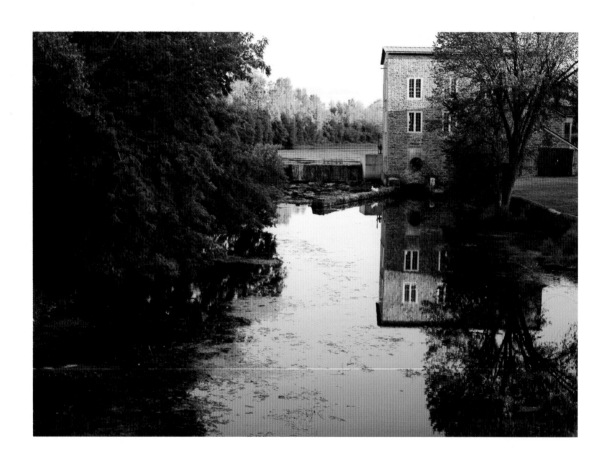

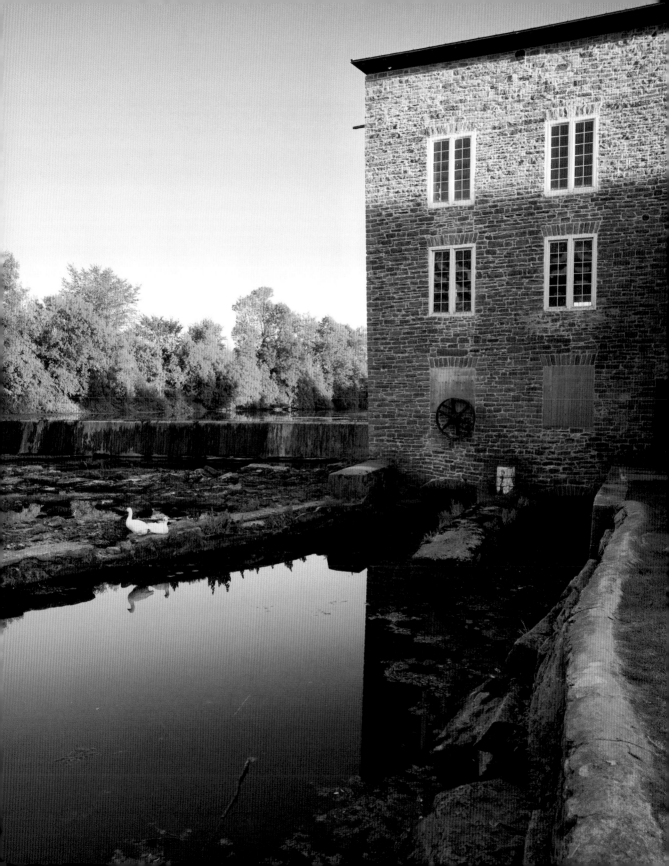

Watson's Mill

Watson's Mill easily ranks as one of the best-preserved and most elegant operational gristmills in Ontario. With one of the strongest community support groups around, the mill is kept in tip-top shape outside and in. Throw in a picturesque setting, a connection to our first Prime Minister, and a good old-fashioned ghost story and you have without a doubt one of the pre-eminent mill destinations in the province.

Originally named Long Island Gristmill, the building was constructed in 1860 by Moss Kent Dickinson and Joseph Currier, two prominent entrepreneurs who each had considerable influence on development in the Rideau Valley. The two men took a few extra steps to ensure that the mill would be a showpiece of the milling community. Rather than using the typical chamfered posts on the first floor, the builders used more ornate rounded columns, each topped with a decorative capital. The high ceilings, tall baseboards and plastered walls seem more fitting for an upper-class home than for a place of industry.

One of the most-recounted stories of the mill surrounds Currier's wife, Ann Crosby Currier. Only a year after the mill was constructed, and less than a month after their marriage, Ann was killed when her dress became tangled in the mill's machinery and she was hurled against a pillar. To this day, the occasional bump, clang or mysterious footstep is attributed to Ann's ghost. Upon Ann's death, Currier sold his portion of the mill to Dickinson. Currier went on to become a Member of Parliament and later built the house that would become the Prime Minister's residence at 24 Sussex Drive in Ottawa.

Dickinson also became a Member of Parliament (1882), but not before a stint as Mayor of Ottawa (1864). He became good friends with Sir John A. Macdonald, and visitors to the mill can delight in seeing the chair once used by our first Prime Minister. Though Dickinson died in 1897, the mill remained the hands of his family until it was sold to Aleck Spratt in 1929. Spratt's family in turn sold the mill to Harry Watson in 1946, who quickly renamed the mill after himself. In 1972, the mill was purchased by the Rideau Valley Conservation Authority and is now operated by a group of volunteers known as Watson's Mill Manotick Inc.

The mill used four 40-horsepower turbines (all cast at Currier's foundry in Ottawa) to power four run of stone, while a fifth turbine powered the bucket elevators and conveyors. A sixth turbine was installed to transfer power using a 3-inch steel cable to a bung mill once located on the far side of the river. Five turbines can still be viewed in the basement level, a dimly lit, yet not-to-be-missed level of the mill where protective screens separate the visitor from moving belts and pulleys. Only two of the turbines are currently in use today, each operated by hand using control wheels clearly visible on the first floor. Remarkably, all of the water used to power the turbines exited the mill via one tailrace arch, visible at water's edge on the north side of the mill.

Mill Name	Watson's Mill
Settlement	Manotick
Built	1860
Current Use	Museum
Original Use	Flourmill
Interior	Museum Hours
Exterior Access	Anytime
Artifacts	Operational
Photography	Excellent
Setting	Suburban
Latitude	45.22703
Longitude	75.68295

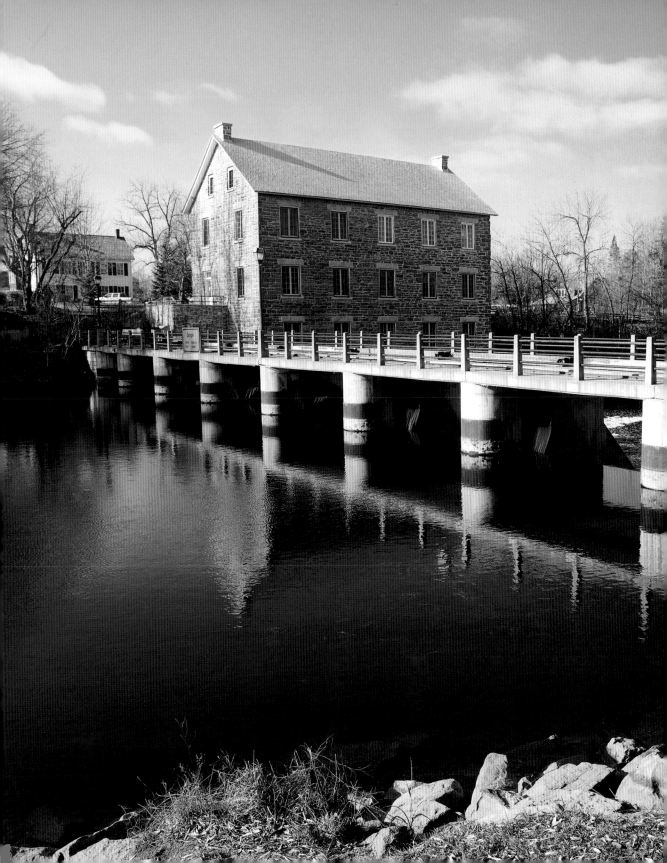

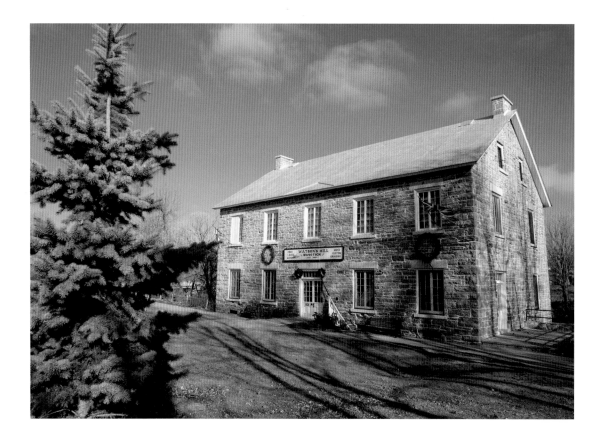

Power from the turbines can still be used to drive two run of stone, and volunteers still grind wheat on a semi-regular basis through the summer. The turbines also power the operational bucket elevators visible on each floor. A small bolter on the second floor is operational, though it is not one of the four that was originally used at the mill. The remains of a hopper boy are located on the third floor. When the mill was used to prepare feeds in the twentieth century, feed sacks were filled using the bagging cone still suspended from the ceiling on the second floor. A wooden chute visible on the second floor (and first floor ceiling) allowed the sacks to be slid down for pick up beside the front door.

Directions

The mill is open throughout the summer and on select special occasions throughout the year. A self-guided brochure and informative displays provide an excellent overview of the history and technology of the mill. At the time of writing, grinding was conducted every second Sunday of the month. From Ottawa, follow Hwy 416 south 18 km to Ottawa Rd 8 (Bankfield Rd). Turn left and drive east for 4.5 km to Ottawa Rd 13 (Rideau Valley Dr). Turn right, proceed a few blocks to Ottawa Rd 8 (Bridge St.) and turn left. Turn right at the first road (Dickinson St.) and proceed to the parking lot on the left, in front of the mill. Information on the season and hours of operation and about special events at the mill is available at watsonsmill.com.

Other Mills: Eastern Ontario

Mills along the Tay River

In addition to Code's Mill at Perth, a number of other old mills are found along the Tay River. Though each is private and not open to visitors, together they combine for a nice short driving tour or canoe trip. The closest and most impressive is Adam's Mill at Glen Tay. This large stone gristmill was built by Abraham Parsall sometime between 1810 and 1820. Between 1896 and 1922, electricity generated at the mill provided power for Perth. The view from the road is fair, being partly hidden by vegetation.

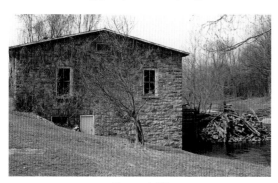

Bowes Mill

One concession road to the west is Bowes Mill, a little stone building that is less spectacular than Adam's Mill, yet much easier to view. At one point, hydroelectricity for Perth was also generated at this mill. A millpond that once built head for the mill is now just a green meadow behind the mill, and all that is left of the former milldam are a pile of stones on either side of the river.

The ruins of Adam's wooden sawmill are located another concession further west but are visible only by canoe. A short distance to the southeast is Allan's Mill on a tributary to the Tay known as Grant's Creek. Easily visible from the road, this stone mill has recently been renovated into a private residence.

Old Killaloe Mill

The mill is believed to have been built by Joshua Hazelton in 1876 and was originally used as a flour and planing mill. Today it is used as a private residence, and also contains a micro-hydroelectric facility rated at 50 kW. It is a favourite of painters and was reportedly painted by A.Y. Jackson of the Group of Seven. See the photograph on page 119.

Watchorn Mill Ruins

The ruins of this stone woollen mill at Merrickville date to 1850. Built by Stephen Merrick, the mill was purchased in 1885 by Robert and Thomas Watchorn. The latter was a former employee at the Rosamond Mills in Almonte. The mill closed in 1954. Parts of the ruins, three storeys high in places, can be explored. A touristy village with lots of heritage buildings, Merrickville is 20 km east of Smiths Falls on Lanark Rd 43.

Wood's Mill

Located at 34 Beckwith St. South, right in the heart of Smiths Falls, this large stone mill complex was built by Alexander Wood in 1887 on a site occupied by several

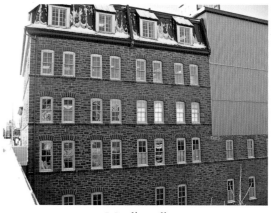

Wood's Mill

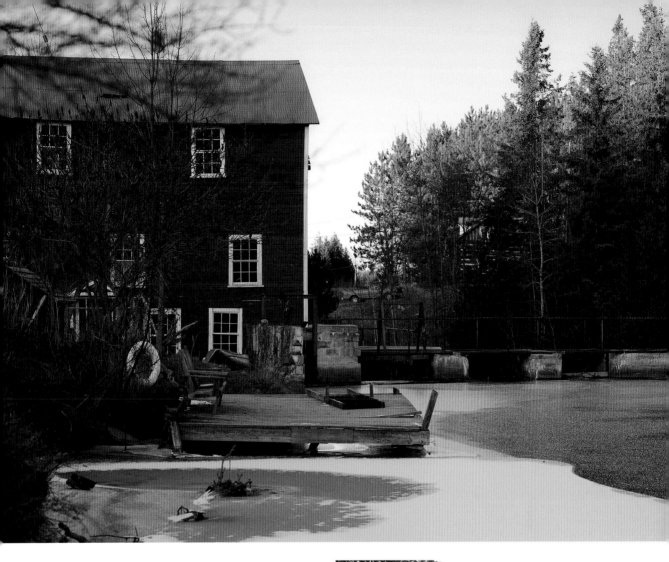

previous mills. At one time, the mill could pack up to 200 barrels of flour per day. The large complex now houses the Rideau Canal Museum, which features four levels of informative and interactive exhibits about the history and environment of the Rideau Canal. The exterior of the building features wonderful ashlar masonry and a rare mansard roof. More information on the museum is available at rideau-info.com/museum.

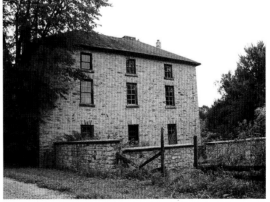

Allan's Mill

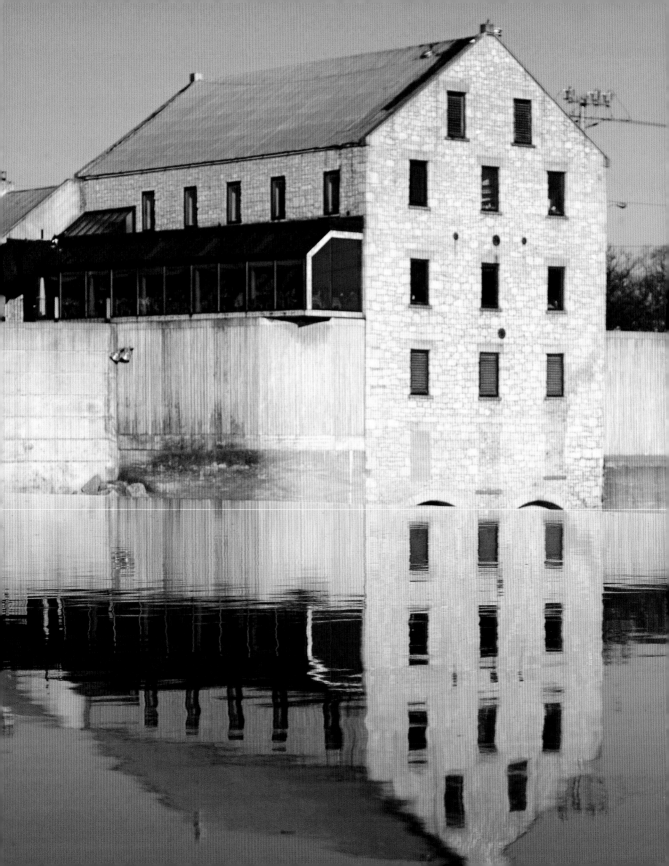

GRAND
RIVER
REGION

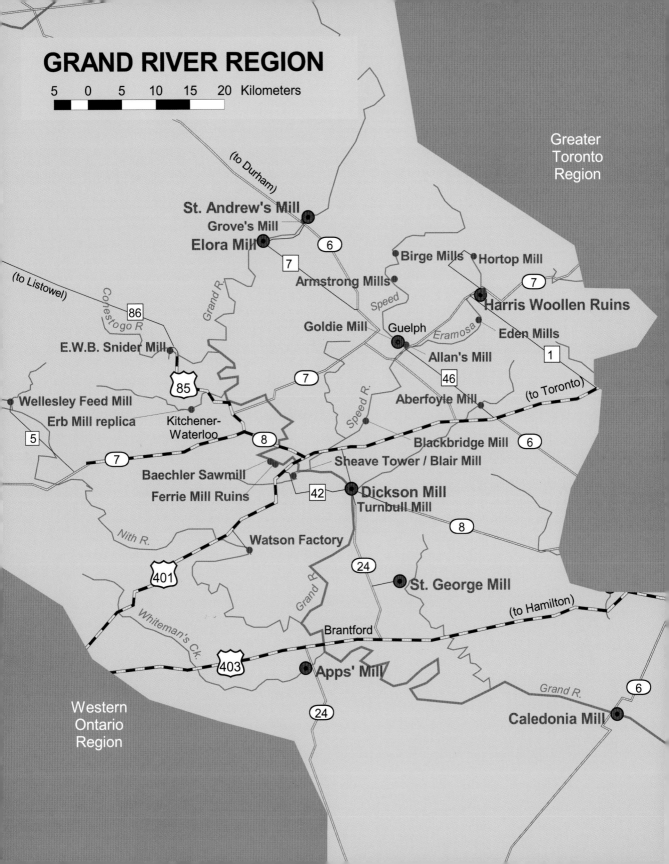

GRAND RIVER REGION

5 0 5 10 15 20 Kilometers

Greater
Toronto
Region

(to Durham)

St. Andrew's Mill
Grove's Mill
Elora Mill

6

7

Birge Mills Hortop Mill

7

Armstrong Mills

Speed

Harris Woollen Ruins

(to Listowel)

Conestogo R.

Grand R.

86

Goldie Mill

Guelph

Eramosa

Eden Mills

E.W.B. Snider Mill

Allan's Mill

1

85

7

46

Wellesley Feed Mill

Aberfoyle Mill

(to Toronto)

Erb Mill replica

Speed R.

Kitchener-
Waterloo

5

8

Blackbridge Mill

6

7

Baechler Sawmill

Sheave Tower / Blair Mill

Ferrie Mill Ruins

42

Dickson Mill

Turnbull Mill

8

Nith R.

Watson Factory

401

24

St. George Mill

Grand R.

Whiteman's Ck.

(to Hamilton)

Brantford

Grand R.

6

403

Apps' Mill

24

Caledonia Mill

Western
Ontario
Region

Apps Mill

Apps Mill has recently been closed to the public due to an infestation by powder post beetles. These little monsters are so named because their larvae, while no more than 2 mm long, can turn wood posts into a fine dust almost like flour. An ironic fate for an old gristmill, yes, but the process has advanced so far that the mill has been declared structurally unsound. Still, the mill site is a nice destination for a weekend walk, as a number of short trails wander into the forest away from the mill. One trail starting behind the building follows the top of the earthen berm that once defined the millpond. It then passes over a concrete-lined overflow channel, and eventually winds up at the banks of Whiteman's Creek, about 200 m distant.

An early settler named Fraser built the mill in 1841. It was purchased by William and Charles Apps in 1856 and was operated by the Apps family until 1954, when flooding by Hurricane Hazel washed away part of the dam directing water to the mill. Following the flood, Whiteman's Creek assumed a new route, leaving the mill all but high and dry. The building sat derelict until being purchased by the Grand River Conservation Authority in 1970 and subsequently incorporated into a 100-hectare conservation area. The Conservation Authority brought milling equipment here from the Caledonia Mill for display in 1980. With the future of the Caledonia Mill now looking a little brighter, some of this equipment was returned in 1998.

The exterior of the mill is now sheathed by attractive cedar shingles, though the original (or at least earlier) red horizontal boards peek through in places and still form the exterior along the covered loading dock. On the far side of the mill, the headrace is now nothing more than a barely wet, overgrown ditch. A concrete box culvert hides the point where water would have entered the mill. In the early years, power was obtained by means of an internal undershot wheel, which was replaced by three turbines sometime around the 1920s. The tailrace is easily spotted at the front of the mill, an runs parallel to Robinson Rd before joining Whiteman's Creek just upstream from the road bridge.

Directions

Follow Hwy 403 to Hwy 24 (Rest Acres Rd), about 8 km west of Brantford. Exit and turn south. Drive about 3 km south to Robinson Rd and turn right. The mill is located in the woods, about 1 km along Robinson Rd, a few hundred metres past the Apps Mill Nature Centre. The Nature Centre serves as an educational centre for local schoolchildren as well as a starting point for more trails criss-crossing the wooded property. One trail leads to a footbridge over Whiteman's Creek, which is well known for Brown and Rainbow Trout.

Mill Name	**Apps Mill**
Settlement	**Brantford**
Built	**1841**
Current Use	**Undetermined**
Original Use	**Gristmill**
Interior	**Undetermined**
Exterior Access	**Anytime**
Artifacts	**Lots**
Photography	**Excellent**
Setting	**Wilderness**
Latitude	**43.13288**
Longitude	**80.37690**

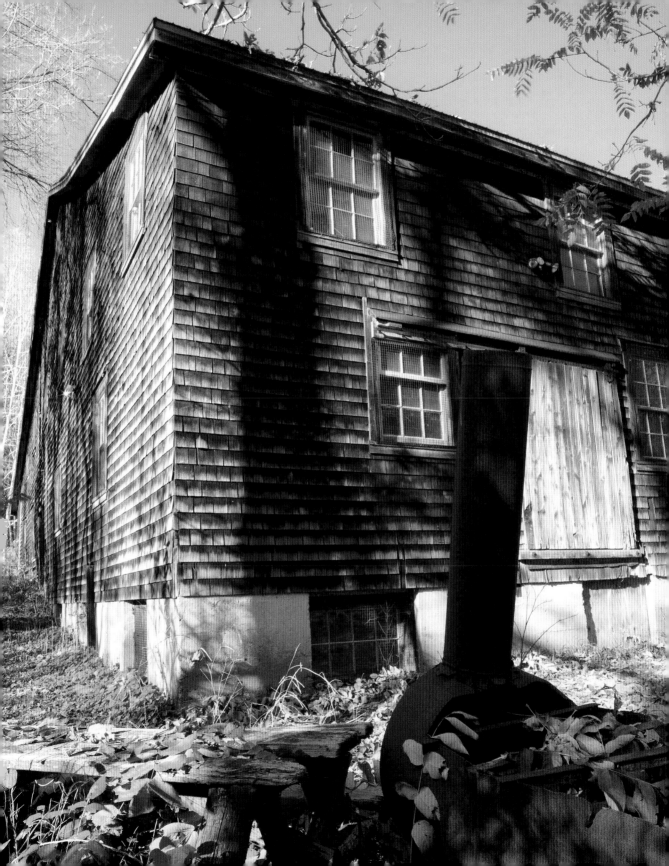

Caledonia Mill

With a growing population and a modernizing business base, much has changed in the community of Caledonia. Through it all, though, the old mill on the Grand River has remained a familiar yet relatively quiet landmark. Though the mill is currently closed to the public, there are big plans for returning the 150-year-old relic to its former role as a bustling centre for the community.

The mill is now maintained by the Caledonia Old Mill Corporation, a non-profit organization formed to preserve the mill and promote the arts. The Millfest Summer Concert series is held each summer, attracting a variety of musical acts who perform for fans from the old loading-dock-turned-stage. But the Corporation has even bigger plans for the building, including restoration of the ground floor as a museum and perhaps conversion of the third and fourth floors to a small theatre. Renovations depend on funding, which is the biggest challenge in every mill restoration.

This flourmill opened in 1857 as the Balmoral Mill. Built by James Little, the name was changed to the Grand River Mill in 1873, and then to the Caledonia Milling Company in 1892. In the early days, power was obtained from an undershot wheel, the foundations for which can still be seen just beneath the surface of the river. Though well-suited to the swift, constant flow of the river at this point, the wheel was later replaced by two turbines still present in the basement. The millrace that brought water to the mill still exists but today appears as a deep, overgrown ditch separating Forfar St. from the river.

The interior of the mill houses an assortment of milling equipment in varying condition. Some of the equipment that had earlier been transferred for display at Apps Mill (see entry) was returned to the mill in 1998. Bucket elevators still connect the ground floor to the fourth, and each floor holds a gem or two, including old rollers, grinders and bolting machines. Perched on the top of the mill, a small cupola draws light into the uppermost floor, once helping to illuminate the complex line-shafting at the apex of the roof. Visible beside the cupola are the vents for two cyclone dust collectors, cone-shaped metal vats installed in later years to draw air (and flammable dust) to the top of the mill for venting to the exterior.

Directions

From Hamilton, follow Hwy 403 up the mountain to Lincoln Alexander Parkway. Go east on the Parkway for 5 km to Upper James St. and exit south. Upper James St. becomes Hwy 6: follow this route for about 17 km to Caledonia. Where Hwy 6 bends to the right, stay straight on Argyle St. to enter the town. Immediately after crossing the bridge over the Grand River (the only 9-span bowstring bridge in Canada), turn right on to Forfar St. and drive 500 m to the mill. At the time of writing, the interior of the mill was not open to visitors on a regular basis, but check for updates at caledoniamill.ca.

Mill Name	**Caledonia Mill**
Settlement	**Caledonia**
Built	**1857**
Current Use	**Undetermined**
Original Use	**Flourmill**
Interior	**Undetermined**
Exterior Access	**Anytime**
Artifacts	**Operational**
Photography	**Good**
Setting	**Suburban**
Latitude	**43.07306**
Longitude	**79.96305**

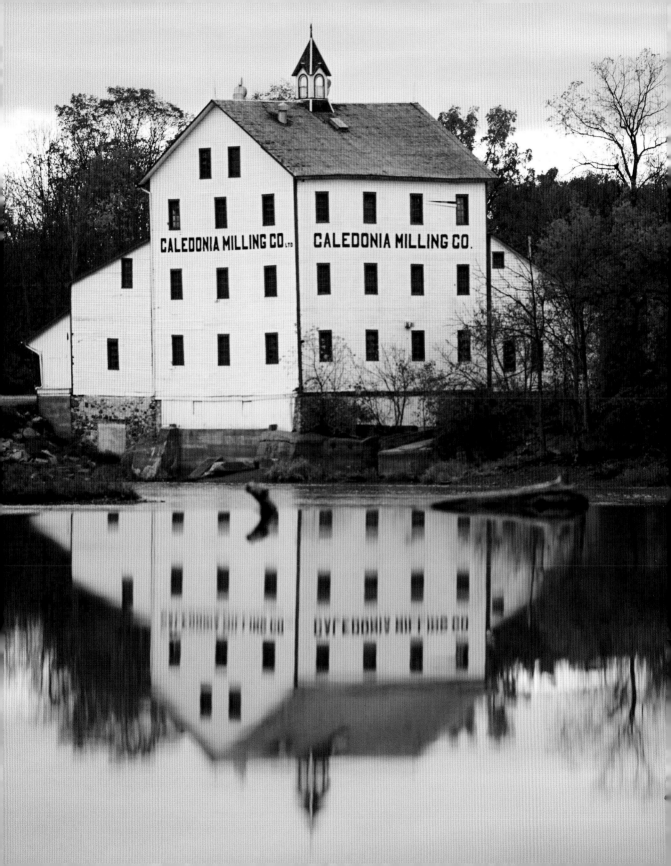

Dickson Mill

Perched high above a bedrock spillway that bypasses a low concrete dam across the Grand River, the Dickson Mill now houses a steakhouse, known at the time of writing as the Riverbank Mill. While some minor modifications to the exterior of the building have been made, the original stonework is intact, and the building is still quite impressive, especially when viewed from the Park Hill Rd bridge.

The view from inside the dining room is equally impressive, as the large windows provide a scenic view of the river and many of the fine old stone buildings in Galt's downtown core. All of the original stone walls and original posts are exposed throughout the mill. The restaurant occupies three floors, and patrons are welcome to explore each. Unfortunately, most of the remaining mill gears were buried by mud in the basement following a large flood on the Grand River in 1975. The current owner of the mill is quite enthusiastic about the building and always ready to chat with patrons about the mill's history and construction.

Robert Dickson built this gristmill in 1843. Shortly after it was built, the mill had to be rebuilt due to damage by a major fire. In 1899, the milling equipment was removed and the building retooled to generate electricity, operating as the Galt Light and Gas Company and providing power for streetlights in Galt. When cheap electricity from Niagara became available at Galt, the power station was closed. Starting in 1936, and lasting until the early 1970s, the building was used by several owners for auto supply or repair shops. Restoration of the building began in 1978, and it soon after housed several different restaurant ventures. Sunday brunch is an excellent opportunity to explore the three floors of the building. Hours of operation and a menu are available at riverbankmill.com.

The Dickson Mill is but one example of the rich milling history of Galt, which now forms the core of Cambridge. Just across the street from the Dickson Mill are the ruins of the Turnbull Knitting Mill, briefly described at the end of this chapter. A few blocks further south is the old Galt Woollens Factory (1843) at 36-38 Water St. The tailrace arch can still be seen at the river side of the building. Immediately across the river is the Riverside Silk Mill. Built in 1922, the three-storey brick mill has recently undergone extensive renovations and is now the home for the School of Architecture of the University of Waterloo.

Directions

Follow Hwy 401 to Cambridge and exit south at Waterloo Rd 24 (Hespeler Rd). Drive south for about 7 km to Galt (the historic heart of Cambridge), where the road becomes a one-way street called Water St. Several blocks south on Water St., watch for the mill, or the sign for the Riverbank Steakhouse. Parking is available on Water St., or if you are going to eat at the restaurant, in a lot surrounding the mill building.

Mill Name	Dickson Mill
Settlement	Cambridge
Built	1843
Current Use	Restaurant
Original Use	Gristmill
Interior	Patrons Only
Exterior Access	Anytime
Artifacts	Some
Photography	Good
Setting	Urban
Latitude	43.36266
Longitude	80.31597

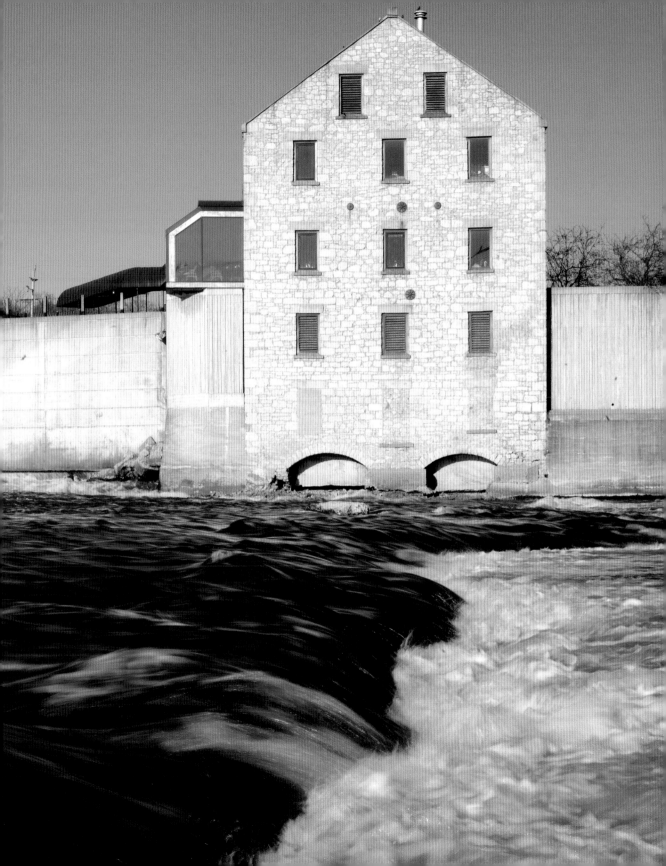

Elora Mill

Forming the historic nucleus of the picturesque, bustling village of Elora is the old mill at the end of Mill St. Old stone buildings, a beautiful waterfall and an eclectic community atmosphere have made this fascinating landscape a favourite of day-trippers for more than a hundred years. And above it all — literally — stands the Elora Mill. At six storeys in height and with metre-and-a-half-thick stone walls, this is one of the largest heritage mills in Ontario, towering above both the adjacent waterfall and streetscape.

Charles Allen built the first mill on this site by 1850. The building was later sold to J.M. Fraser, but then burned in 1859. Fraser quickly built a newer, larger building, probably using dolostone blocks from the nearby gorge walls. The mill passed through several owners before being purchased by Norman Drimmie in 1944. He operated feed and lumber businesses until 1974 (the mill is occasionally referred to as "Drimmie's Mill"). Eventually the mill was transformed from an industrial workhorse to an elegant, famous inn.

The Elora Mill Inn combines upscale accommodations and dining with a rich cultural and natural landscape. There may be no mill better suited for a weekend getaway in all of Ontario. Though extensive renovations have occurred, most of the exterior and much of the interior have been preserved. This includes the Gorge Dining Room, where the thick stone walls of the mill are exposed, and the Penstock Lounge, where the large-diameter steel penstock has been tastefully incorporated into the bar. A door from the lounge leads to a balcony offering a precarious yet spectacular view of the falls and gorge. In addition to its aesthetic use, the penstock now delivers water from the pond above the mill to a small hydroelectric plant at its base: evidence that while times have changed, the old mill still gets its energy from the river.

The attractiveness of the mill is clearly enhanced by its natural surroundings. Foremost is a lovely ramp waterfall licking at the foundations of the mill. Splitting the falls in two, just metres from the mill, is the infamous Tooth of Time. Legend states that the founder of Elora, William Gilkison (1777-1833), planned to build a bridge to ford the river using the Tooth as a natural pillar. Fortunately, a bridge was never constructed, and apart from a concrete suit of armour to reduce erosion, the Tooth stands defiant against the force of the Grand River. Trails lead for several kilometres along both sides of the Grand River, connecting at bridges 1.5 and 3 km downstream (part of the trails are on Conservation Area property). You can descend to the rocky river bed of nearby Irvine Creek or follow stairs through a "hole-in-the-wall" along the south side of the river. Even the parking lot has something to offer, with abundant fossils to be found in the bedrock wall behind the row of parked cars.

Mill Name	**Elora Mill**
Settlement	**Elora**
Built	**c.1860**
Current Use	**Inn**
Original Use	**Gristmill**
Interior	**Patrons Only**
Exterior Access	**Anytime**
Artifacts	**Some**
Photography	**Excellent**
Setting	**Urban**
Latitude	**43.68072**
Longitude	**80.43086**

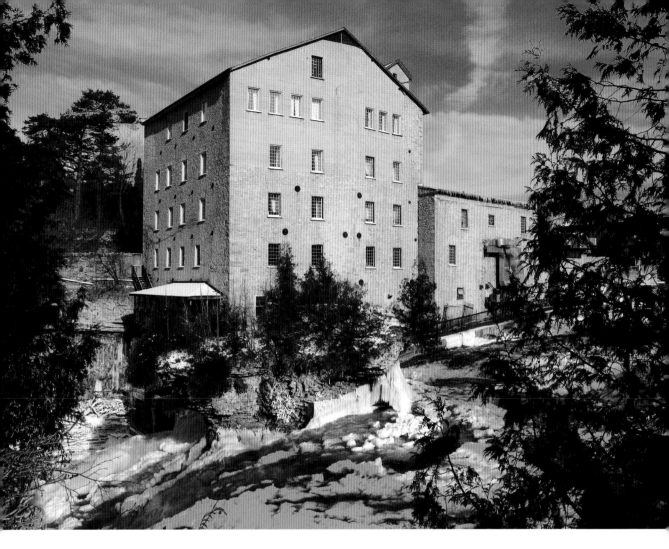

Directions

Follow Hwy 401 to Hwy 6 and drive north to Guelph. Hwy 6 bends right and follows Woodlawn Rd for a few kilometres before turning left and continuing north. Four kilometres out of the city, turn left on Wellington Rd and drive 14 km to Elora. Turn right at the stoplight at McNab St., which soon becomes Metcalfe St. Before crossing the bridge over the river, turn left and park in the municipal lot. A short walk over the Metacalfe St. bridge leads to Mill St. and the mill.

If you are interested in visiting the interior of the mill, why not make reservations for dinner or for High Tea?

This is a private business, but you can easily enjoy the mill from the exterior via a stroll down historic Mill St. or from the south side of the Grand River. More information about the mill and its business is available at eloramill.com.

On the south side of the river, be sure to look for the old stone-lined millrace and wheel pit at the water's edge, just upstream from the waterfall. The remains of another old factory building are located in the woods further downstream. Use caution here. While the trails are heavily travelled, there are steep cliffs and the rocks can be slippery.

Goldie Mill

Unfortunately, many mills burn down at some point in their life. But were the Goldie Mill not destroyed by fire in 1953, the people of Guelph would certainly be missing out on a unique multi-purpose facility. Used for concerts, art shows, a potters' market and other functions, these ruins are proving to be far more versatile than the original mill building might ever have been. The building is rectangular in shape, with walls reaching up to four storeys high. The southern portion of the mill can be explored at any time and consists of a rectangular open-air courtyard enclosed by the remains of the mill's thick stone walls. The northern portion contains a beautiful garden that is not open on a regular basis. Just steps from the mill, at the end of Norwich St., is a historic bridge of iron girders and wooden slats, built in 1882 and now closed to vehicular traffic.

This property is generally believed to be the site of the first sawmill in Guelph, built in 1827. Several other buildings that were added to the property burned in 1864. James Goldie bought the charred remains in 1866, and by 1867 had built a large flourmill using four turbines to power six run of stone. The Goldie family operated the flourmill well into the first part of the twentieth century, reaching outputs in the range of 80,000 barrels per year. The mill was sold in 1918 and later used as a warehouse for a number of years until it was consumed by fire in 1953. A number of government partners restored the mill and opened it as a park in 1984.

Also in Guelph is the Allan's Mill Ruins, located at the east corner of Wellington and MacDonell St. The five-storey flourmill was built in the 1830s by William Allan and at one time operated with seven run of stone. It burned to the ground in 1966, leaving nothing but a portion of the foundations, a turbine, and a large pulley wheel. While the ruins themselves are less than spectacular, they are located along a pleasant path beside the Speed River.

Directions

Exit Hwy 401 at Wellington Rd 46 (Brock Rd, then Gordon St., then Norfolk St.) and drive north for 16 km, passing through downtown Guelph. At London Rd, turn right and drive one block to Cardigan St. and turn right. Drive for one block to the parking area on the left side of the road just before Norwich St. Walk towards the footbridge at the end of Norwich St. and then follow the path to the left. The mill is just a short walk away, hidden behind the Guelph Youth Music Centre at 75 Cardigan St.

Mill Name	Goldie Mill
Settlement	Guelph
Built	1867
Current Use	Ruins
Original Use	Flourmill
Interior	Anytime
Exterior Access	Anytime
Artifacts	None
Photography	Good
Setting	Suburban
Latitude	43.55069
Longitude	80.25383

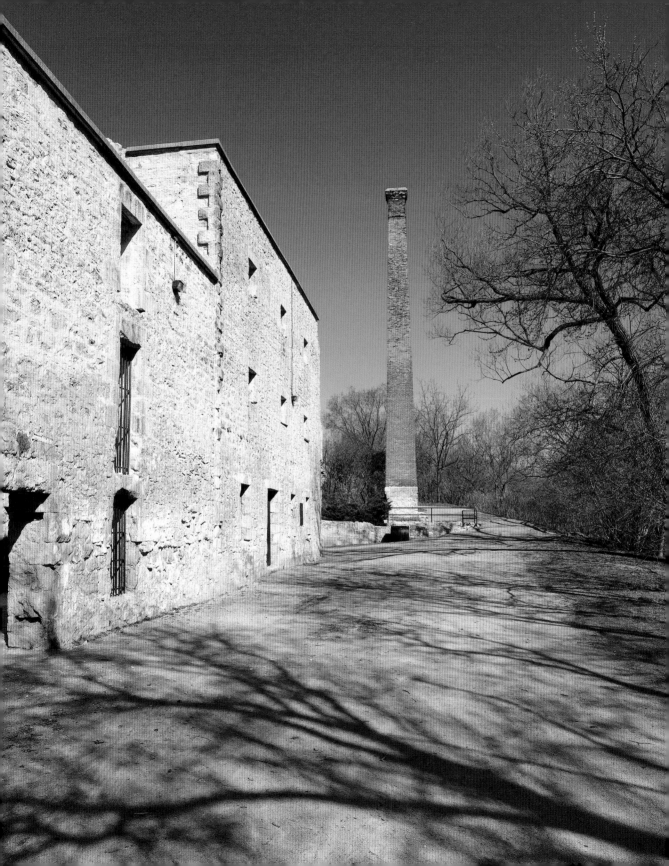

Harris Woollen Mill

The ruins at Rockwood are like an ancient castle in the English countryside that you can explore but still make it home in time for supper. OK, that may be a bit of a stretch, but the old remains and surrounding park are lots of fun. Haunting yet beautiful, the giant stone walls reach three storeys in some places.

The sprawling building is separated into several "rooms," each with walls of varying height and degree of deterioration. The front room encloses a large, grassy lawn that is occasionally used for weddings or other gatherings. A walk to the back room leads to a small wooden footbridge over the stone-lined mill-race running through the base of the mill. A stone inlay on the small tower at the eastern corner of the building proudly proclaims that the business was "Established AD 1867." For a fun challenge, try to follow the millrace from where it catches water from the upper pond, flows through the mill, and eventually drains to the river below the small waterfall.

One of the first settlers in Rockwood was John Harris, who arrived in Ireland about 1820. Harris' three sons founded the Rockwood Woollen Mills in 1867. The original mill burned and was replaced by the existing stone structure in 1884. The mill produced a number of goods, such as tweeds, underwear and bedding, as well as blankets for the Canadian Army during World War I. First powered by the fall of the Eramosa River, the mill was later run by steam, and then finally by electricity for a few years before it closed in 1933.

The building was purchased by the Grand River Conservation Authority in 1959 and represents a cultural centrepiece of the attractive Rockwood Conservation Area. Besides the mill, this 79-hectare park offers just about everything, including vertical dolostone cliffs, a waterfall, walking trails, canoeing, camping, swimming, and even a small cave. A short trail from the parking lot into the woods leads to some remarkable glacial pothole formations. Geologists figure that these giant circular depressions in the bedrock were formed by floods of water flowing beneath the massive glaciers that covered Ontario several times in the past few million years.

Directions

Follow Hwy 401 west from Toronto and exit at Halton Rd 1 (Guelph Line). Go north on Halton Rd 1 for 19 km to Rockwood. Turn right on Alma St. (Hwy 7), and then drive about 0.8 km to Fall St. Turn right, and enter the conservation area. The park is open from May to October and you should be prepared to pay a small admission charge. After going through the gates, turn to the left and follow the road through the forest and down the hill to the gravel parking lot beside the mill. The mill grounds are occasionally used for weddings and family reunions during summer, so you may wish to contact the park first at 519-856-9543.

Mill Name	Harris Woollen Mill
Settlement	Rockwood
Built	1884
Current Use	Ruins
Original Use	Woollen Mill
Interior	Park Hours
Exterior Access	Park Hours
Artifacts	Some
Photography	Good
Setting	Park
Latitude	43.61052
Longitude	80.14437

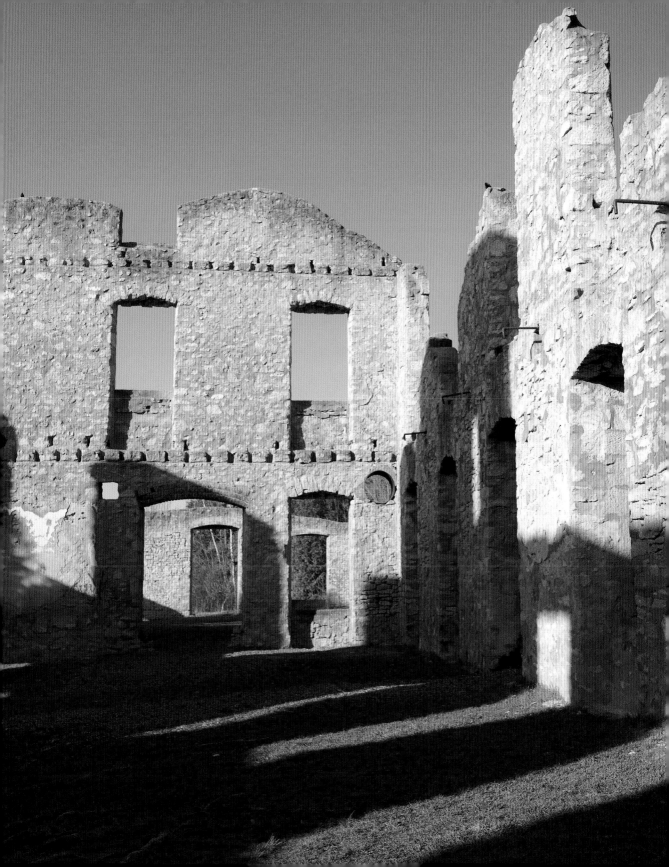

St. Andrews Mill

Have you ever wanted to live in an old mill? Finding an old mill for sale is difficult, and transforming one into a livable home can be a painstaking challenge. Your best bet may be a unit in a development such as the St. Andrews Mill. Renovated in the early 2000s, this historic complex now features 67 upscale condominium units, many of which incorporate some of the original structural components into their design. The mill was built by James Wilson in the 1850s and was known through the years as Wilson's Mill, Walkey's Mill, and Monkland's Mill. Oatmeal from the mill won first prize at an exhibition in Philadelphia in 1876, and was shipped as far away as Scotland.

The mill buildings have been beautifully restored with only tasteful visual modifications to the exterior. During restoration efforts, records show that "wooden grain chutes and 10 tons of driveshafts and cast iron wheels" were removed from the site. While the loss of this equipment may seem like a crime to the mill enthusiast, it was no doubt a necessary price to pay to make the site safe and workable for residential use. A modern turbine installed at the mill in 2003 generates 270 kW of electricity available for local use.

The building and grounds are completely private property, and exploration is off-limits unless you know someone who lives in the mill. Fortunately, a beautiful trail along the forested and rocky south side of the river affords a panoramic view of the two main buildings. The foundations of each building step right into the river, and a dam and bedrock outcrop form a pretty little waterfall, below which fishermen and Blue Herons vie for fish.

Right behind the historic downtown of Fergus, the Grand River flows through a deep, rocky gorge. Though arguably not as pretty as at Elora, it is much more readily accessible as it cuts through the heart of the town. Located on the edge of the gorge is Grove's Mill, which was originally built by Thomas Watson as a tannery. The building was later purchased by Dr. Abraham Grove, who converted it into a flourmill, and then in 1890, to a hydroelectric generating station. Ten years later, he was believed to be the first person to transmit electricity between two Ontario towns when lines were run to Elora. The Grove's Mill Brew House was once Watson's home, but now serves as a great place to enjoy a pint or pub fare after a tour of this historic town.

Mill Name	St. Andrews Mill
Settlement	Fergus
Built	c.1850
Current Use	Private Condominium
Original Use	Gristmill
Interior	Private
Exterior Access	Roadside Only
Artifacts	Unknown
Photography	Moderate
Setting	Suburban
Latitude	43.71111
Longitude	80.37098

Directions

Follow Hwy 401 to Hwy 6 and drive north to Guelph. Follow the signs for Hwy 6 through the city, and then continue north for 19 km to Fergus. Follow Hwy 6 across the St. David St. bridge over the Grand River and turn right on to St. Andrew St. Drive for 1 km to Gartshore/Scotland St., which is just past the mill. Turn right, cross the river, and park in the small gravel lot at Confederation Park. A short walk across a grassy field leads to the path along the river. Retrace your steps to Grove's Mill at the St. David St. bridge.

St. George Mill

The old mill in St. George sits at the bottom of a hill, just inches from the sidewalk along Main St. Though set on ground lower than the diminutive downtown strip, the building is still one of the most prominent landmarks in St. George. The mill is tall and square, and represents one of the finest examples of ashlar masonry. Large, uniformly cut stone blocks give the four-storey building a rock-solid appearance, and unlike many of the province's mills constructed of wood or rubble stone, this building isn't going anywhere soon! The more recent addition of an aluminium roof is slightly out of context, but will no doubt help to preserve the mill for longer still. Solar panels on the roof are, again, a little out of place, yet show the owner returning to the power of the elements to run the building.

The mill was constructed between 1869 and 1871 by William Snowball: his initials are set in a keystone facing Main St. Originally run by water, the mill switched to more reliable steam power in 1885. A free-standing stone wall projecting behind the mill may be evidence that the building was somewhat larger at one time. Sometime later, between about 1967 and 1993, the building housed St. George Feed and Seed.

Signs for that old enterprise still adorn the north and south walls of the building.

A millstone on display in front of the building is one of the only reminders of the mill's grinding past. At the time of writing, the mill was dormant, though it had been recently been fitted with newer textile machinery brought from a site in Quebec. A peek in the large windows facing Main St. revealed a number of textile machines spread between the large chamfered wood posts. Large spools of coarsely wound, rope-like wool "roving" were seen piled on the floor in front of the machinery. There were no definite plans for the building at the time of writing, and the mill was currently not open for touring.

Directions

Follow Hwy 403 west from Hamilton to Brantford. Exit north on to Hwy 24 (King George Rd) and go north for 4 km to Brant Rd 99 (Governors Rd). Turn right and drive 2.5 km to Brant Rd 13 (St. George Rd, becoming Main St.). Turn left and drive for about 4 km to St. George. The mill is on the left side of the road. It is best to turn left on the next street to the north (High St.) and park in the paved municipal parking lot. The parking lot overlooks the mill building, about 50 m to the south. St. George's short downtown strip is but a short walk away and contains a pub and a small number of shops.

Mill Name	Snowball Gristmill
Settlement	St. George
Built	c.1871
Current Use	Private Business
Original Use	Gristmill
Interior	Private
Exterior Access	Roadside Only
Artifacts	Some
Photography	Good
Setting	Urban
Latitude	43.24392
Longitude	80.25241

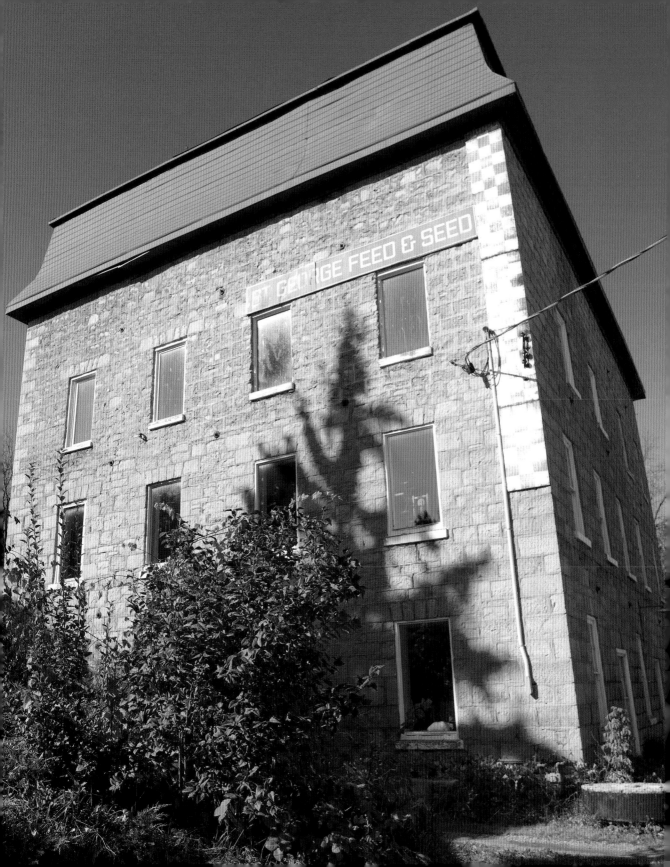

Other Mills: Grand River

Aberfoyle Mill

Located on Brock Rd in the village of Aberfoyle, this two-and-a-half-storey brick gristmill was constructed in 1859 by George McLean. Employing up to four run of stone, the mill produced oatmeal that won a gold medal at a fair in Paris in 1867. It has operated as a restaurant since 1966, offering fine dining, banquets and weddings in a setting rich with Canadian antiques. Some of the original mill equipment is visible in one of the dining rooms. More information is available at aberfoylemill.com

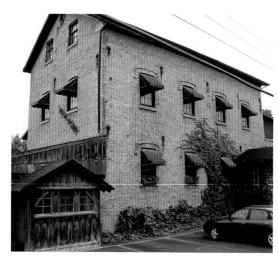

Aberfoyle Mill

Birge Mills

This four-storey gristmill building was built by Alonzo Birge in 1880. It remained in the Birge family until 1941, when it was bought by Carl and Cyler Wheeler. After changing hands several more times and serving as a feedmill until the late 1980s, it was purchased by the present owners in 2001. At the time of writing, the owners were renovating the mill with the intent of one day using it as a private residence.

The original turbine, hurst, plate chopper and floor scale still exist, and will no doubt help to make this a unique home. The mill is not visible from the road and you must not trespass on the property without permission.

E.W.B. Snider Mill

Located in the tourist town of St. Jacob's, this red-brick mill (c. 1851) was the first in Canada to employ steel rollers, which were fully operational in 1881. A sign on the exterior proudly proclaims "Manitoba White Daisy, Blended White Lily and Gold Pastry,": flour products once produced at the mill. In 1981 the mill was extensively renovated into the St. Jacobs Country Mill, selling a wide variety of gifts, artwork, and handicrafts. A few pieces of milling equipment are scattered through the extensive building, which is a neat place to explore. The headrace is believed to be the longest in Ontario. A pleasant gravel trail leads through the woods alongside the millrace, passing under a railway trestle and ending at a small dam beyond the town. The trail is accessible behind the mill by a short walk to the end of Front St.

Hortop Mill

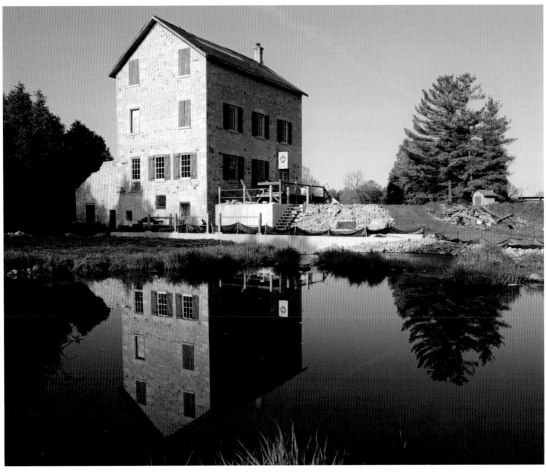

Birge Mill

Hortop Mill

This mill is located just outside the small community of Everton. It was operated by Henry Hortop Jr., whose father built and operated the gristmill at Eden Mills and another at Rockwood. Though fully visible from the road at the time of writing, access was off limits due to unsafe conditions. It's more fun to track down the stone foundations of a ruined mill on the other side of the river. A special treat is the stone millrace arch, still standing, somehow refusing to give up its fight against the elements and vandals.

Exit Hwy 401 at Halton Rd 25. Go north for 27 km, through Acton, to Wellington Rd 124. Turn left and drive 5 km to Wellington Rd 49. Turn left again and drive 1.7 km to the mill and ruins, located across from the reservoir.

Sheave Tower

This neat little structure is located next to the old Blair Corn Mill, built c. 1846. The tower was constructed around 1876 and was restored in 1998 by Heritage Cambridge. A cable suspended above the ground

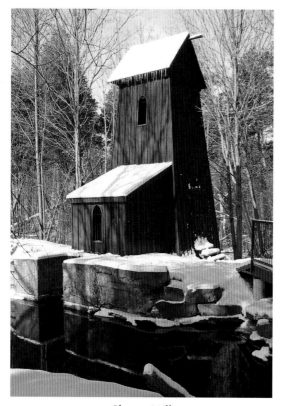

Sheave Mill

Turnbull Knitting Mill. Built shortly after 1897, the building used waterpower until the early 1950s. The old millrace runs through the entire site, forming a deep stone-lined chasm that cuts through the ruins. Some of the original gearing can still be seen in the raceway, though it is now rusting and half hidden by vegetation. An outdoor amphitheatre constructed at the northern edge of the park incorporates the stone remains a wall lining the river's edge. As well as being a popular spot for wedding photography, the amphitheatre serves as the main venue for the Annual Millrace Festival of Traditional Folk Music. (See the photograph on page 143.)

Wellesley Feedmill

The "Big Blue Building" in Wellesley was built in 1856 for use as a flourmill. At the time of writing, the exterior was covered in sky-blue metal sheeting. While it could sure use a coat of paint, the patchy appearance leaves a "love-it-or-hate-it" impression. The interior post-and-beam structure is well preserved, as are selected pieces of milling equipment. Plans are to have the mill restored for use as a community and arts focal point. More information on the restoration and the mill is available at wellesleymill.com

by a 2.5 m diameter iron wheel once transferred an additional 15 hp from a turbine in the base of the tower to the mill, almost 100 m to the south. The tower and short walking trail can be visited anytime, but the Blair Mill is not open to the public. Exit Hwy 401 at Waterloo Rd 17 (Fountain St./Homer Watson Rd) and drive east for 0.7 km to Waterloo Rd 28 (Dickie Settlement Rd). Turn right, and then left on to Old Mill Rd, and proceed 0.4 km to the mill on the left.

Turnbull Knitting Mill Ruins

Just across the street from the Dickson Mill in Cambridge is the Mill Race Ruins, an urban park opened in 1977 and incorporating the ruins the

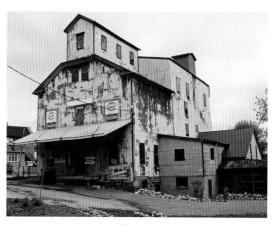

Wellesley Mill

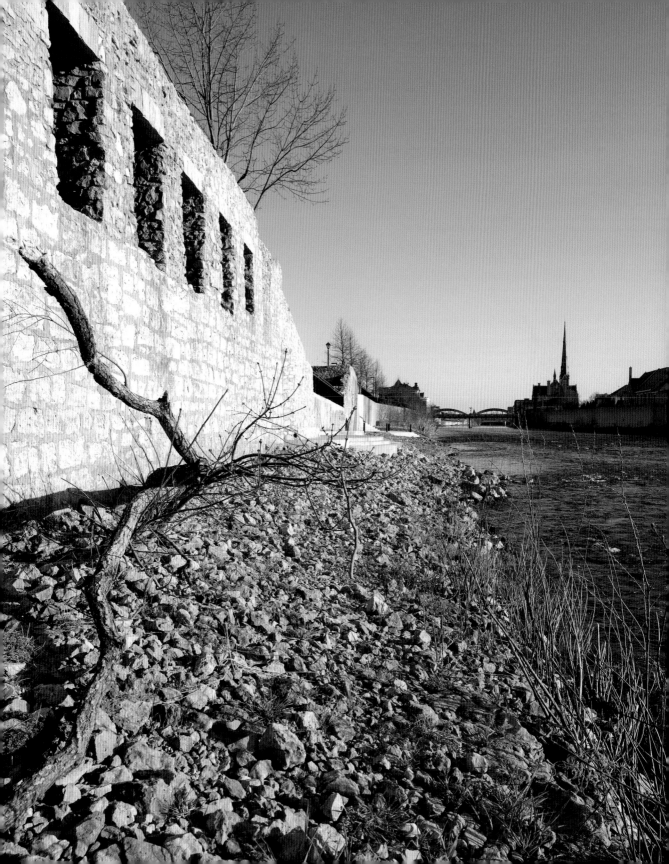

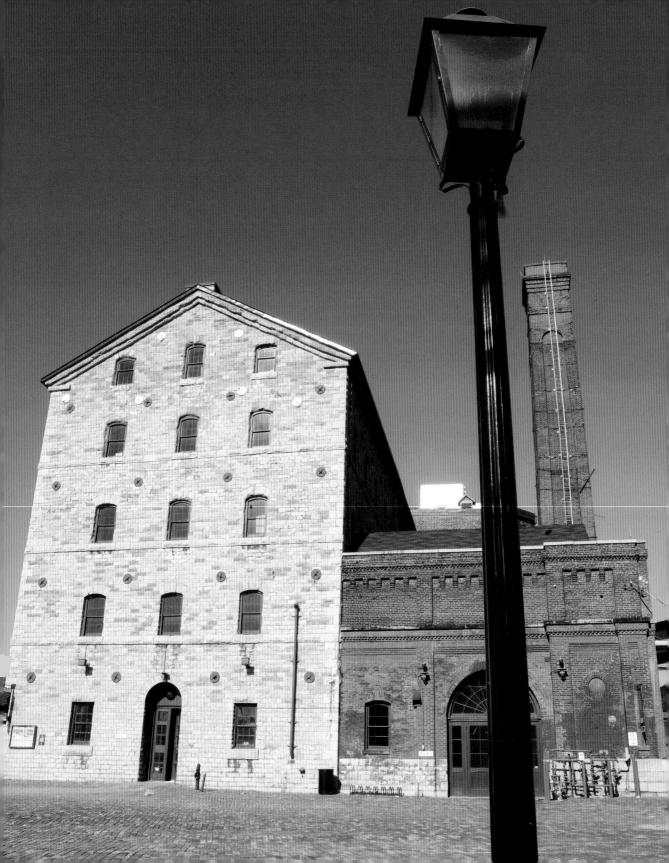

GREATER TORONTO
REGION

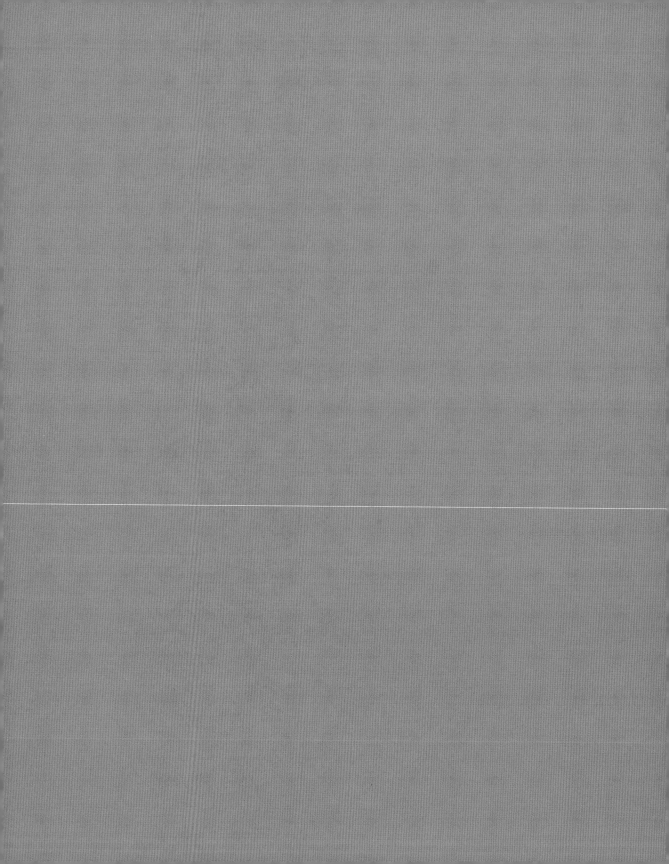

Coldwater Mill

Marchmont Mill

Hillsdale Mill

Coldwater R.

11

Nottawasaga R.

Bell
Gristmill

400

56

Nicolston Gristmill

89

Lindsey Ruins

7

Sutton Mill
Udora Mill

Baldwin
Mill

Scugog R.

Holland R.

Black R.

Uxbridge Br.

404

48

12

Port Perry
Grain Elevator

Schomberg
Feed Mill

9

Tyrone Mill

14

Alton Mill

Cedar Lane Mill

Humber R.

Bruce's Mill

7

Brooklin Flour Mill

Dod's Knitting Mill

Deagle's Mill Ruins

10

Credit R.

Cheltenham Mill
Beaumont Knitting Mill
Williams Mill

Don R.

Rouge R.

401

Roblins Mill

Vanstone Mill
Cream of Barley Mill

7

Barber Mill
Limehouse ruins

Credit R.

Todmorden Mills

Distillery District

Hilton Ruins

16 Mile Ck.

Old Mill at Toronto

GREATER TORONTO REGION

10 0 10 20 30 40 50 Kilometers

Darnley Gristmill

6

Ancaster Old Mill

QEW

Secord Mill

20 Mile Ck.

Ball's Gristmill

Merriton
Cotton Mill /
Lybster Mill

Grand
River
Region

Morningstar Mill

24

Welland Mills

Dean Saw Mill

Ancaster Old Mill

This is great example of how an old mill can be tastefully renovated for a new purpose without ruining its historic charm. Purchased by the Ciancone family in 1972 and opened as the Ancaster Old Mill in 1979, the mill remains the focal point of this well-known and well-respected dining and banquet facility. The mill building is actually the fourth to occupy this prime location. The first, Wilson's Mill, was built about 1791, while the present building was built by Alonzo and Harris Egleston in 1863, when it was known as Ancaster Mountain Mill. The mill originally obtained its power by two waterwheels each about 5.5 m in diameter.

Three storeys in height, the mill's walls are constructed of locally quarried limestone and dolostone, and are over a metre thick at the base. Much of the interior of the building has been renovated, with many stone walls hidden by drywall. Still, the original chamfered posts and ceilings have been preserved and feature prominently throughout the building. The lower floor and third floor have been converted to elegant banquet rooms, while the ground floor houses an entrance foyer and a small but stunning stone-walled bar. A modern, glass-en-closed addition called "The Solarium" is certainly one of the most beautiful dining settings in Ontario. Also on the ground floor is a very small glass-enclosed exhibit room displaying a pair of millstones, hopper, stone crane, and several other nineteenth-century artifacts.

The picturesque creek slicing through the property tumbles over two small waterfalls, one of which licks at the foundations of the mill. Running along-side the creek is the remains of a rusty-red penstock that once delivered water from above the dam down to the mill. The view from the stairs leading to the upper parking lot is splendid. True enthusiasts can dine at the Inn, though you will be seated in the newer building situated high on the bank on the far side of the creek. This, however, affords a fantastic view of the mill, the waterfalls and the old house that was originally the miller's home. Dining is upscale and reservations are required. See ancasteroldmill. com for more details.

Directions

Exit Hwy 403 at Mohawk Rd/Rousseaux Rd in Hamilton. Go west on Mohawk Rd for 1.8 km to Wilson St. and turn right. Drive for 0.8 km down the hill to Montgomery Dr and turn left. Shortly after, turn left on Old Dundas Rd and proceed for 0.5 km to the mill. Mill Falls, beside the mill, is just one of dozens in the city of Hamilton. Sherman Falls is just downstream on Ancaster Creek and can be reached by following Old Dundas Rd back around the bend to the intersection with Lions Club Rd. Though hidden in the woods, it is a very short, easy walk in from the road.

Mill Name	**Ancaster Old Mill**
Settlement	**Ancaster**
Built	**1863**
Current Use	**Restaurant**
Original Use	**Gristmill**
Interior	**Patrons Only**
Exterior Access	**Anytime**
Artifacts	**Some**
Photography	**Good**
Setting	**Suburban**
Latitude	**43.23613**
Longitude	**79.97242**

Ball's Falls Gristmill

Ball's Falls Conservation Area is one of those great places that your entire family can enjoy. Plan to spend the afternoon, for in addition to Ball's historic mill, there are two splendid waterfalls, several kilometres of gravel nature trails, a small pioneer village and picnic grounds. Weekends can be quite busy, with picnickers, weddings and fairs such as the Thanksgiving Festival Craft Show and Sale. A walk through the park on a quieter day is just as rewarding, with plenty of nature, history and recreation for everyone.

In 1807, John and George Ball purchased almost 500 hectares along Twenty Mile Creek for 150 pounds, and by 1809 this gristmill was busily serving the Loyalist immigrants to the area. A few years later, during the War of 1812, the mill was a vital resource in the local war effort. General Brock dispatched an entire company of soldiers to safeguard it against the American raids that proved so devastating to the mills along Lake Erie (see Backus Mill). After the war the mill attracted other early businesses, and enthusiastic residents, hoping that the new community of Glen Elgin would become a regional centre, even prepared plans for a grid of town streets. Unfortunately, the railways stayed below the escarpment, and the community never took off.

Positioned within metres of Ball's Falls, the overgrown remnants of the old headrace are still visible under the little footbridge. A giant overshot wheel nearly 10 m in diameter transferred power to four run of stone, several of which are now on display in front of the mill. A stone addition on the west side of the mill housed a turbine that replaced the wheel sometime in the 1880s. While visitors may be disappointed when the falls run dry in summer, a miller would have been devastated! Ball eventually eliminated the unreliability of the water supply by switching to steam power.

The ruins of a woollen mill also constructed by Ball are a small reward for those willing to make the hike up to Upper Ball's Falls. Built in 1824, this magnificent wooden building was set high above the boulder-strewn creek, reaching five storeys high and capturing power with a 5.5 m diameter overshot wheel. Falling victim to its poor geography sooner than the mill at the lower falls, the building was dismantled in 1883 leaving just the small portion of the stone foundations still visible beside the trail. An arched window in the foundation wall forms the last safe descent to the to the river's edge before the falls.

Directions

Follow the Queen Elizabeth Way to Niagara Rd 24 (Victoria Ave) and drive south for 6 km (watch for signs to the park). Turn left on Sixth Avenue and drive 0.7 km to the large parking lot on the far side of Twenty Mile Creek. There is a small parking fee. The park is open all year, though the mill and other historical buildings are only open from Victoria Day to Labour Day.

Mill Name	Ball's Falls Gristmill
Settlement	Ball's Falls
Built	1809
Current Use	Museum
Original Use	Gristmill
Interior	Museum Hours
Exterior Access	Anytime
Artifacts	Lots
Photography	Moderate
Setting	Park
Latitude	43.13413
Longitude	79.38262

Bell Gristmill

When viewed from a distance the Bell Gristmill is the focal point of a peaceful scene just itching to be painted. The millpond in the foreground and unbroken forest in the background frame the mill almost perfectly. Unfortunately, at the time of writing, conditions proved less than perfect as you got closer to the mill. Most of the windows had been smashed, the doors had been boarded up, and graffiti artists had left their mark inside the building. This is such a shame, as the interesting century-old building and its pleasant setting still hold much potential as a focal point for the local community.

But all hope for the mill is not lost! A group known as the Utopia Gristmill Committee plans to rescue the mill and has built a war chest of close to half a million dollars for this task. Not too shabby for a community of about 100! Some of the mill's original equipment is reportedly being held in safekeeping by members of the community. Plans are to convert the mill to a working museum. While it was clear that the group still had a lot of work ahead of it, it was also clear that they are a dedicated bunch. For an update, see their webpage utopia.on.ca/thebellgristmill.htm.

Richard Bell built this mill in 1904, one year after an earlier mill that he had purchased from James Spink burned to the ground. Timbers for construction are said to have been hand-hewn, which is surprising given one could assume that sawn lumber would have been available in the area by this time. In the following few decades the mill produced flour under several names, including Gold Coin, used for bread, and Snowflake, which was used for pastry. By the late 1930s or 1940s, flour was no longer produced at the mill and operations instead focused on chopping and mixing of grain. The mill closed in 1965, and Bell's son donated the mill to the Nottawasaga Valley Conservation Authority.

Several old mills in Ontario used sheet metal as their exterior covering. At Utopia, the metal was applied as hundreds of small, square plates, and this appears to be unique in the province, other than perhaps at Lower Brewers Mill. The stone foundations are said to be almost a metre and a half thick at the base. Some of the old iron gearing pieces can be spotted, half hidden among the weeds below the dam. Power to the gearing was originally supplied by turbine, but when floods from Hurricane Hazel blew out the dam in 1954, the owner switched to diesel.

Directions

Follow Hwy 400 to Barrie and exit at Hwy 90 (Dunlop St.). Head west and drive about 12 km to 6th Line. Turn left and drive south for 1.5 km to Old Mill Rd, and turn left. Park just 0.2 km down the road where a trail on the right leads down a hill towards the mill and pond. After examining the exterior of the mill, take a walk through the conservation area, join fishermen at the dam, or follow the 300 m wooded path along the river back to 6th Line.

Mill Name	**Bell Gristmill**
Settlement	**Utopia**
Built	**1904**
Current Use	**Undetermined**
Original Use	**Gristmill**
Interior	**Private**
Exterior Access	**Anytime**
Artifacts	**Some**
Photography	**Moderate**
Setting	**Suburban**
Latitude	**44.32679**
Longitude	**79.83486**

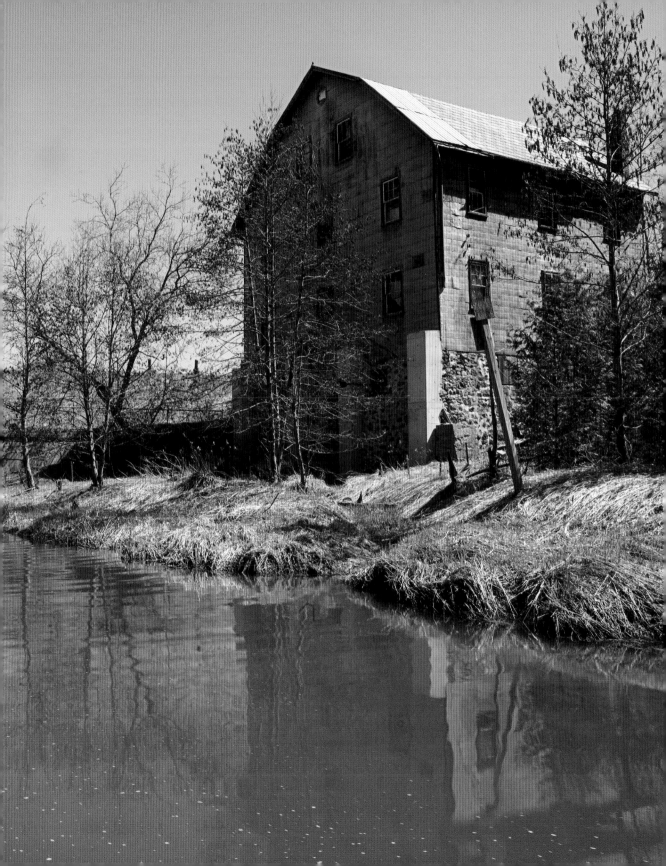

Bruce's Mill

Bruce's Mill is the name of a popular conservation area just north of Toronto. The park has been operated by the Toronto Region Conservation Authority since 1965 and is used for a variety of community events. The majority of the visitors to the park probably never even see the actual mill' though, as the unpretentious building sits quietly away from the centre of the action.

Casper Shark, a German immigrant, had constructed a mill and dam at this site as early as 1829. By 1842, the building was sold to William and Robert Bruce, who renamed the site Carrick Mills. The brothers reportedly knew little about milling, but built a successful business nonetheless. The current building dates from 1858 and used some of the wood from the demolition of the earlier mill. Unlike the taller southern section, which is covered by clapboard, the northern addition was built using vertical board-and-batten construction. The whole mill is painted white with green trim around the shuttered windows, an exterior feature that was only noted at a few other Ontario mills.

Housed behind a chain-link fence in a shed at the south end of the mill is a large steel overshot wheel, installed in 1912 and manufactured by the Fitz Water-wheel company of Pennsylvania. The 3.8 m wide wheel is a rarity in Ontario, since most mills discarded their waterwheels long ago in favour of turbine power. The shed probably helped operations continue into the winter, when freezing conditions crippled many wheel-driven mills. Water was directed from the millpond to a mill via a now nearly buried steel penstock, just visible between the mill and the pond.

For a long time the original millpond was used as a popular swimming hole. Recently, however, the pond has all but filled in with sediment and vegetation, and at the time of writing, the Toronto Region Conservation Authority was considering whether to decommission the dam altogether in efforts to improve downstream water quality in the Rouge River. The Rouge River drains an area of 17 square kilometres upstream of the mill. During summer, much of the flow in the Rouge is obtained from ground water discharging into small streams that rise along the southern slope of the Oak Ridges Moraine, just a few kilometres to the north. Though comparatively small, this reliable supply of water would have given the Bruce brothers an advantage over other mill sites on many other creeks of similar size.

Mill Name	Bruce's Mill
Settlement	Stouffville
Built	1858
Current Use	Museum
Original Use	Flourmill
Interior	Special Occasion
Exterior Access	Park Hours
Artifacts	Lots
Photography	Good
Setting	Park
Latitude	43.94111
Longitude	79.36403

Directions

From Toronto, go north on Hwy 404 to York Rd 14 (Stouffville Side Rd), about 20 km north of Hwy 401. Go east for 3.5 km to the entrance to the Conservation Area. Drive about 1.5 km along the main road to the mill. The 100-hectare Conservation Area can be bustling with picnic-goers on summer weekends. Expect to pay a fee for admission. In spring the park is home to the York Children's Water Festival, as well as the annual Sugar Bush Maple Syrup Festival, where visitors can sample liquid gold, boiled down onsite!

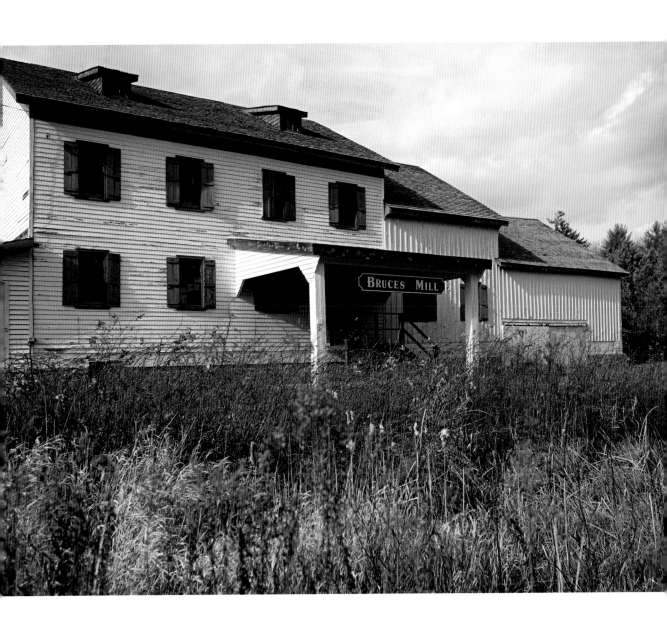

Coldwater Mill

Though it looks "good as new," the Coldwater Mill is actually one of the older remaining mills in Ontario. Together with a sawmill, the building was constructed in 1833 by the government for use by the local Ojibwa native band. But the band relocated to Rama just three years after the mills were built, and by 1849 had sold the mill to George Copeland. Over the next century and a half, the mill was owned and operated by a long succession of different owners. As a gristmill, production peaked at 100 barrels of flour per day in 1880. Millstone technology was replaced by steel rollers in 1889. Then from 1924 the building operated as a feedmill until business ceased for good in 1994.

For the first 50 years of operation, the mill obtained its power using an undershot wheel. In 1880, the wheel was replaced by a turbine, which is now on display in a gazebo in the small park behind the mill. Here you can reach out and touch the old machine, and learn how it worked by means of an informative interpretive sign. This turbine was replaced in 1906 by a larger Barber turbine, rated at 63-horsepower. Fifty years later waterpower was pushed aside altogether in favour of electricity.

Due to the dedication of the Coldwater Mill Heritage Foundation (and through donations from Casino Rama), the mill has been lovingly preserved and is open to visitors on a fairly regular basis during the warmer months. Currently, the visitor is limited to exploration of the ground floor of the mill. But there is still a lot to see, including a number of grain chutes, remnant gears and pulleys and an old cash register that could accommodate purchases up to the princely sum of $6.99! No fewer than 11 grain bins remain on the second floor, all intact and constructed of 2 by 6 rough-cut planks laid flat. Since 2002, the former office and retail portion of the mill has been occupied by the Gristmill Café, an intimate, upscale little restaurant that prides itself on offering a different menu every day of the week.

Directions

Follow Hwy 400 to Barrie and continue north for 42 km to Coldwater. Exit at Simcoe Rd 23, turn right and go 1.2 km to Simcoe Rd 17. Turn right and drive south for a few blocks to Mill St., then turn right again and drive half a block to the mill. There is a parking lot behind the mill, but it is intended for patrons of the restaurant. An inexpensive booklet prepared by James Angus is available and provides an excellent account of the history and construction of the mill, as well as the development of the community. Excerpts from the booklet have been enlarged and are posted on the exterior of the mill. Angus also prepared an informative book entitled *Mills and Mill Villages of Severn Township*, in which he documents the existence of no fewer than 73 mills once standing in the township. See the website at coldwatermill.com

Mill Name	**Coldwater Mill**
Settlement	**Coldwater**
Built	**1833**
Current Use	**Museum/Restaurant**
Original Use	**Gristmill**
Interior	**Retail Hours**
Exterior Access	**Anytime**
Artifacts	**Lots**
Photography	**Good**
Setting	**Urban**
Latitude	**44.69647**
Longitude	**79.64156**

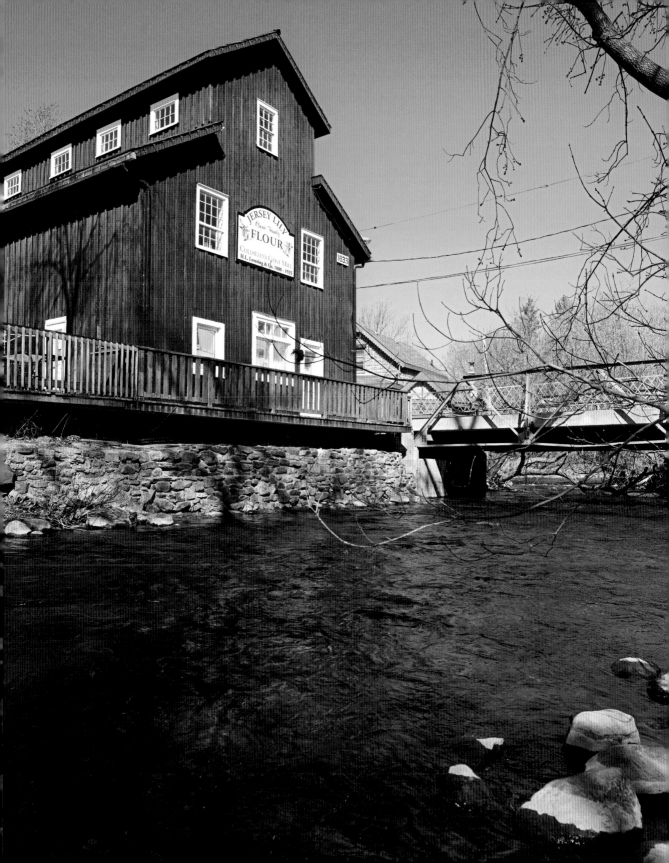

Darnley Gristmill

Most Ontarians know that the City of Hamilton has a strong industrial heritage. Few, however, are aware that much of the earliest industry was centred in a small community about 10 km west of the massive complexes now firmly entrenched by the lakeside. The small community of Crooks Hollow was once the site of up to 12 different mills and factories, employing well over a hundred workers. James Crooks (1778-1860) came to Upper Canada from Scotland in about 1791 and moved to the Hamilton area in 1805. By 1813, he had constructed the Darnley Mill. In the early days, his mill produced flour and feed ground by four run of stone, all powered by a massive 9 m overshot wheel. Crooks went on to build other industries in the Hollow, including Upper Canada's first paper mill, constructed in 1826 about 100 m downstream from the ruins.

After Crooks sold the mill in 1853, the building changed ownership a number of times before being run for a long period by James Stutt after 1872. The success of Crooks' paper enterprise led Stutt to retool the mill for paper production. In 1934, the mill was ruined by fire and was never rebuilt. Just four years earlier, the mill had been painted by A.J. Casson of the Group of Seven in a work entitled, aptly enough, *Old Mill, Crooks Hollow*.

The view of the ruins from the bridge over Spencer Creek is stunning, especially with the Darnley Cascade (Stutt's Falls) rumbling away in the background. The exterior of the building is entirely of stone, though some of the floors have been improved with the addition of concrete. An abrupt change in the pattern of the stonework facing the road suggests that the mill was probably built in stages. Avoid the temptation to hop the fence and explore the interior of the building. As the sign points out, the walls are at imminent risk of collapse! Fortunately, the crumbled west wall has been replaced with a chain-link fence, allowing for a panoramic view of most of the mill's interior. Of interest, look for the deep, narrow channels formed into the concrete base of the mill. Since concrete wasn't available when the mill was first built, these channels were likely added at a later date as a means of directing water to different portions of the mill.

Directions

At Hamilton, exit Hwy 403 at Hwy 6 and go north for 2.5 km to Hwy 5. Turn left on Hwy 5 and drive for 7 km to Hamilton Rd 504 (Brock Rd). Turn left and follow Brock Rd south for 1.6 km to Old Brock Rd. Turn right, and then after a few hundred metres veer left on to Crooks Hollow Rd. The mill ruins are located about 1.5 km west along this scenic road. The closest lawful place to park is in a gravel lot found 400 m before the mill. While the walk may appear to be an inconvenience, it is actually quite pleasant, and an interpretive sign at the parking lot provides an account of the different industries that once flourished in the area.

Mill Name	**Darnley Gristmill**
Settlement	**Crook's Hollow**
Built	**1813**
Current Use	**Ruins**
Original Use	**Gristmill**
Interior	**Private**
Exterior Access	**Anytime**
Artifacts	**Some**
Photography	**Good**
Setting	**Rural**
Latitude	**43.28010**
Longitude	**79.99605**

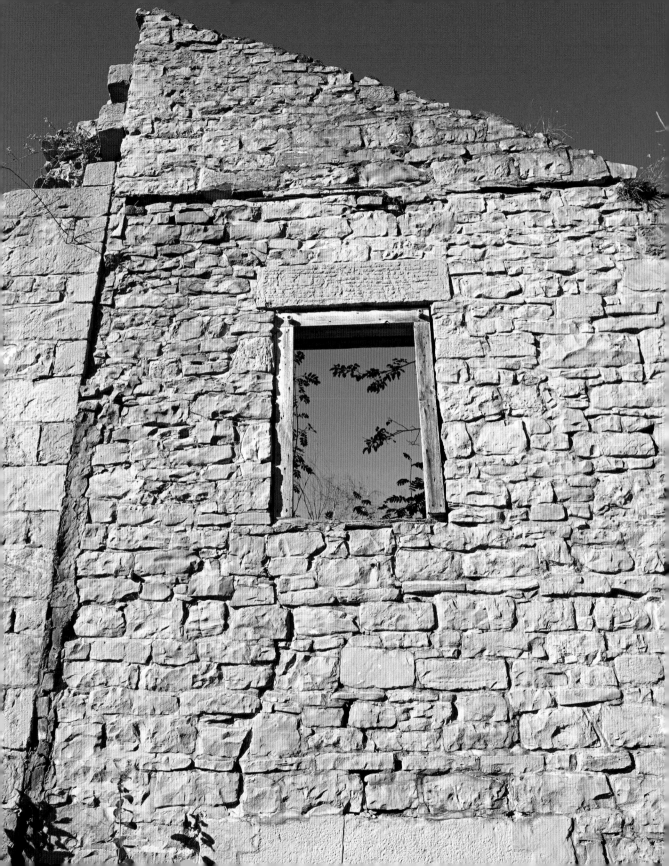

Lindsay Old Mill Ruins

Sitting just metres from Lock 33 of the Trent-Severn Waterway, the old mill ruins in Lindsay is the only physical reminder of the town's once glorious milling past. The L-shaped building once housed a flourmill and a sawmill. A tramway carried sawn lumber north across the river to now-abandoned railway tracks. While most of the building's interior is off limits to exploration, the large window openings do afford a decent view of the mill's interior. And you can safely explore the smaller section of the "L" where the walls are lower and the ground higher. Large, light-textured stone blocks have been used as quoin stones at the corners of the building. The rest of the walls have a broken-course construction and incorporate smaller rectangular blocks of varying colour and size. A cement cap lining the top of the stone walls should prevent deterioration of the structure.

The first mills in Lindsay were constructed in about 1828 by William Purdy, and until 1836, the village was known as Purdy's Mills. Purdy's Mills were built beside a dam on the Scugog River that he constructed near the foot of Georgian St. The dam raised water levels in the river by just a metre or two. No big deal, right? Well, Purdy's poor understanding of the environment led to the flooding of more than 24,000 hectares of flatlands upstream, and led to the formation of present-day Lake Scugog. In subsequent years, many deaths were attributed to ague, a malaria-like sickness brought about by the swamped landscape. In 1838, angry settlers marched to Lindsay from as far away as Port Perry to destroy the dam. The Purdy family rebuilt a smaller dam and toda, the Trent-Severn Waterway controls the lake level for navigation and recreation by means of stop-logs at a dam in Lindsay.

The existing ruins are all that is left of a mill built by William Needler and Thomas Sadler in about 1869. Situated about three blocks downstream of Purdy's original mill site, this mill was constructed to replace another earlier mill that was burned in the great fire that tore through Lindsay on July 5, 1861. The fire swept through more than half of the town, consuming nearly 100 buildings in the village's business district, most of the which, unlike today, was located to the east of William St. Ironically, though not at all uncommon, this replacement mill itself burned in 1978, leaving just the stone carcass. Needler's house is preserved under the Ontario Heritage Act and is located two blocks to the south at 10 Russell St. E.

Mill Name	Lindsay Old Mill
Settlement	Lindsay
Built	1869
Current Use	Ruins
Original Use	Flour/sawmill
Interior	Anytime
Exterior Access	Anytime
Artifacts	None
Photography	Good
Setting	Suburban
Latitude	44.35851
Longitude	78.73785

Directions

Follow Hwy 115 north to the Hwy 35 exit. Drive 30 km north to Lindsay, where Hwy 35 becomes known as Lindsay St. Drive through town until you pass Kent St., which is the main street in town. One block past Kent St., turn right on Kent St. East, which is a more minor road. Drive for two blocks to the gravel parking lot beside the mill ruins, at the foot of Mill St. After examining the mill, be sure to take a short stroll along the Wilson Boardwalk, which begins at the mill. The boardwalk and trail was opened in 1990 and winds its way along the Scugog River through town.

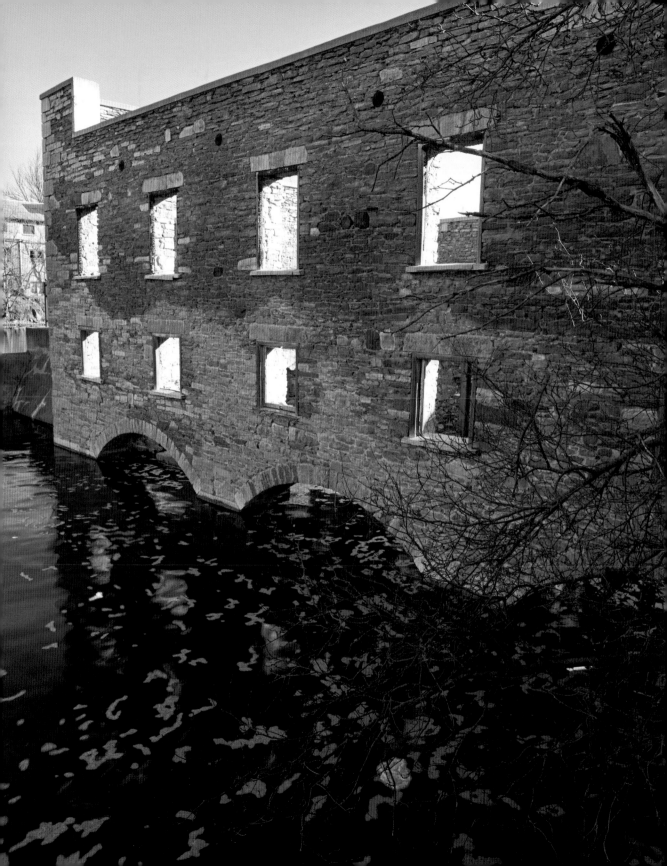

Dods' Knitting Mill

Standing like a medieval castle guarding a beautiful millpond, the Millcroft Inn and Spa preserves one of the prettier mill settings in the province. The building has transformed from a woollen mill into one of Ontario's premier country Inns. Unlike many other mills converted for commercial purposes, the exterior appearance of the original building has been largely left untouched. What few modifications have been made carefully blend in to the surroundings, such as the small three-floor veranda at creek's edge or the wedding pavilion constructed beside the pond.

The first mills along Shaw's Creek are believed to have been constructed in the 1840s. In 1875, Benjamin Ward constructed a knitting mill that became known as the Upper Mill, to distinguish it from the "lower" site of the present-day Alton Mill. As was common (and economically essential) in early days, building stone was obtained from local quarries; in this case, from one near Inglewood. Ward sold to his son-in-law John Dods in 1892, and the mill eventually became known as the Dods Knitting Mill, becoming a well-known producer of woollen long underwear.

After a fire in 1917, the interior of the building was rebuilt including at one time a rather ingenious "water floor" on the third level to guard against further fires. The mill continued to operate in the family for several decades after Dods died, before operations closed in 1965.

Operations at the mill first obtained power from the creek for several decades, before switching to coal for steam towards the end of the nineteenth century. The intake to the turbine can still be seen at the head of the pond. Today, water from the creek still drives a turbine, though it is used to produce electricity rather than woollen products.

As with any privately owned mill, please be sure to ask for permission before exploring the grounds and especially before taking a peek inside. The facility hosts weddings on weekends throughout the year, so avoid the temptation to show up in someone's wedding photos! The parking lot and driveway actually allow fantastic close-up views of the mill and associated buildings. A short trail leading through the trees on the far side of the wooden bridge ends up at a beautiful spot overlooking the mill and its pond. Guests of the mill can enjoy elegant dining in the River Room overlooking the beautifully constructed waterfall, which also serves as the outlet for the millpond.

Mill Name	Dods' Knitting Mill
Settlement	Alton
Built	1875
Current Use	Inn
Original Use	Knitting Mill
Interior	Patrons Only
Exterior Access	Roadside Only
Artifacts	Some
Photography	Excellent
Setting	Suburban
Latitude	43.85664
Longitude	80.07684

Directions

Follow Hwy 401 west to Hwy 410. Go north on Hwy 410 and continue north as the Hwy becomes Heart Lake Rd. Drive north past a few concession roads to Peel Rd 9 (King St.) and turn left. Follow King St. for 4 km to Hwy 10, turn right and drive 15 km to Peel Rd 24. Turn left and go west for about 4 km to Peel Rd 136 (Old Hwy 136). Turn right and follow Peel Rd 136 for a few kilometres to the village of Alton. Turn left at Queen St., and go west for a several blocks to John St., watching for the signs for the mill. Turn right and drive to the mill. More information about the mill and inn is available at millcroft.com.

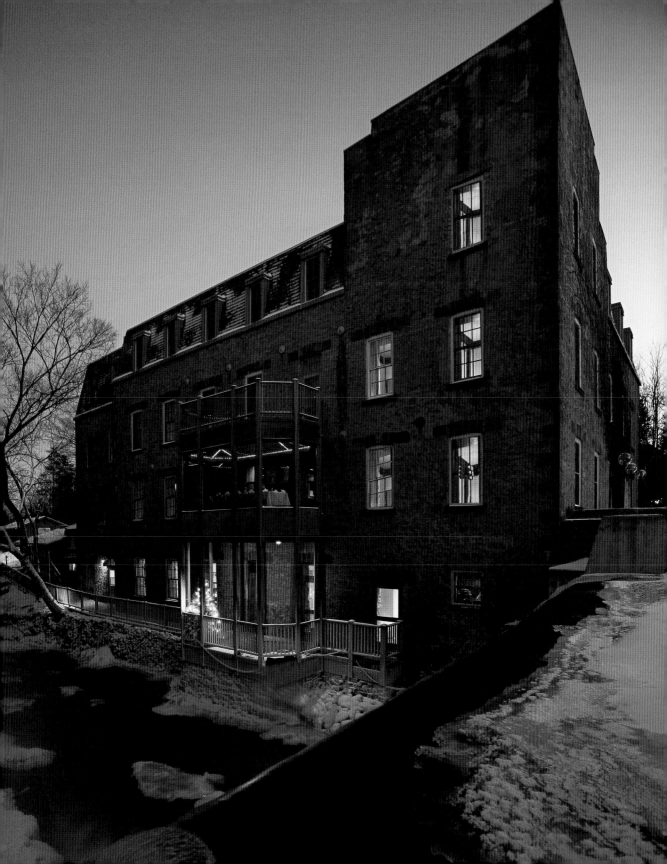

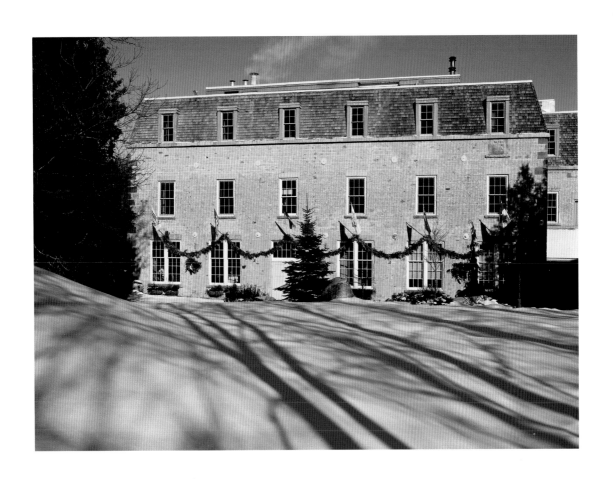

Morningstar Mill

At only one and a half storeys, the Morningstar Mill is smaller than the other operating historic gristmills in Ontario. But don't be discouraged by its small size: this is one of the quaintest little mills in the province. Were it not for the large municipal water-treatment plant just off to the right, the whole scene could transport you back to the mid-nineteenth century. Even so, positioned right at the crest of the spectacular 20 m Decew Falls, the natural setting of this mill can't be beat!

The mill is able to use much of the available head by directing water to a 49-horsepower turbine positioned 12 m below at the bottom of a large iron shaft. This arrangement is rather rare in Ontario, being limited to locations where a large vertical drop was available (eg., the mill at Walter's Falls). This large head of water and the fact that Twelve Mile Creek rarely freezes allowed the mill to operate efficiently for most of the year.

The interior of the building is packed with enough milling equipment to stock a heritage mill nearly twice its size. The ground floor houses a single run of stone on a small hurst at the far end of the main floor. Three roller mills are located along the back wall, and a

Mill Name	Morningstar Mill
Settlement	Decew Falls
Built	1872
Current Use	Museum
Original Use	Gristmill
Interior	Museum Hours
Exterior Access	Anytime
Artifacts	Operational
Photography	Excellent
Setting	Rural
Latitude	43.11052
Longitude	79.26444

diagram on the opposite wall explains the multi-break roller process. A large fanning mill, chopping mill and corn sheller are also on exhibit, while a bolter and some lineshafting can be examined on the upper floor. But it is the turbine shed attached to the back of the main building that really excites the soul of the mill enthusiast. Completely reconstructed for safety reasons, the shed shakes and rumbles when the mill is in operation. Be sure to take a peek down into the deep excavation housing the turbine shaft and access ladder.

Robert Chappel built this mill in 1872, though John Decew is said to have constructed a sawmill and gristmill at this site almost a hundred years earlier. Soon after its construction, Chappel's mill fell victim to a dam constructed by the City of St. Catharines across Beaverdams Creek. This greatly diminished the water supply to the mill and it was not until the construction of the third Welland Canal in 1887 that sufficient water was again available from the creek. The mill was sold to Wilson Morningstar in 1883 who operated it until he died in 1933. For a time, the mill died too, and the building, badly in need of repair, changed hands a number of times. A few years after being purchased again by the City in 1989, a dedicated group of volunteers known as the Friends of Morningstar Mill began to restore the mill.

In addition to the gristmill, a long-vanished sawmill has been recreated recently on the far side of the river. In a rare reversal of a typical progression, the original building was used as a community hall before Morningstar converted into a sawmill, which was taken apart when Morningstar died. Almost 75 years later, the Friends of Morningstar Mill began reconstruction of the mill, which was still underway at the time of writing. The ultimate goal is to use power from a turbine to run a 50-inch circular saw. If completed, this would be one of the few locations in

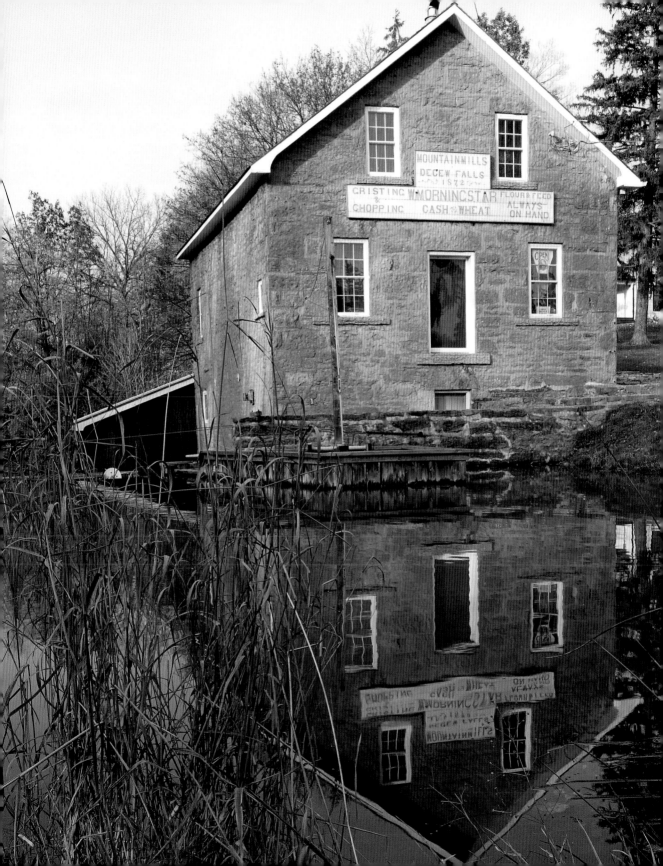

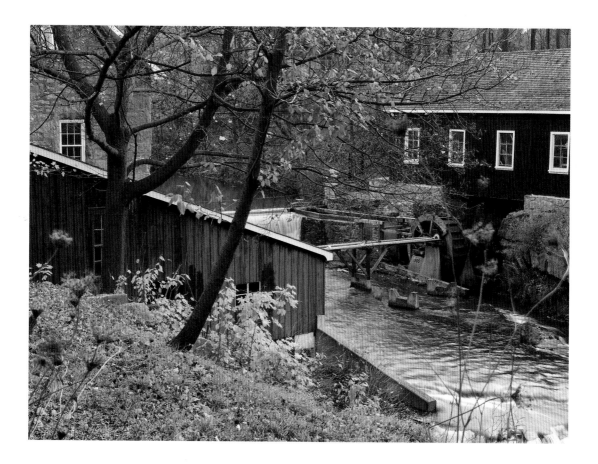

Ontario with two water-powered mills side by side: rare today, yes, but a very, very common situation long ago.

Directions

To find the Morningstar Mill, follow the Queen Elizabeth Way to St. Catharines and exit on Hwy 406. Drive through the city for 11km and exit at St. David's Rd West. Continue to the stoplight at Merritville Hwy, turn left, and continue south to Beaverdams Rd. Turn right and follow this very scenic road for 2 km to the mill. While the prime operating season is summer, the mill is also run on selected dates throughout the year. Even when not in operation, the mill, grounds and waterfall can be visited. The Friends of Morningstar Mill operate a website at morningstarmill.ca with information on operating dates and hours. A pleasant gravel trail leads from the mill to the upper edge of the scenic gorge. An access point to the base of the waterfall (and to the crest of another) can be reached along this trail. Use caution: the descent to the gorge, while not impossible, is risky and is only for the adventurous.

Nicolston Gristmill

From the outside, the Nicolston Gristmill is a rather non-descript, red-brick building with little evidence to suggest that it's anything out of the ordinary. But as soon as you walk through the front door, it's clear that this really is a special building! While now used primarily as an office for the adjacent campground and as a store selling birdseed, birdhouses, books and garden decor, the building's milling past is immediately evident. Wooden grain chutes are scattered throughout the merchandise on the main floor, and a number of wooden control levers hang from the ceiling, grazing the head of any visitor taller than about 6 feet.

The mill was built in 1907 by the present owner's great grandfather, John Nichol. The dam on the Nottawasaga River provided 3.5 m of head; sufficient to drive a 125-horsepower turbine. Housed in a wooden shed on the south side of the building, the "Little Giant Turbine" was supplied by the W.M. and J.G. Greey Mill Furnishings Firm of Toronto, one of the province's principle suppliers of milling equipment in the later years. Power was transferred into the mill via a long horizontal shaft that is still visible in the basement and outside the building. Operations ceased at the mill in 1967, and the headrace that once provided water to the mill was backfilled in 1986 for safety reasons. The old turbine is on display behind the mill.

Though water is no longer diverted to the mill, the gears are not yet silent, as the current owner periodically powers mill machinery using an antique tractor. The tractor drives the main horizontal shaft, and the visitor is allowed to explore the basement level to see first-hand how this drives some of the old belts, pulleys and shafts that once transferred power through the mill. One belt running up to the main floor drives the seed mixer, which is the large red metal kiln prominently featured on the main floor. Various mixtures of birdseed are blended by a large vertical auger inside the mixer and are then bagged and sold on the premises. Also visible on the main floor, though not currently connected to the power system, are a double roller mill and a Roberts grinder mill.

Directions

Follow Hwy 400 for about 45 km north of Toronto to Hwy 89. Exit Hwy 89 and go west for 13.5 km to 5th Line Essa, just before the Nottawasaga River. Turn right and drive for about 0.4 km to the mill on the left. The mill store and is open year-round, though closed on Sunday and Monday from September to June. The campground also offers a small mini-golf course and canoe rentals. Also located on the campground property is the first fish ladder ever constructed in Ontario. Built by the Department of Lands and Forests in 1961, the ladder allows fish to continue upstream around the dam. A small admission fee may be requested, so please check with the camp office. For more information see the camp website at nicolston.com.

Mill Name	**Nicolston Gristmill**
Settlement	**Alliston**
Built	**1907**
Current Use	**Retail/Museum**
Original Use	**Gristmill**
Interior	**Retail Hours**
Exterior Access	**Anytime**
Artifacts	**Operational**
Photography	**Moderate**
Setting	**Park**
Latitude	**44.16783**
Longitude	**79.81185**

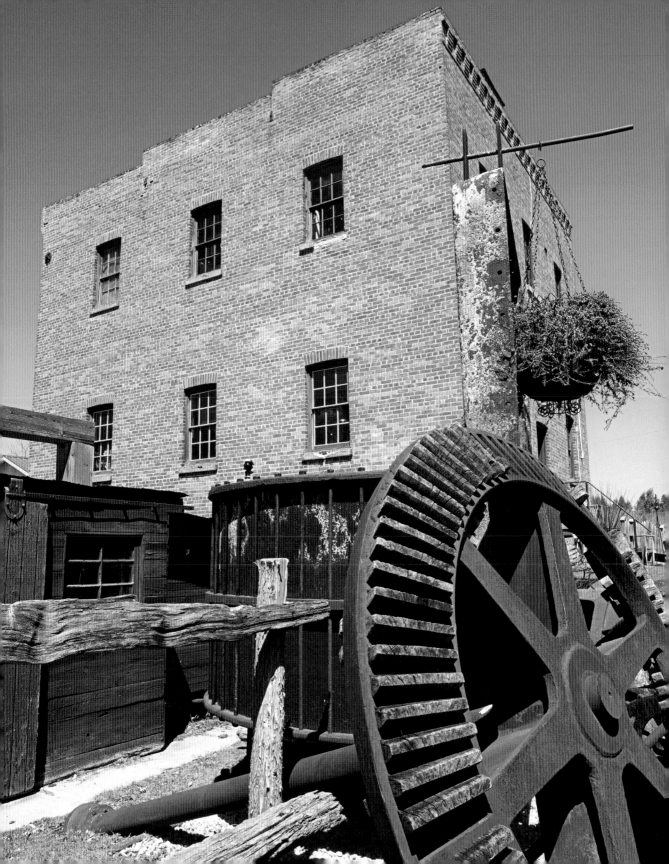

Roblin's Mill

Who would guess that one of the best-kept and nicest-looking old mills in the province is located within the city limits of Toronto? Old mills are supposed to be forgotten old buildings hidden in backwater towns, their mere existence only preserved because nobody could think of anything better with which to replace them. Instead, here we have a fantastic example of early Ontario industry located just a city bus ride away from millions of people. Its no wonder then that of all the heritage mills in Ontario, the Roblin Mill, as part of the Black Creek Pioneer Village, probably accepts more visitors than any other in Ontario.

But before we give the city too much credit for somehow preserving this gem through a century and a half of progress, it must be pointed out that the mill was actually moved here from Ameliasburg, about 175 km to the east, in Prince Edward County. Originally the visual focal point of the village, you can bet that there are a few regrets for letting the old landmark go. It was moved to Toronto in 1965. A plaque alongside a walking trail circling the old millpond in the Harry Smith Conservation Area at Ameliasburg marks the location where the mill once stood.

Mill Name	**Roblin's Mill**
Settlement	**Toronto**
Built	**1842**
Current Use	**Museum**
Original Use	**Gristmill**
Interior	**Museum Hours**
Exterior Access	**Park Hours**
Artifacts	**Operational**
Photography	**Excellent**
Setting	**Pioneer Village**
Latitude	**43.77457**
Longitude	**79.52001**

Owen Roblin (1806-1903) built the mill at Ameliasburg in 1842. The grandson of a United Empire Loyalist, Roblin also built a sawmill, shingle mill and carding mill, all using the same millpond for power. Roblin Lake, situated just a few hundred metres upstream of the millpond, provided a steady supply of water. It is said to have supported so many fish that a full-time worker was needed to net pike so they didn't clog up the flume (don't bring your fishing rod to Black Creek, though!). The original setting of the mill permitted to Roblin to power three run of stone with a giant overshot wheel just over 9 m in diameter. At peak production, the mill packed a hundred barrels a day, exporting much flour to the northern states during the Civil War. Flour was loaded at the docks at nearby Rednersville, now a pretty little hamlet just 6 km to the north of Ameliasburg.

With the major exception of the stone walls, which were replaced by stone found along the Humber River at Mimico, almost the entire building and contents were moved to Toronto. The exercise was not without its challenges. Was there anyone still alive in Ontario that knew how to properly size, gear and install an overshot wheel? In addition, since the Pioneer Village was constructed to represent life prior to Confederation (1867), much of the equipment brought from Ameliasburg was actually too new, and more appropriate equipment of the correct vintage had to be found.

One of the successes of the restoration of Roblin's Mill is that the visitor can clearly follow the milling process from pond to flour. This requires several passes up and down the stairs, though here we will attempt to save you the workout. Water in the upper pond is transferred to the mill by means of an elevated wooden flume, which directs it to the 5.5 m diameter overshot wheel. Both the wheel (originally 9 m) and

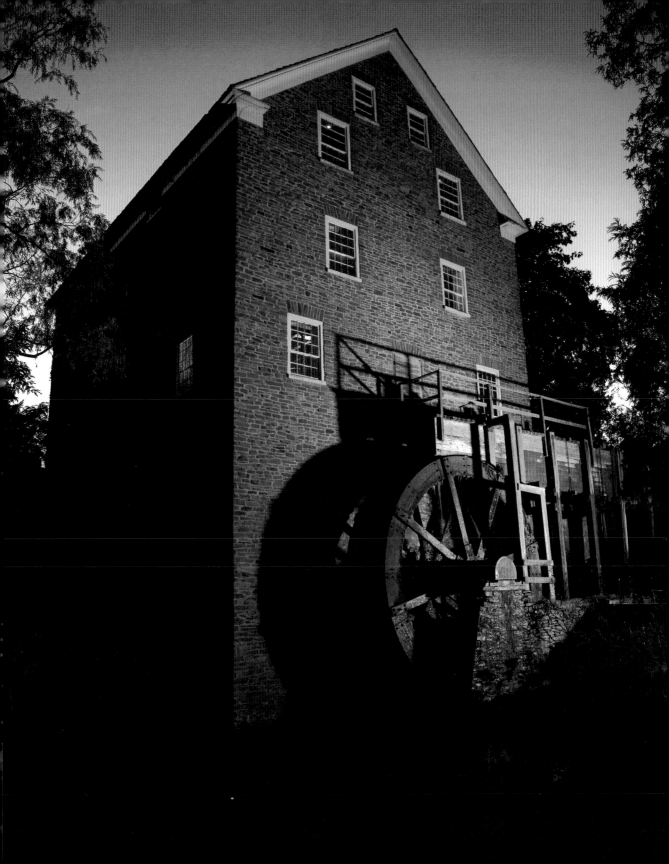

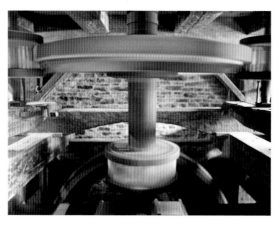

Great spur wheel driving two trundle wheels.

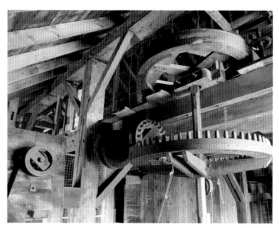

Gearing in the attic.

the flume (originally 5 m wide) needed to be scaled down to fit the setting at Black Creek. In the basement, behind a floor-to-ceiling protective screen, the visitor is afforded an excellent view of the primary gearing. The pit wheel is the large vertical gear parallel to the far wall of the mill. It connects to a small lantern gear (or "wallower") that in turn drives the main shaft, a piece of oak almost half a metre in diameter. Connected to the main shaft is a large horizontal "spur wheel," which in turn transfers power to the two smaller trundle wheels that connect directly to the millstones immediately above on the ground floor.

Grain that was brought to the mill was weighed in a scale visible on the ground floor. From here, the grain was transferred to the uppermost floor of the mill by means of bucket elevators, which can be seen on all floors of the mill. In the attic and third floor of the mill, the grain was passed through a revolving screen and smutter, both of which were used to separate non-grain material. The grain then descended to the second floor where it was stored in large holding bins until ready for processing.

Grain was dropped to the ground floor for grinding at one of two sets or "run" of millstones. The visitor can easily examine both run of stone. At the Roblin

Mill, one run was normally used for custom milling for the farmer, while the other was used for merchant milling. Once the grain had been ground, the flour would be transported back to the third floor for cooling in the hopper boy; the example restored here being one of the best in the province. Flour was then transferred to the bolters for grading. A large bolting reel almost 6 m in length and an even larger 3 m high bolting chest dominate the equipment visible on the second floor. At the bottom of each bolter, look for the auger, which was used to convey flour away and then back down to ground floor for packing.

Directions

Exit Hwy 400 at Steeles Ave and turn left (east). Drive east on Steeles Ave for 1.3 km to Murray Ross Pkwy and turn right. The entrance to the Pioneer Village is a short way along the road. (If coming from the north, exit Hwy 400 at Hwy 7 and turn left, then follow Jane St. south to Steeles Ave and turn right.) There is an admission charge to Black Creek Pioneer Village, but exploration of the village can easily fill an afternoon. For up-to-date information and operating hours please visit blackcreek.ca.

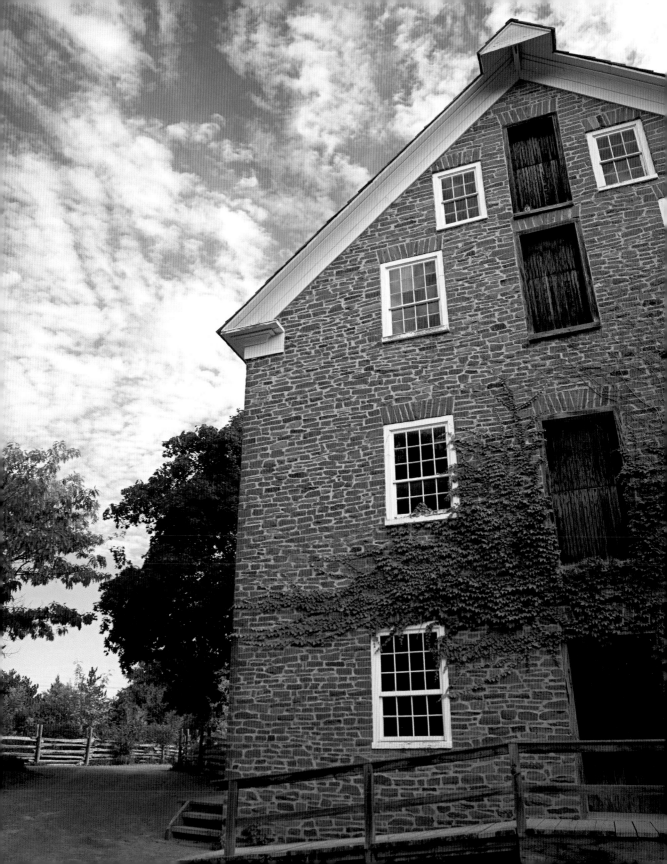

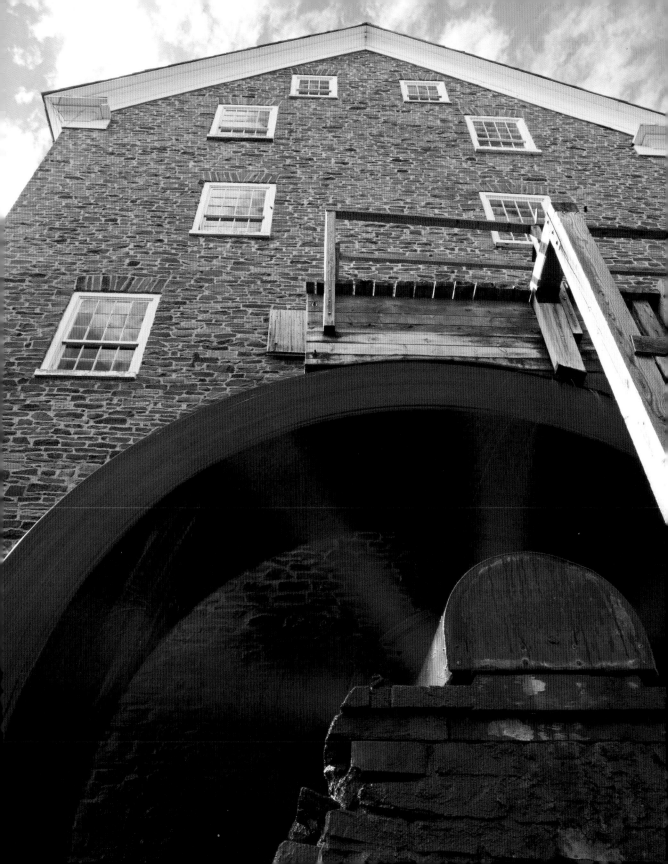

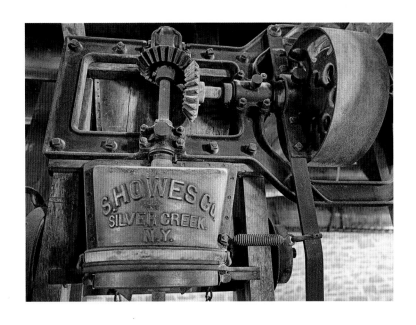

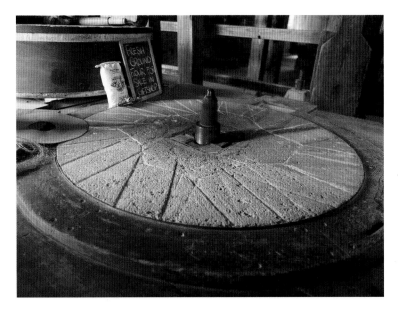

Vanstone Mill

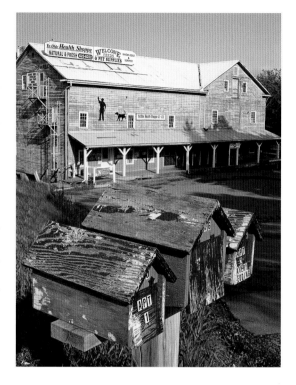

The Vanstone Mill was constructed in 1850 and was the largest of a number of mills in Bowmanville. Now, 150-odd years later, it is probably the largest historic frame mill remaining in the province. Covered in fading blue-grey clapboard, the mill is four storeys in height on its river side, and twice as long as most mills in this book. The stone foundation is visible only on the river side, as is the steel penstock that once delivered water to the base of the mill. The side of the mill facing the parking lot is somewhat less imposing, but is more inviting, with a long, covered loading bay-turned-porch giving access to a small number of shops marketed together as the Shops of Vanstone Mill. Parts of the mill may be visited by shopping at these establishments.

An earlier gristmill occupying this site was built in about 1805 by John Burk, a Loyalist settler. Around 1856, Samuel Vanstone moved his operations from Tyrone (see entry for Tyrone Mill) and rented this much larger mill which had been built in 1850. Samuel's son Jabez purchased the mill in about 1886, and ownership remained in the Vanstone family until Samuel's great-grandson Byron ceased milling operations in 1975.

Mill Name	Vanstone Mill
Settlement	Bowmanville
Built	1850
Current Use	Multi/Retail
Original Use	Gristmill
Interior	Retail Hours
Exterior Access	Anytime
Artifacts	Unknown
Photography	Good
Setting	Suburban
Latitude	43.91331
Longitude	78.69291

Directions

Exit Hwy 401 at the Liberty St. exit and follow Liberty St. north for 1.5 km to Durham Rd 2 (King St.). (travellers from the east actually exit Hwy 401 at Duke St., which is one block west of Liberty St.). Turn left on King St. and drive 1 km to Scugog St., just before the bridge over Bowmanville Creek. Turn right, and immediately turn left into the parking lot in front of the mill. A panoramic view of the mill is available from the bridge over the Creek.

Only 2 km to the east is the Cream of Barley Mill. This plain yet well-kept 3-storey red-brick mill was built in 1905 to replace an earlier wooden mill built by Timothy Soper that burned the previous year. Its name is based on a major product that was produced here and used for many an Ontario breakfast in the 1920s and 1930s. It is topped by an excellent example of a monitor roof, installed in industrial buildings

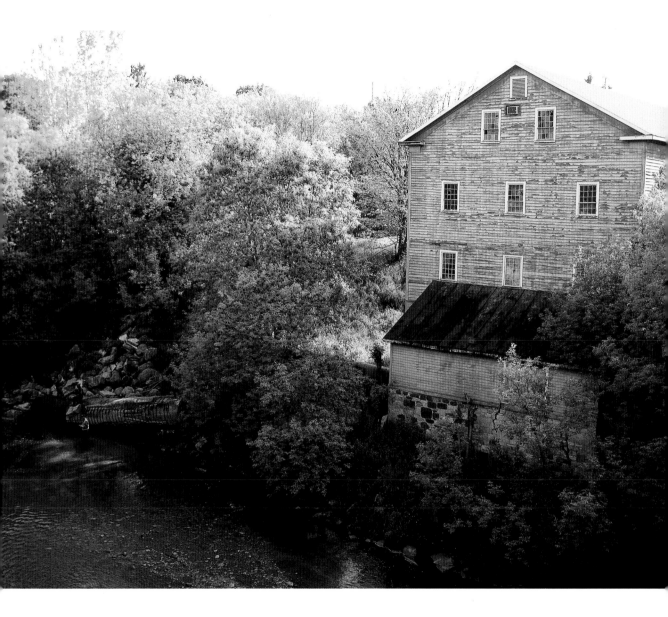

to increase air circulation. The old flourmill now houses the Visual Arts Centre of Clarington, which offers constantly changing art exhibitions as well as a wide range of art programs for young and old. More information, historical notes and gallery hours are available at vac.ca.

To reach the Cream of Barley Mill, exit Hwy 401 at Liberty St. and go north to the first street, which is Baseline Rd. Turn left and go east to the next street, which is Simpson Ave. The parking lot for the mill is just a few hundred metres up the road on the right.

Tyrone Mill

There is perhaps no mill better suited as a destination for a Sunday drive out of the big city than the Tyrone Mill. Located about an hour from east Toronto, the little wooden country mill has something for everyone! The ground floor houses a small country store, selling everything from locally baked goods and jams to fresh apple cider, pressed onsite from September to May. Sawn lumber, cut and planed onsite is, also available for purchase from the mill. But while the casual visitor may at first figure this to be a somewhat rustic looking general store, there is much heritage to be explored once you explore beyond the small room used for retail.

As you enter the mill, you will immediately note the hurst on your left. This is the elevated platform used to support the millstones and associated equipment. Two run of stone still exist here, each set in light-blue vats atop the hurst. One run is still in use to grind wheat and is fed with grain delivered from the upper floor via a conspicuous, angled steel pipe. Towards the back of the mill, look for the staircase leading up to an antique woodworking shop on the second floor. It is run entirely by waterpower, and anyone even remotely interested in woodworking will at once begin

to drool over the assortment of antique saws, lathes and presses, all meticulously connected and driven by a spaghetti of lineshafting. Visitors are welcome to take a peek in the shop whenever it is not in use.

The Tyrone Mill was constructed in 1846 by John Gray and James McFeeters. In 1852, the building was sold the mill to Samuel Vanstone, who continued to operate the building as a flourmill for some time. By about 1890, though, the focus had switched to feed, as the Vanstone family were now more heavily involved with flour milling at their mill in Bowmanville (see entry for Vanstone Mill). Vanstone later sold the mill to the Goodman family in 1908, which operated the mill as a feedmill until 1953. The mill changed hands several times from the 1950s to 1970s, during which a sizeable unused portion of the building was demolished, though a sawmill was added to the west side of the building. Finally, in 1979, the mill was purchased by the current owner.

A pleasant pond located immediately behind the mill can be reached via a short catwalk leading from the second floor of the building. Water from the pond enters the mill via a partially buried steel flume pipe, just visible from the catwalk. Water is delivered to a turbine housed in a 2.1-metre diameter casing beneath the elevated platform in the main room of the mill. The turbine was installed in 1986: a number of photos plastered on the walls leading to the store section document the installation efforts. The turbine rotates at a rate of about 200 to 225 rpm, and power is transferred throughout the building. Special gearing is used to ramp rotary power up to about 550 rpm for the sawmill on the west side of the building. Power is transferred from the vertical shaft through the turbine to the vintage 1942 planer via a quarter turn belt.

After making just $50 in his first year of operation, the present owner knew he had to diversify

Mill Name	Tyrone Mill
Settlement	Tyrone
Built	1846
Current Use	Retail
Original Use	Gristmill
Interior	Retail Hours
Exterior Access	Anytime
Artifacts	Operational
Photography	Good
Setting	Rural
Latitude	44.00821
Longitude	78.72248

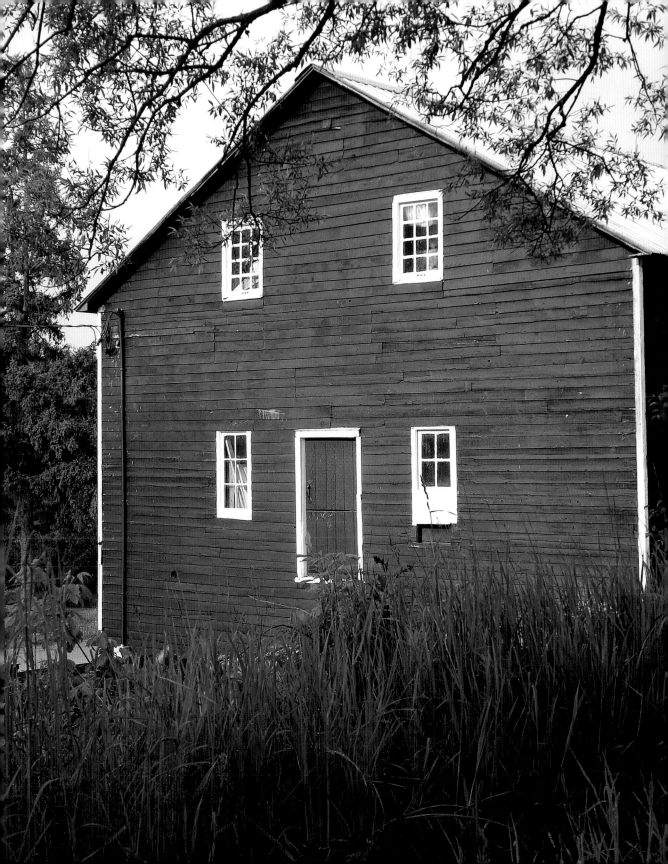

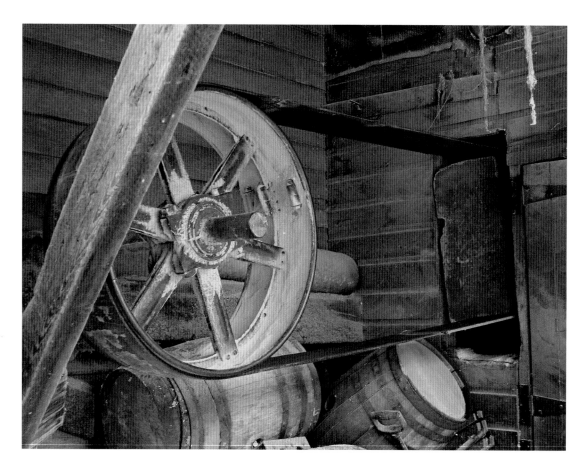

in order to make the mill profitable. Early efforts were concentrated on the sawmill, and this quickly blossomed into a lumber supply outlet, resulting in a seemingly untidy yet well-stocked lumber yard surrounding the building. Situated at the western end of the Lake Ontario apple belt, the owner also saw a niche for fresh apple cider and installed a cider press in 1981. By 1996, two run of stone had been installed, with one currently in use for flour production.

Directions

From Toronto, drive east on Hwy 401 to Bowmanville. Exit at Durham Rd 14 (Liberty St.) and go north for about 13 km to Tyrone. When the Regional Rd begins to bend to the right, watch for a short little road on the left that leads to the mill at the intersection with Concession Rd 7. At the time of writing, the store was open from Monday to Saturday, from 9 to 6, and from 12 to 5 on Sundays. A word of warning though: the mill is extremely busy on Thanksgiving weekend, which is, of course, the most beautiful time of the year to visit!

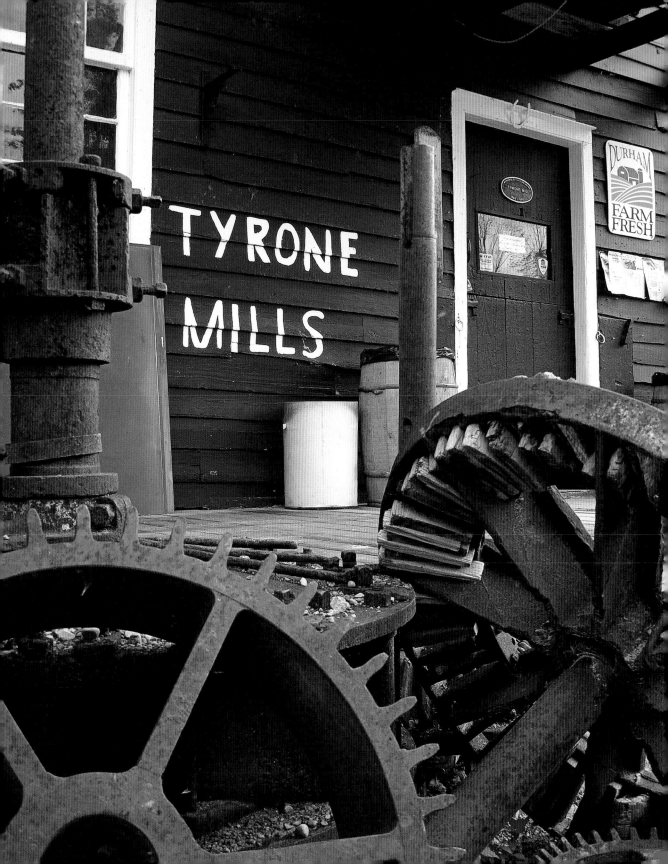

Other Mills: Greater Toronto

Alton Mill

Alton Mill

At the time of writing, this large yet quaint stone mill was undergoing a major transformation into an arts and heritage centre. A number of artisans had already taken up residence. The plan is to develop more studios, meeting spaces and a cafe by 2007. An "industrial heritage exhibit" is also envisioned to show off the original turbine and steam boiler. Originally built in 1881 as a knitting mill, the building later housed a rubber factory that operated until about 1982. At one time the mill was owned by John Dods, the owner of the knitting mill now housing the Millcroft Inn, just upstream on Shaw's Creek. (See the photograph of the Alton Mill at top of page.) More information about the progress of the restoration may be available at altonmill.com.

Brooklin Flourmill

Located at 25 Cassels St. E, in the historic portion of Brooklin, north of Whitby. Considered to be one of the oldest brick mills in Ontario, this mill operated from 1848 to 1991. The building now houses a private Montesorri School. There is no access to the interior, but a historical plaque on the exterior reviews the history of the building, site and community.

Dean Sawmill

Located in the Marsh Heritage Village near Wainfleet, this operational sawmill is housed in a barn moved here from Port Colborne. The original mill, which had operated up until 1971, was badly damaged during a storm in 1984. The circular saw machinery dates from 1883 and was originally powered by a 40-horsepower steam engine. A newer steam engine has been installed and is used to run the mill on a few select dates each year, notably the Labour Day weekend, when it is operated by the fifth generation of the Dean family.

Distillery District

The Distillery District is a fascinating portion of old Toronto, representing one of the largest and best-maintained streetscapes of Victorian-era industrial

Gooderham and Worts Distillery (above and right).

architecture on the continent. Industrial use commenced in 1832 with the founding of the Gooderham and Worts Distillery. One of the earliest remaining buildings is the gristmill and distillery, a prominent limestone building of ashlar masonry dating to 1859. By the late nineteenth century, the distillery was one of the world's largest, producing close to 8 million litres of whiskey per year. The production of spirits didn't finally dry up until 1990. The unique landscape of cobblestone roads and old brick buildings was soon used to film hundreds of movies, including *Chicago* and *X-Men*. In 2003, the entire district was converted to an expansive, pedestrian-only collection of artisans' studios, restaurants, galleries, museums and boutiques. The district is located one block southeast of Parliament and Front Streets; more information is available at thedistillerydistrict.com. The gristmill is shown in the photograph on page 185.

Eden Mills

This gristmill was built around 1858 by Henry Hortop Sr., to replace an earlier frame mill built 15 years earlier by Aaron and Daniel Kribbs. In 1917, it was purchased by the Barden family, which added a cider mill and sawmill. After the building burned in 1979 it was sold and the stone remains were used as the framework for a unique private home. The mill is not open to the public. (See the photograph on page 187.)

Armstrong Mills

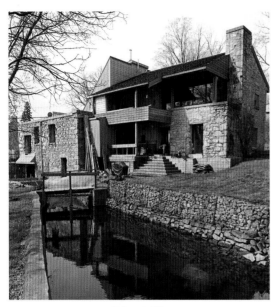

Eden Mills

Merritton Cotton Mill and Lybster Mill, St. Catharines

The former Merritton Cotton Mill building was renovated in 2002 to house a franchise of a popular steakhouse chain. Constructed in 1881 of mottled red sandstone, this large building was later retooled and used by the Independent Rubber Company to make rubber footwear during World War I. Though not your typical little country mill, the factory-like building is a local landmark and, though heavily renovated, still possesses a few vintage treats for the budding industrial archeologist. Across the street is the former Lybster Mill, another large stone cotton mill. Three storeys high and built in 1860, it was one of the first cotton mills in Canada. After changing hands several times, it was acquired by Domtar Paper in 1961, which closed up shop in 2002. At the time of writing, renovation of the building for residential and/or commercial use was underway. Both mills are located at the corner of Glendale Ave and Hartzel Rd.

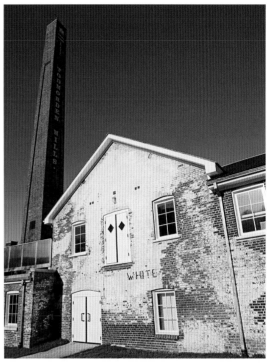

Todmorden Mills

Old Mill at Toronto

A sawmill constructed on this site in 1793 was one of the first "King's Mills." For a decade it supplied lumber for early construction before burning to the ground. A gristmill constructed on the site in 1834 also burned down, and William Gamble replaced it with a much larger, seven-storey stone flourmill in 1848. Like its predecessors, this building burned too, this time in 1881. It left a large stone ruins that stood by the banks of the Humber River for over a hundred years. In 1914, the Old Mill Tea Garden was built overlooking the ruins. Decade by decade, the establishment grew into the now mammoth upscale banquet-restaurant-bar-inn facility so well known by Torontonians. In 2001, the old ruins were torn down, with the stones being used to construct the lower portion of the new Old Mill Inn (see photo on page 188).

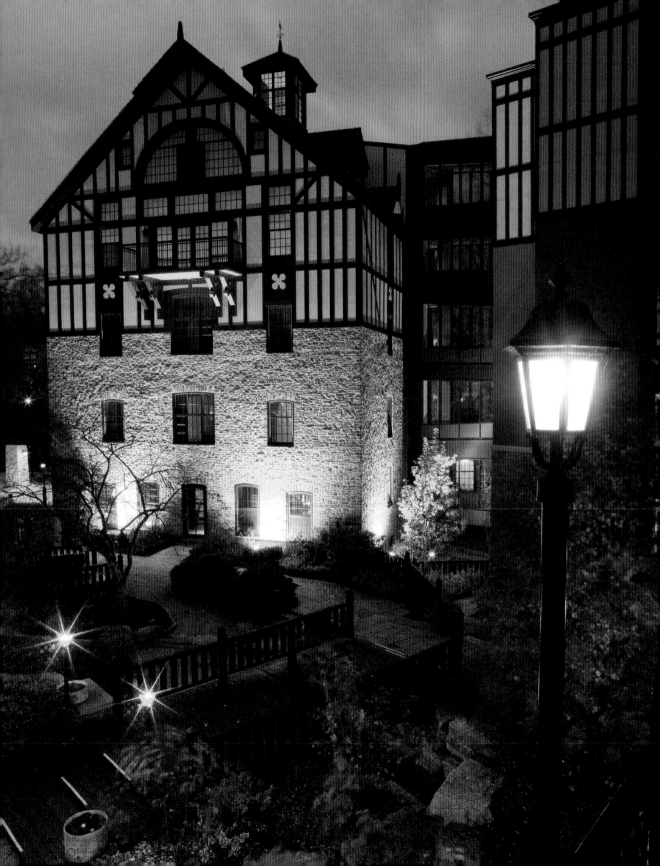

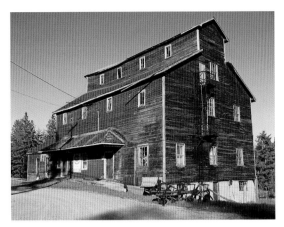
Mill at Hillsdale

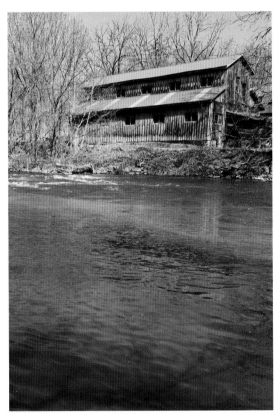
Cheltenham Mill

Port Perry Grain Elevator

This building was built in the 1870s by George Currie on the waterfront at the foot of Queen St. Like the hundreds or even thousands that once dotted Canada's prairie landscape, it was used as a storehouse for grain. At 18 m in height, this elevator, like most in eastern Canada, was shorter but more rectangular in plan that those in the west. The ground floor of the complex is now used by a small number of retailers. A short walk up the hill on Queen St. leads to the town's picturesque row of touristy shops.

Schomberg Feedmill

A pleasant drive through the hills of King Township leads to Schomberg, where this 1884 feedmill sits prominently at 357 Main St. The mill houses a couple boutique shops and two restaurants. A closer look reveals that the entire building is constructed of 2-by-4 planks stacked on top of one another. Even the rooms now used for washrooms are built this way! However, other than a large dust-removal cyclone in the larger restaurant, little milling equipment remains. Another old feedmill on Hwy 9 is occupied by a hardware store; its prominent orange elevator visible for some distance.

Udora Mill

A pretty mill with an uncertain future, the Udora Mill sits idle beside the Black River. Built in 1865, it operated until the 1970s, making it one of the last gristmills to close up shop. Some refer to the building as "Peers' Mill," named after George Peers who purchased the mill in 1885. The mill operated 24 hours per day to produce flour during World War I, but also focused on chopping animal feed before and after the war. The mill is easily visible from the side of York Rd 82 (Victoria St.). While access to the mill was restricted at the time of writing, there were reportedly plans to renovate the mill into an art centre or cafe. (See the photograph on page 191.)

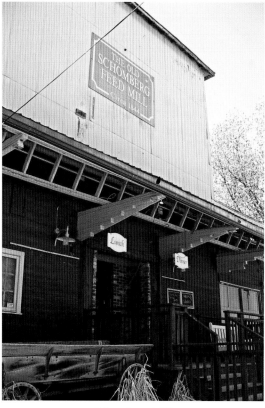

Schomberg Mill

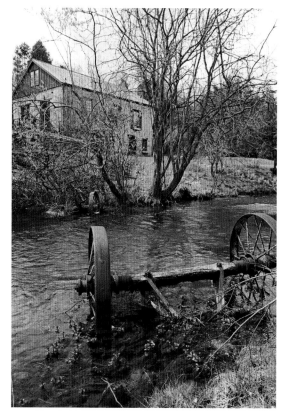

Cedar Lane Mill

Welland Mills

Located at 20 Pine St. North in Welland, this is a rock solid-looking building constructed of gorgeously coursed ashlar limestone masonry. It was built by Jacob Keefer in 1846 along the route of the now vanished second Welland Canal. At the time of its construction, it was the largest flourmill in Ontario, producing 300 barrels per day and capable of storing 70,000 bushels of wheat. It later became part of Maple Leaf Mills, and today is the only remaining original mill from that firm. At the time of writing, a developer was renovating the mill into a mixed-use facility to include retail space as well as affordable housing units.

Williams Mill

A quaint old frame building at 515 Main St. in the picturesque tourist village of Glen Williams, it forms part of a small art studio and gallery complex that is open to the public. The mill is believed to date to the 1850s. See williamsmill.com for hours and dates of operation. The former Georgetown Electric Light Company Power Plant, a beautiful stone building, is also part of the arts complex. Just a kilometre north on Main St. is the old Beaumont Knitting Mill, built in 1872 and operated until 1982.

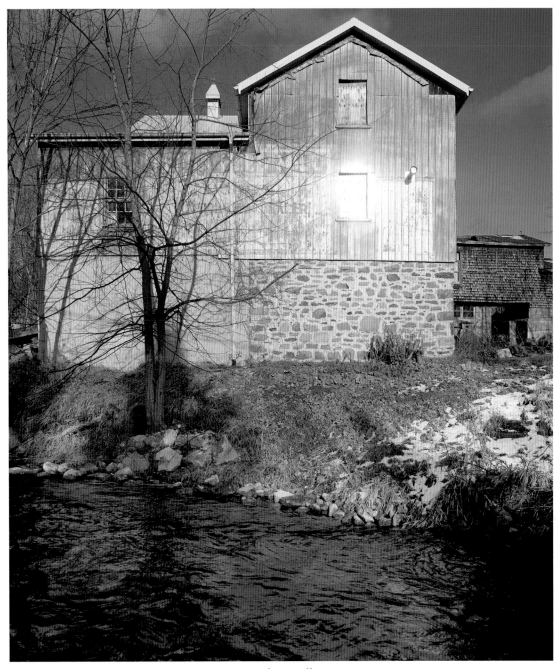

Udora Mill

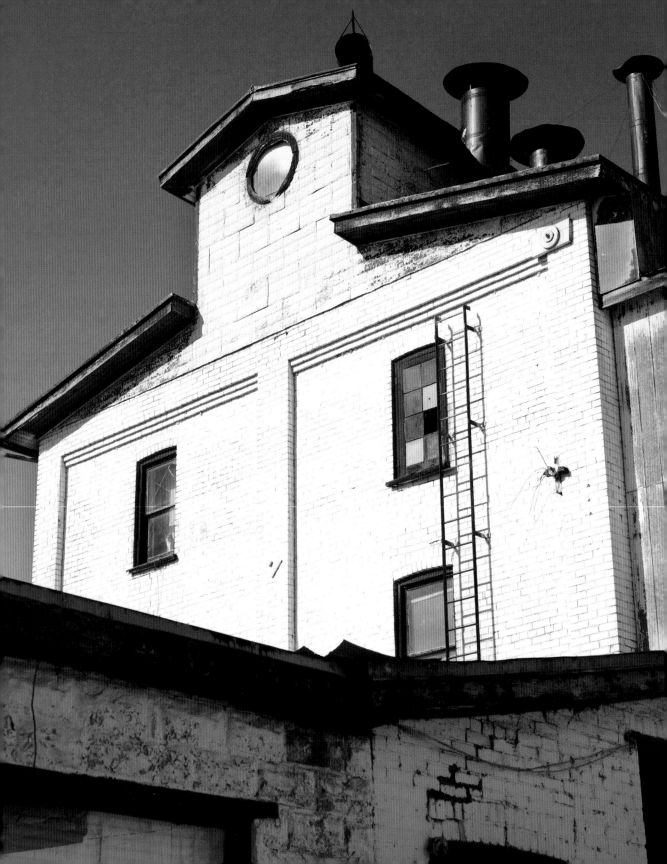

WESTERN
ONTARIO
REGION

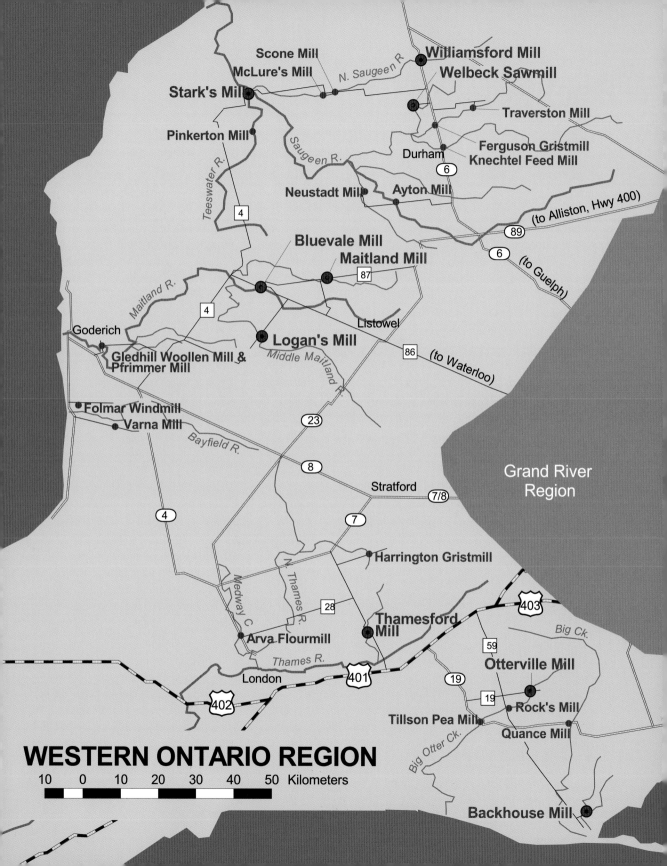

Scone Mill

McLure's Mill

Williamsford Mill

Welbeck Sawmill

N. Saugeen R.

Stark's Mill

Traverston Mill

Pinkerton Mill

Ferguson Gristmill
Knechtel Feed Mill

Durham

Saugeen R.

6

Teeswater R.

4

Neustadt Mill

Ayton Mill

(to Alliston, Hwy 400)

89

6

(to Guelph)

Bluevale Mill

Maitland Mill

87

Maitland R.

4

Listowel

Goderich

86

(to Waterloo)

Logan's Mill

Gledhill Woollen Mill &
Pfrimmer Mill

Middle Maitland R.

Folmar Windmill

Varna Mill

Bayfield R.

23

8

Grand River
Region

Stratford

7/8

4

7

Harrington Gristmill

403

Big Ck.

Medway C.

N. Thames R.

28

Thamesford
Mill

59

4

Arva Flourmill

19

Otterville Mill

Thames R.

London

401

19

Rock's Mill

402

Tillson Pea Mill

Quance Mill

WESTERN ONTARIO REGION

Big Otter Ck.

10 0 10 20 30 40 50 Kilometers

Backhouse Mill

Backhouse Mill

The Backhouse Mill is located in the Backus Heritage Conservation Area. No, this isn't a typo. Descendants of the mill's founder, John Backhouse, changed their name to Backus to escape the ridicule of a name sounding very similar to "outhouse." Though Backhouse died in 1827, the mill was operated by his family until it was sold to the Big Creek Valley Conservation Authority (now part of the Long Point Conservation Authority) in 1955. Backhouse's mill is now the historic core of a 500-hectare conservation area that also includes a sizeable heritage village, a conservation education centre and part of Backus Woods, reportedly Canada's largest tract of Carolinian forest.

Backhouse arrived in Upper Canada in the 1790s from Yorkshire, England. In 1797, he constructed a sawmill, and a year later, using wood from his own mill, he erected this gristmill. Not only has the mill survived the elements for over two centuries, it was one of the only mills in the area to survive the War of 1812. Mills were the big prize for raiding American forces, as a burned mill could have devastating effects on the entire region. In fact, the Backhouse Mill is only one of three believed to have survived through the war (the other two were to the east at Vittoria). The reason for this is unclear, but local folklore suggests that Backhouse's red coat tricked American forces into thinking that the British Army was patrolling the area, when in fact, area defenses probably didn't exceed a few dozen militiamen.

Covered in a fresh coat of red paint and a metal roof added in 2005, the structure almost looks new from a distance. But make no mistake: this is widely considered to be the oldest continuously operated mill in the province. And apart from the Secord Mill near Niagara (much renovated and now a private home), this may be the oldest mill structure in Ontario.

Water from the pond is delivered to the mill's overshot wheel by a rather uncommon elevated flume about 30 m in length. Lined with black plastic sheeting to prevent rot, the flume has been reconstructed in the same spot as the original. The mill currently captures power using an overshot wheel, one of only three such mills remaining in Ontario to do so (the other two being Roblin's Mill and Bruce's Mill). A while later, the mill was run by turbine, and then later still, by a combustion engine, added after 1885 so work could continue when the flume froze in winter. At the time of writing, there was interest in reviving the old 25- horsepower beast, which still dwells in a dark corner of the mill's basement. A rusty old turbine and used millstones are easily viewed on the lawn in front of the building.

While there is still much work to do to restore the interior of the mill, efforts have progressed to the point where wheat can be ground for visitors throughout the park season. Grinding is performed by two sets of stones located on the main floor. A small window in the floor between the two stones provides a view of the spinning gears in the level below. As you enter the basement level, you can see how these gears are

Mill Name	Backhouse Mill
Settlement	Port Rowan
Built	1798
Current Use	Museum
Original Use	Flourmill
Interior	Museum Hours
Exterior Access	Park Hours
Artifacts	Operational
Photography	Good
Setting	Park
Latitude	42.64951
Longitude	80.46872

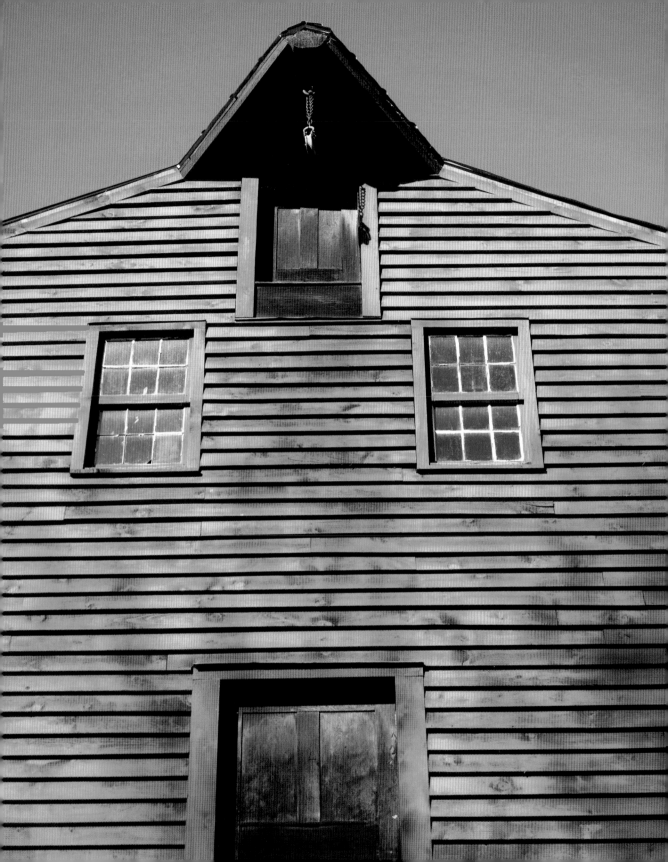

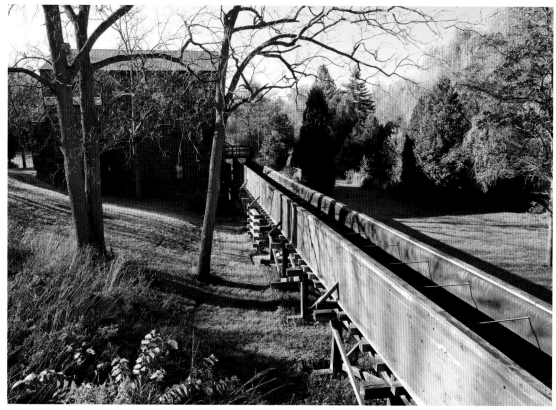

Flume delivering water to the overshot wheel.

composed of hardwood teeth inserted into slots in a metal frame. Before leaving the basement level, note the giant one-piece rough-hewn beams running the entire width of the building. While the most of the remainder of the equipment in the mill is not yet in working order, there are dozens of vintage pieces to examine on all four floors, including weighing apparatus, hoppers, a smutter, roller mill, augers and a rundown yet still fascinating system of belts, pulleys and wheels.

Directions

Follow Hwy 401 to Woodstock and exit at Oxford Rd 59. Go south on this road for about 11 km. Turn right on Oxford Rd 13, and continue south (Oxford Rd 59 bends to the east here). Drive south on Rd 13 for 20 km to Hwy 3, where the road once again becomes Oxford 59. Continue south for 27 km to Concession Rd 2 and then turn left. Drive for 2.5 km to the entrance to the Backus Heritage Conservation Area. The mill is about 1 km along the road leading into the conservation area. There is a small admission charge during the park season, which runs from May to mid-October. For hours and season of operation, and to find out more about the Heritage Village, visit lprca.on.ca/backus.htm.

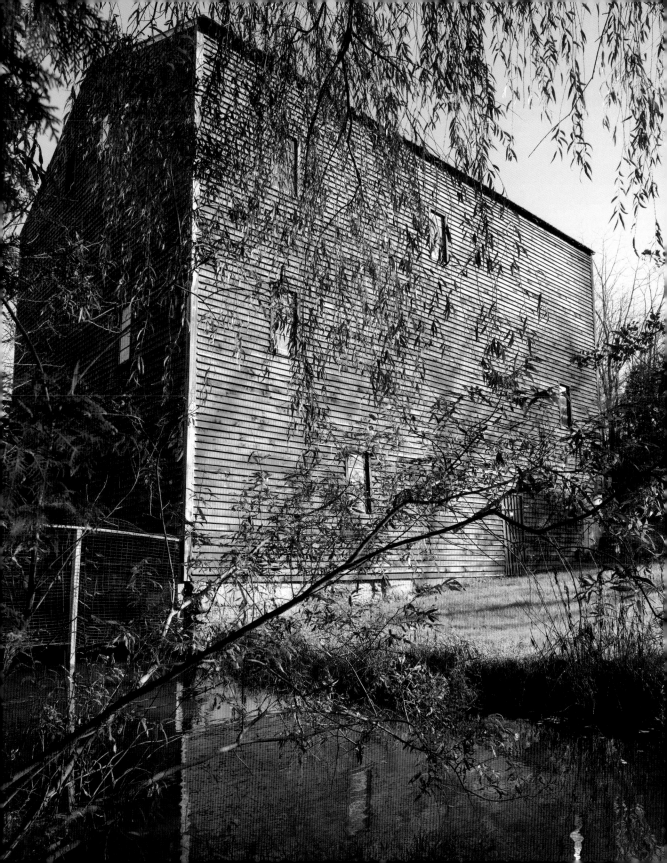

Bluevale Mill

Clad in a coat of armour made from sheet metal, the old blue mill at Bluevale is a photogenic, though not exactly beautiful, building. The mill is set beside a nice little dam on the Little Maitland River just outside the village. Right across the river is Pioneer Conservation Area, a quiet, park offering swimming, fishing and canoeing. While you can walk across the dam from the Conservation Area to the mill, you should obtain permission from the mill owner before exploring the mill property.

The old sawmill was built in the 1870s by Joseph Leech, no doubt a relative of the Leech brothers who settled nearby in Howick Township and built the Maitland Mill. Over the years, the Bluevale Mill has waged war with the elements: generally winning against floods, but usually losing to fire. In fact, between 1883 and 1908, the building burned four times, including two times in 1893! In a story all too common for a small country mill, business ceased in the early twentieth century when the mill's hinterland ran out of choice timber. Little is documented about the mill's later years, though older topographic maps suggest that it operated for some time as a feedmill.

Today, the building is back in business and is even involved (well, sort of) in the cutting of wood. R & V Schmidt and Sons sells chainsaws as well as a variety of lawn and garden tools and equipment. All of the milling equipment is long gone, but on every day except Sunday, customers can wander around the store, which occupies most of the first floor of the building. The original post-and-beam construction is well preserved, and the owner's recent renovations using pine boards help to preserve the historic atmosphere.

Directions

Follow Hwy 401 to Hwy 8 and head north to Kitchener. Exit right on to Hwy 7 and continue as the road becomes Hwy 85 to Waterloo. Continuing through Waterloo, Hwy 85 becomes Waterloo Rd 85. Just before Elmira, turn left to follow Waterloo Rd 85 (Listowel Rd) for 3 km to Waterloo Rd 86. Turn left and follow county Rd 85 for 60 km to the village of Bluevale. Just before the main intersection with Huron Rd 87, turn left on to Clyde St. and drive about 5 blocks to the mill. Park on the left in the gravel lot for the Conservation Area located on the far side of the bridge.

Mill Name	Bluevale Mill
Settlement	Bluevale
Built	c.1909
Current Use	Retail
Original Use	Sawmill
Interior	Retail Hours
Exterior Access	Anytime
Artifacts	None
Photography	Good
Setting	Rural
Latitude	43.85479
Longitude	81.24960

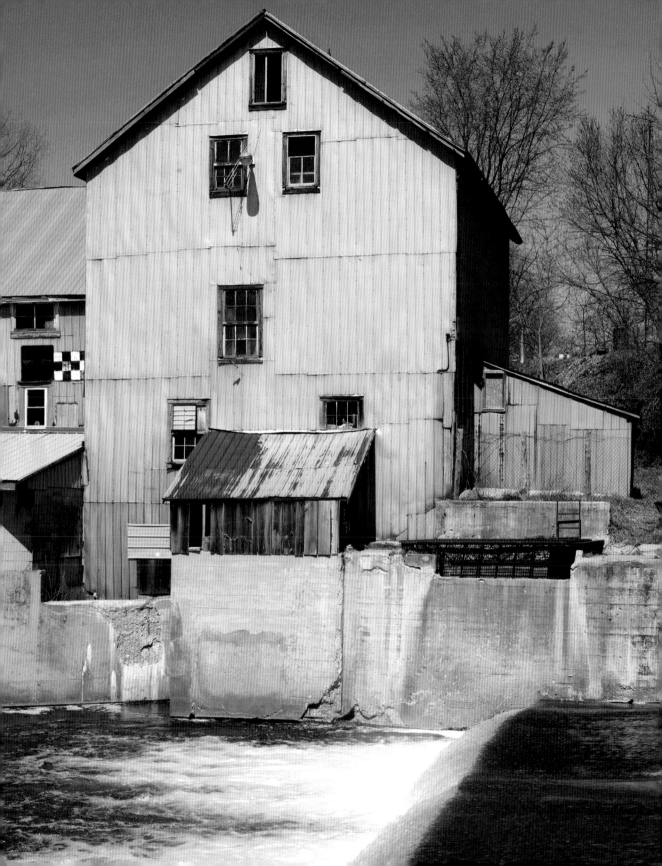

Logan's Mill

Many of Ontario's heritage buildings are opened to the public only during annual "Doors Open" events. The Logan Mill is no exception, but be warned: "doors open" means that the door will be opened, but nothing more! This is because the floors are currently so unstable that visitors are only permitted to peek inside the door. In contrast, the building itself should continue to stand for a long time, because the old gristmill is constructed of poured cement. Some of the original grist milling machinery is still present in the mill, and hopefully it will one day be safely displayed for visitors. One of the two turbines that once powered the equipment can be examined on the lawn in front of the building.

The first mill on this choice site was a three storey wooden gristmill constructed by William and James Vanstone in 1859. To increase the head of water for the mill, the Vanstones also built a wooden dam where a bedrock exposure formed a small rapid on the Middle Maitland River. Parts of these rapids are still visible below the dam. After a fire in 1871, the mill was rebuilt, but when it burned again in 1911, the site was sold to John Logan. Using the existing foundation constructed of rubble stone, Logan built the existing mill using poured cement, a relatively new building material at the time. He also added a cement cap to the dam and supplemented waterpower with a diesel engine installed in the basement of the mill. The mill operated until 1967 and has been owned by the Maitland Valley Conservation Authority since 1972.

Even though the mill is only "open" once or twice a year, the whole site is a pleasant destination for a picnic or a stroll. A walkway along the lengthy dam connects the mill with the Brussels Conservation Area, a quiet park with tall trees and loads of little spots for picnicking or just taking in a nice summer afternoon. At the far end of the park, a short walk along Alfred St. leads to a much-photographed view of the mill, framed by trees at the end of a long pool in the river.

Directions

Follow Hwy 401 to Hwy 8 and head north to Kitchener. Exit right on to Hwy 7 and continue as the road becomes Hwy 85 to Waterloo. Continuing through Waterloo, Hwy 85 becomes Waterloo Rd 85. Just before Elmira, turn left to follow Waterloo Rd 85 (Listowel Rd) for 3 km to Waterloo Rd 86. Turn left and follow County Rd 85 for 53 km to Huron Rd 12. Turn left and drive 11 km to Brussels. As soon as you cross the river, turn left on to Sports Dr (also mapped as Mill St.), and drive a few blocks to the mill on the left.

Mill Name	**Logan's Mill**
Settlement	**Brussels**
Built	**1911**
Current Use	**Undetermined**
Original Use	**Gristmill**
Interior	**Special Occasion**
Exterior Access	**Anytime**
Artifacts	**Lots**
Photography	**Moderate**
Setting	**Park**
Latitude	**43.74157**
Longitude	**81.24689**

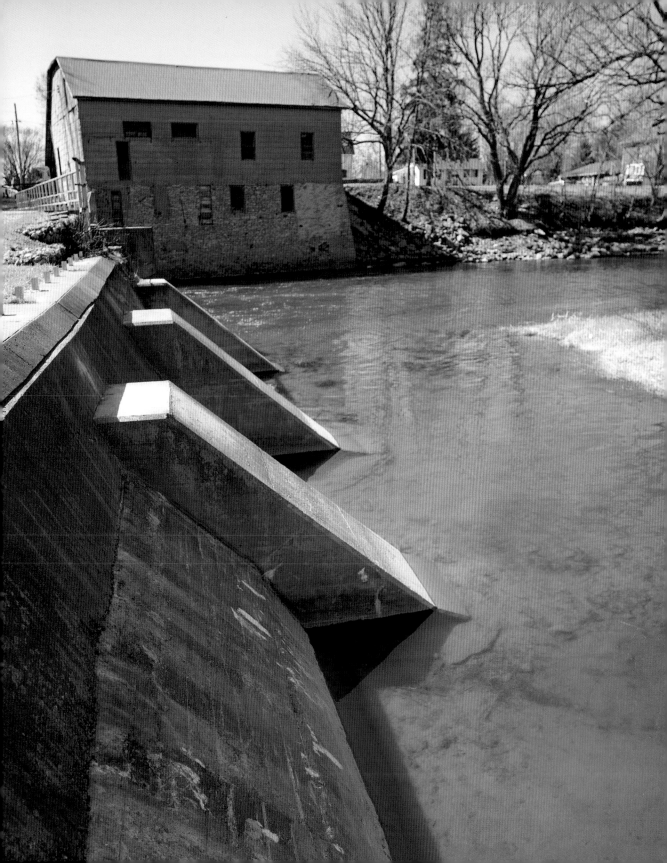

Maitland Mill

Seven brothers named Leech arrived in Howick Township in 1855 and within just one year had constructed this gristmill. At its peak, the mill is believed to have produced upwards of 150 barrels of flour a day. Flour and feed milling continued for some time, until the mill was purchased by the Maitland Valley Conservation Authority in 1962. The building stood silent for several decades until 1997 when a volunteer association began restoration of the building. The association worked diligently for several years to restore the mill, even participating in a February "polar bear dip" to raise funds. Unfortunately, at the time of writing, the association had become inactive, and restoration efforts were left in limbo.

The mill is a two-and-a-half-storey rectangular frame building clothed in rusty-red clapboard and peaked with a tiny cupola. It sits on a colourful foundation made with fieldstones of every size, colour and shape; a product of the mill's distance to a source of uniform rock. A milldam (since modernized and now with a small lookout platform) located about a hundred metres upstream provided the necessary head for the mill. A long, now-overgrown, millrace brought water from the millpond to two turbines now housed in an open, concrete-lined pit, visible on the east side of the mill. The driveshafts from the turbines can be seen extending vertically up into a shed constructed beside the mill, where power is transferred to equipment within the mill. At the base of the foundation a beautifully intact tailrace arch marks the start of the tailrace, which makes its way as a gentle ditch back towards the Maitland River near the Gorrie Line bridge.

Directions

Follow Hwy 401 to Hwy 8 and head north to Kitchener. Exit right on to Hwy 7 and continue as the road becomes Hwy 85 to Waterloo. Continuing through Waterloo, Hwy 85 becomes Waterloo Rd 85. Just before Elmira, turn left to follow Waterloo Rd 85 (Listowel Rd) for 3 km to Waterloo Rd 86. Turn left and follow County Rd 85 for 46 km to Perth Rd 178 and turn right. Follow this road for 2 km, go around the bend to the left, and continue on the road that is now called Huron Rd 28 (Gorrie Line). Drive north for 7 km to the village of Gorrie. Immediately after you pass Mill St., turn right at the driveway to Gorrie Park.

Mill Name	Maitland Mill
Settlement	Gorrie
Built	1856
Current Use	Undetermined
Original Use	Gristmill
Interior	Private
Exterior Access	Anytime
Artifacts	Lots
Photography	Good
Setting	Park
Latitude	43.87654
Longitude	81.09348

Otterville Mill

Built in 1845 by Edward Bullock at a cost of £470, this was not the first, nor the last, mill to be constructed in Otterville. As the sole survivor, though, it is an excellent example of early industry in a small southern Ontario village. Ownership of the mill has changed hands several times through the years. Many locals still refer to the building as "Treffry's Mill," after Lorne Treffry, who purchased the mill in 1942. Fearing the costs of conversion to metric in 1980, Treffry closed up operations and the mill was subsequently purchased by the municipality in 1981 for its heritage value. Since then, the South Norwich Historical Society has restored much of the building to working order and periodically produces flour or feed in front of visitors in summer.

Waterpower reaches the mill via a shallow mud bottomed headrace leading from a pleasant millpond on the far side of Otterville Rd. The low, wide concrete dam visible from the bridge was built in 1904 and maintains the pond by raising the water level of Big Otter Creek by about 2 metres. With the turn of a simple handwheel, water from the headrace is allowed to flow into a single turbine, the housing of which is visible from the outside at the southeast corner of the building. A large central pulley used to convey the turbine's energy to equipment throughout the mill hangs prominently from the ceiling above the ground floor.

Power was originally used to drive three run of stone, but was redirected to rollers sometime in the 1880s. The original wooden oat roller still stands towards the back of the room on the ground floor. More modern equipment was introduced in the early twentieth century, including a grain grinder, corn sheller and mixer that are still operational and look a little out of place because of their bright red, green, and grey metal construction. Cup elevators and auger-like conveyors can still be used to transfer grain vertically and horizontally throughout the mill. When pressed, though, the mill operators will quietly admit that they don't fully understand the elevator system. Grain put into certain elevators never returns; the exact pathways known only to the millwrights of generations past.

Much more of the original mill-related equipment is on display on the ground floor, with many pieces still in working order. A trolley track leading into the mill from the loading dock passes over the floor-mounted scale constructed by the Buffalo Scale Works Company. To the right, two bagging chutes hang from the 6 m ceiling: the round chute was used to pour flour into bags, while the pyramid-shaped chute was used to fill barrels. Finally, set on the grass in front of the mill is a small turbine that was once used to power the long-since-vanished Teeterville Mill.

At the time of writing, this interesting mill was not open to the public on a regular basis. Fortunately, tours of the interior of the mill may be arranged in summer by contacting the South Norwich Historical Society through historicotterville.ca.

Mill Name	Otterville Mill
Settlement	Otterville
Built	1845
Current Use	Museum
Original Use	Gristmill
Interior	Special Occasion
Exterior Access	Anytime
Artifacts	Operational
Photography	Excellent
Setting	Suburban
Latitude	42.92602
Longitude	80.60611

The mill is also open during special occasions, such as the annual Otterville Mill Classic Car Show. Hundreds of classic cars and classic car enthusiasts meet in the park, resulting in a strange juxtaposition of nineteenth-and twentieth-century technology (ottervillecarshow.com). The exterior of the mill can be visited anytime, with a peek through the front windows providing but a glimpse of the treasures inside.

Directions

Follow Hwy 401 west from Toronto to Woodstock, and exit south on Oxford Rd 59. Go south for 22 km to Oxford Rd 19 (Otterville Rd). Turn left and drive for 5 km to Otterville. Immediately after crossing the bridge over Big Otter Creek, turn right onto the short gravel driveway leading to the mill.

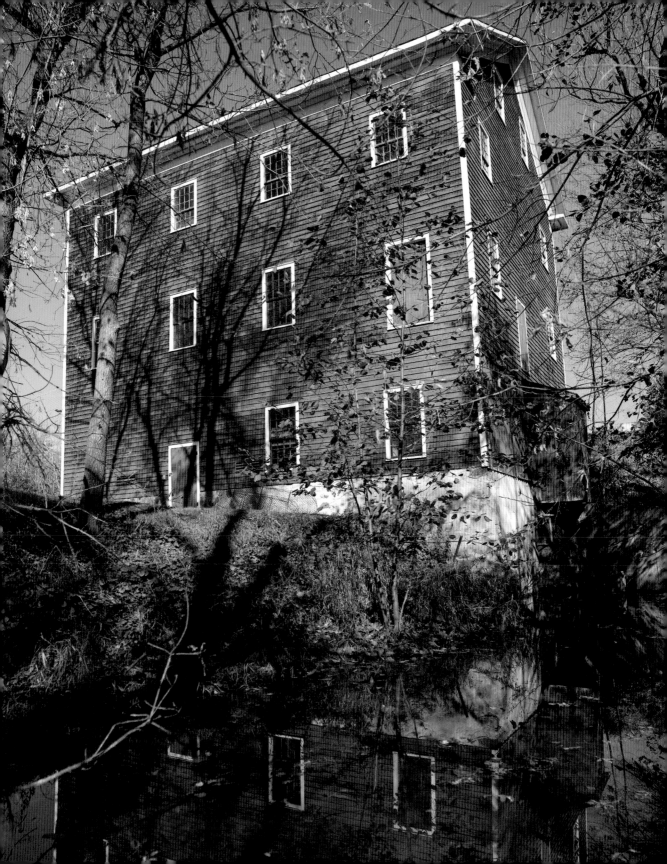

Stark's Mill

Just as you think you've left the small community of Paisley, Stark's Mill pops out of the woods as you round the bend on Mill St. Likely one of the tallest wooden mills in Ontario, the striking building instantly seizes the driver's attention. James Stark purchased this property in 1872 and operated an earlier flourmill here until it burned down in 1884. The following year, Stark built the existing mill on the same site, but this time replaced the older stone technology with roller mills. Two new turbines that were added to develop almost 250-horsepower still reside in the basement of the mill. For a time, flour from the mill was shipped around the world, but after World War II, business was focused on the more local feed supply. Ownership stayed in the Stark family for a century, with operations finally closing in 1972.

Like so many others, the old mill sat derelict for many years; its heritage value appreciated by the locals, yet its future remaining uncertain. In 2000, the building was purchased, and within a few years, the ground floor of the mill building had been converted into a rather eclectic retail venture, offering everything from books to fountains to antiques to pottery; all tied together by five general themes: earth, wind, fire, sun and water. The owner has even created some unique furniture pieces that incorporate some of the "mill junk" found in the buildings and around the property. Only the true mill enthusiast could fully appreciate the lamps made from old grain augers or tables made from lineshaft pulleys.

The second floor of the building has an open concept, serving as a unique space for meetings and community events such as art displays and quilt shows. The third and fourth floors have yet to be renovated, and together with the turbine room in the basement, are occasionally opened to the public during Doors Open events. A smaller building attached the mill once housed grain silos capable of holding 640 tons of grain, but is now used for storage. And sandwiched between the mill and elevator buildings is the owners' residence, built where once a path allowed covered wagons to pass between the two buildings. A turbine on display in front of the mill is believed to have captured power for a sawmill long since reclaimed by the woods.

Directions

Follow Hwy 6 north from Guelph, and drive 100 km north to Dornach. Turn left on Grey Rd 25 and continue to Chesley. Turn right on Bruce Rd 10, and then left on Bruce Rd 11, following the road for 15 km to Paisley. Once you reach Paisley's Main St. (Queen St.), turn right and then immediately left on to Mill St. The mill is 1 km along this road. Consult the webpage to find out when the mill store is open to the public: naturesmillworks.com. Three other old mills on the Teeswater River are located closer to Queen St. Twin tailrace arches for one mill are just visible below the Queen St. bridge, but it takes a little detective work to find the other two buildings.

Mill Name	Stark's Mill
Settlement	Paisley
Built	1885
Current Use	Retail
Original Use	Gristmill
Interior	Retail Hours
Exterior Access	Anytime
Artifacts	Lots
Photography	Excellent
Setting	Rural
Latitude	44.30069
Longitude	81.27902

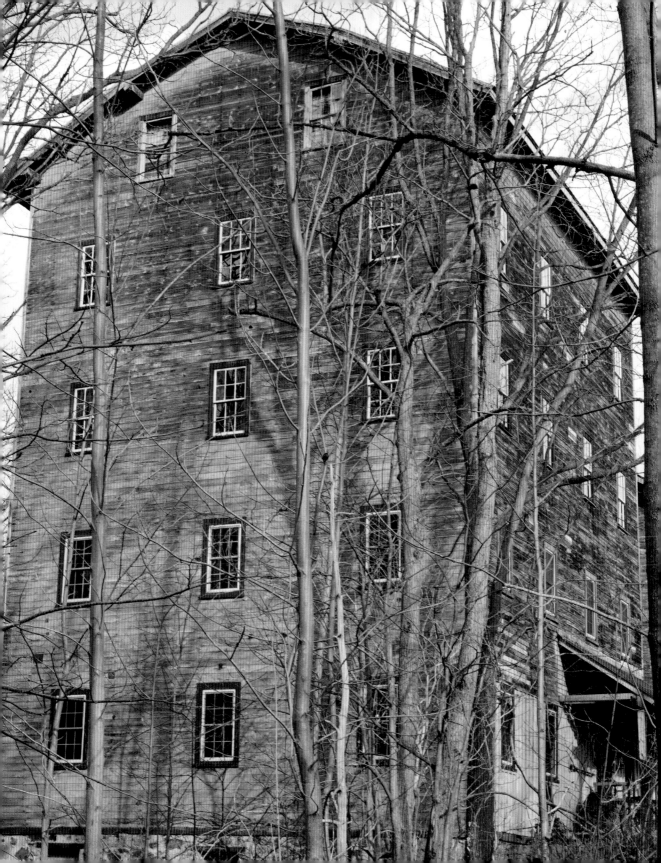

Thamesford Mill

Before brushing off the Thamesford Mill as nothing more than a big, old, ugly building, take a closer look. Yes, it's big, and arguably ugly, yet its frozen-in-time appearance has drawn photographers and painters for some time. The original white brick mill is snuggled in the western end of the complex, its clerestory still overlooking the Middle Thames River, five storeys below. Anchoring the eastern end are three tall silos, which are connected to the original mill building by a dilapidated mess of sheet metal. At the time of writing, the mill was abandoned, and interior access is prohibited and certainly very dangerous. Fortunately, the building is easily visible from both Dundas St. and Milton St., a dead-end street that provides easy access to a big grassy field between the mill and the millpond on the Thames River.

Thamesford had been settled by the 1830s, primarily by Scots, who initially called their community St. Andrews. John Finkle built a gristmill and sawmill on the Thames River in about 1847. His mill doubled for some time as a temporary site for the local Anglican congregation, which didn't begin to build the nearby St. John's Anglican Church at 220 Dundas St. until 1861. Finkle's mill burned in 1898, leading to the construction of the existing building shortly after. At least parts of the complex operated as the Thamesford Feedmill into the 1990s. Some of the original gearing and equipment is reportedly still present in the brick mill, though a lot of work is probably required to restore the complex as a heritage building.

A low, wide concrete dam situated behind the mill holds back a narrow millpond. While a quick stroll to the pond is recommended, the walking trail around the millpond at Dorchester is a much more pleasant experience for a family outing. A mill once located here burned in 1964, though the miller's house and milldam still exist at the corner of Hamilton Rd and Mill Rd. A gravel trail winding through a variety of habitats circles the 10-hectare pond, connecting to a picnic area, lookout and boardwalks.

Directions

Go west on Hwy 401 past Ingersoll and exit north on to Middlesex Rd 30 (Putnam Rd). The road soon becomes Oxford Rd 45. Follow Rd 45 for about 7 km to the end and turn left at Oxford Rd 119. Drive for 2 km to Thamesford. Continue straight past the stop sign at Oxford Rd 2 (Dundas St.) and park opposite the mill on Milton St. The building is on private property, though it is easily visible from close proximity at many angles. For the Dorchester Millpond, drive back towards Hwy 401, but turn right on Middlesex Rd 29 and drive 10 km to Dorchester. The milldam is visible from the road, on the western edge of the village.

Mill Name	Thamesford Mill
Settlement	Thamesford
Built	c.1900
Current Use	Derelict
Original Use	Gristmill
Interior	Private
Exterior Access	Roadside Only
Artifacts	Unknown
Photography	Moderate
Setting	Suburban
Latitude	43.06006
Longitude	80.99617

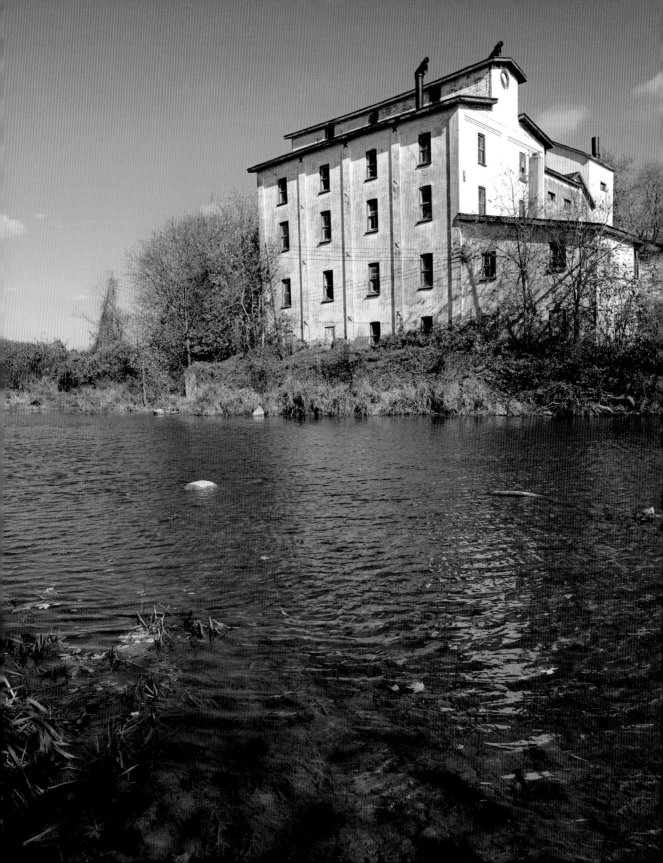

Welbeck Sawmill

OK, so it's not exactly old, and the bright red metal waterwheel is only for show, but of the "replica" sawmills spread throughout the province, the Welbeck Sawmill is probably one of the best-known and best-visited, and still gets an "A" for visitor value. Hidden deep in the woods of Bentnick Twp, this shingle mill is a fascinating place for mill fans. The first hint is the wooden sign hung high above the circular saw proclaiming "Welcome to the lingering scent of cedar." Breath in — it doesn't get much better than this!

One of the earliest settlers in the area was Pat Walsh, an Irishman who built a cabin along the Styx River in 1849. By 1872, a sawmill on this site was providing lumber to local settlers. The settlement became known as Welbeck shortly before the turn of the century. The original mill burned in 1966, and the existing building was rebuilt in 1984, using timberframe construction and an exterior of board and batten. Two turbines generate the power for the mill. One runs the circular saw and other equipment, while the second generates electricity for the building. Water is delivered to the turbines by a lengthy wooden penstock that connects to the large pond to the east hidden behind the woods. The mill only operates in summer because, when the white cedar blocks are frozen, they cause the blade to waver during cutting.

In a small shed at one end of the little parking lot is an old Barber turbine, built in Meaford by Charles Barber, who patented the design in 1869. In 1876, the model won an award for the best turbine at the Centennial International Exhibition in Philadelphia. This particular turbine is believed to have been used first at a mill in Walkerton, then moved to Lueck's Mill, and then operated at the original mill at Welbeck from 1946 until the mill burned in 1966.

Directions

Follow Hwy 6 north from Guelph for 80 km to Durham. Continue north on Hwy 6 for 11 km to Welbeck Rd, and turn left. Drive west for about 4 km and follow the signs to the Welbeck Sawmill Store. Continue just past the store for about 0.2 km to the mill, which is in a clearing on the left. While the mill can be viewed from the parking lot, please check with staff at the store for permission to explore in or around the building. And if you are woodworking fanatic, expect to spend several hours salivating over tools, materials and books available at the large store. The Welbeck Woodcrafters Expo is held here (and in nearby Durham) each year on the second Friday and Saturday of August. Further information about the mill, store and Expo are available at welbecksawmill.com.

Mill Name	**Welbeck Sawmill**
Settlement	**Durham**
Built	**1984**
Current Use	**Retail**
Original Use	**Sawmill**
Interior	**Retail Hours**
Exterior Access	**Anytime**
Artifacts	**Operational**
Photography	**Good**
Setting	**Rural**
Latitude	**44.27482**
Longitude	**80.88939**

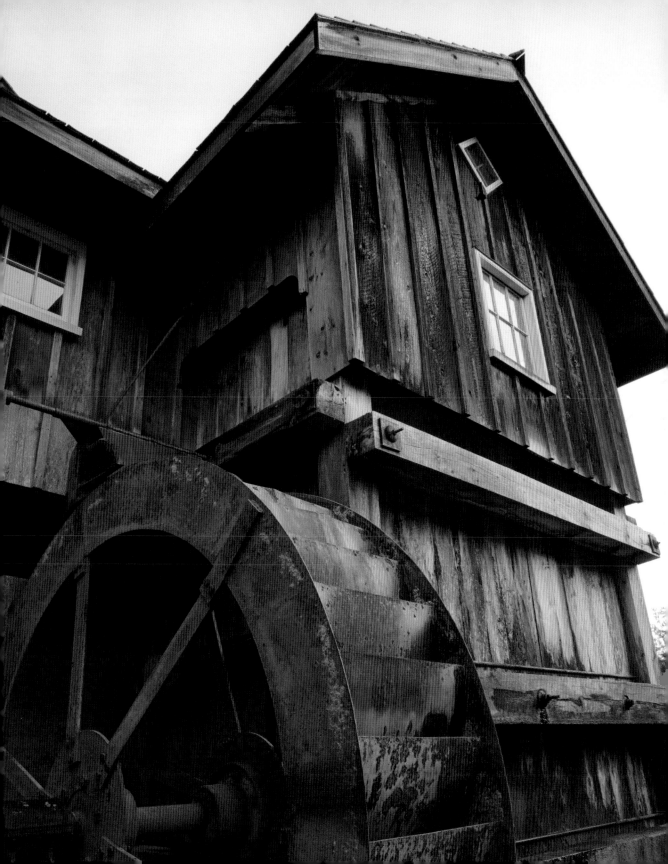

Williamsford Mill

This former flourmill was built in 1858 by Adam Scott Elliot, and while some may refer to the mill as "Elliot's Mill," most now simply use "the Williamsford Mill." In the 1930s the mill converted to a feedmill and continued to serve this purpose until the early 1970s. Between 1977 and 2005, the building was home to the Mill Restaurant, a popular spot for dining and wedding receptions. In mid 2005, however, the restaurant business closed, and the mill gained regional notoriety when it was discovered that a large marijuana grow operation had been in place for some time, quietly humming away as patrons dined on the ground floor. It turns out that the Barber turbines that once powered the mill had been used to produce hydroelectricity since the late-1970s and obviously represented a fantastic and likely untraceable source of power for the grow operation. If you currently own a mill, let the record show that we do *not* condone this particular use of waterpower!

At the time of writing, the mill's new owners planned to take the old building in a new direction by opening a bookstore and café. The café will feature organic foods, baked goods and other healthy fare.

The bookstore will feature new and used books, have public readings, place special orders for patrons, as well as provide internet access and host community events. Old garner bins constructed of stacked 2 by 4s have been cut open and may be used as "book nooks." A focus on environmental issues and awareness will be a central theme. Both endeavours will make use of the mill's excellent interior space, broken only by the magnificently preserved post-and-beam structure. The owners plan to open for business in early 2007.

The building is two and a half storeys in height and at the time of writing was covered in peacock-blue clapboard with red trim. The short headrace is actually a pretty little pond in the front of the mill, surrounded by lush vegetation and crossed by a little wooden footbridge leading to the mill: no doubt a beautification project for the mill's long-time use as a restaurant. The Barber turbines are still producing power, but now export electricity to the provincial grid to the tune of roughly 100,000 kWh per year. Water leaves the mill from its back corner and makes its way along a nice stone-lined tailrace back to the North Saugeen River.

Directions

Follow Hwy 6 north from Guelph for 85 km to Durham. Continue north on Hwy 6 for another 23 km to the village of Williamsford. The mill is a large blue building on the left side of the highway, located immediately before the bridge over the river. The bookstore's webpage is greatbooks.ca.

Mill Name	**Williamsford Mill**
Settlement	**Williamsford**
Built	**1858**
Current Use	**Restaurant**
Original Use	**Gristmill**
Interior	**Patrons Only**
Exterior Access	**Anytime**
Artifacts	**Some**
Photography	**Moderate**
Setting	**Suburban**
Latitude	**44.37876**
Longitude	**80.87108**

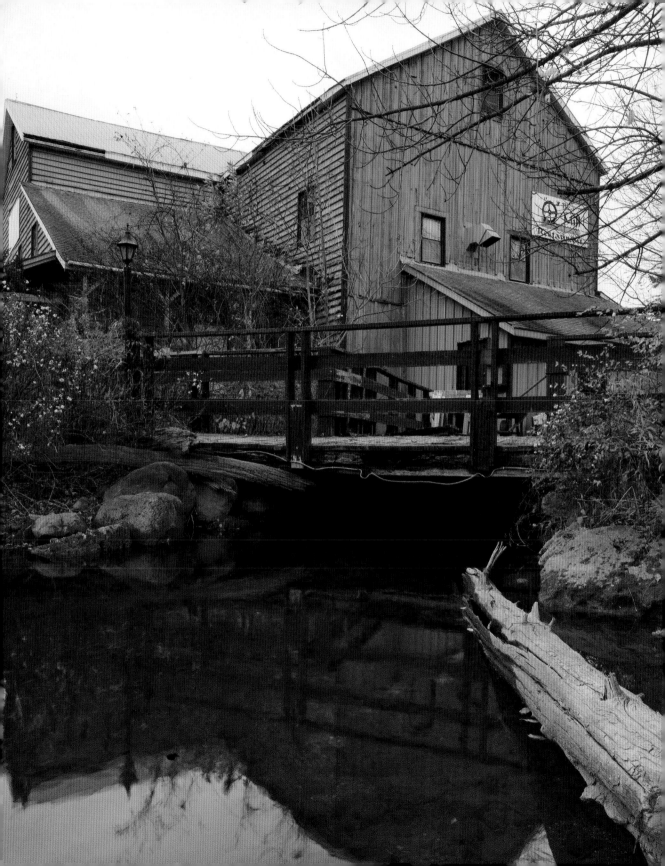

Other Mills: Western Ontario

Arva Flourmill

A few other waterpowered mills featured in this book are able to produce flour for tourists as a novelty. But at the Arva Flourmill, flour isn't a hobby, it's a way of life! Water from Medway Creek still powers the rollers, choppers, mixers and elevators. And the visitor to the mill's small retail store is able to see much of the action through a window into the roller room. Among other baking ingredients, the store sells a variety of the mill's flours, ranging from pastry to whole wheat to organic to spelt. The retail store is open regularly, but for hours of operation, check arvaflourmills.com. Arva is 4 km north of London on Hwy 4 (Richmond St.).

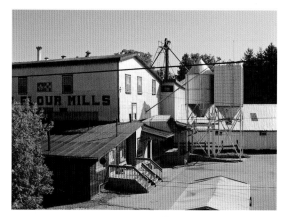

Arva Mill

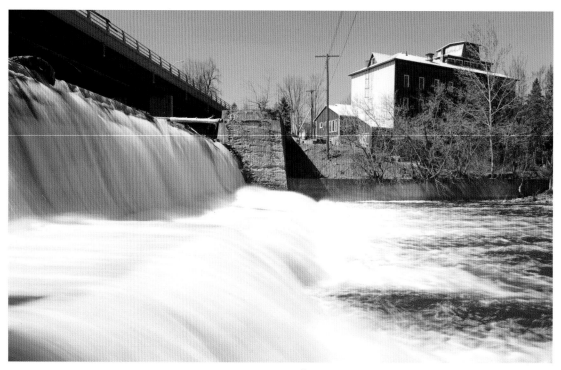

Ayton Mill

Ayton Mill

This large mill has been converted to a private residence and is not open to visitors. Built in 1864 by Thomas Robertson, it served first as a gristmill before being used as a feedmill in later years. The view of the mill from the county road bridge is stunning, as the building towers above a wide gorge on the South Saugeen River. Ayton is 13 km west of Hwy 6 along Grey Rd 9.

Ferguson Gristmill

This elegant little mill was built by John Ferguson in 1857 and remained in operation until 1940. The mill is located about 5 km north of Durham, at the far end of a long pond on the Rocky Saugeen River, just visible from Hwy 6. It has long been a private residence and is not open to the public.

Gledhill Woollen Mill/ Pfrimmer Gristmill

These two former mill buildings are at the centre of the Benmiller Inn, a classy country retreat set beside a picturesque stretch of the Maitland River. The gristmill was built by three brothers named Miller, but was later sold to the Pfrimmer family. In 1857, Thomas Gledhill purchased the adjacent woollen mill and began to manufacture fine woollen blankets. The woollen mill closed in 1964 and the gristmill closed in 1972. Each has been extensively renovated to contain the guest rooms for the inn. Looking to be pampered at an old mill in a beautiful country setting? This is the place! About 10 minutes from Goderich. See benmiller.on.ca for more information.

Harrington Gristmill

The mill is believed to have been in continuous operation between 1846 and 1966. First powered by an overshot wheel, a Little Giant Turbine was installed sometime in the 1880s. After sitting derelict for several decades, the Harrington Community Club began an extensive restoration project in 1999 that was nearing completion at the time of writing. A brand-new exterior of board-and-batten and new roof were added to protect the interior for years to come. An oat roller installed in 1899 has been completely restored, and restoration of the turbine has already begun. Located in the Harrington Conservation Area, in north Oxford County. More information at ocl.net/projects/harrington_grist_mill

McClure's Mill

William Elliot constructed this mill in 1881, several decades after his father Adam constructed that mills that helped to establish Chesley. The mill is now closed, though functional, as much of the original equipment still remains inside. Just outside of town, with a beautiful little pond and (for now) a one-lane bridge, the mill photographs (or paints) beautifully. Just two kilometres to the east is the Scone Mill, built in 1856, which now houses an art gallery and Garden Centre. (See the photograph of McClure's Mill on page 220.)

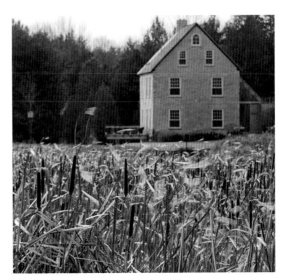

Ferguson Mill

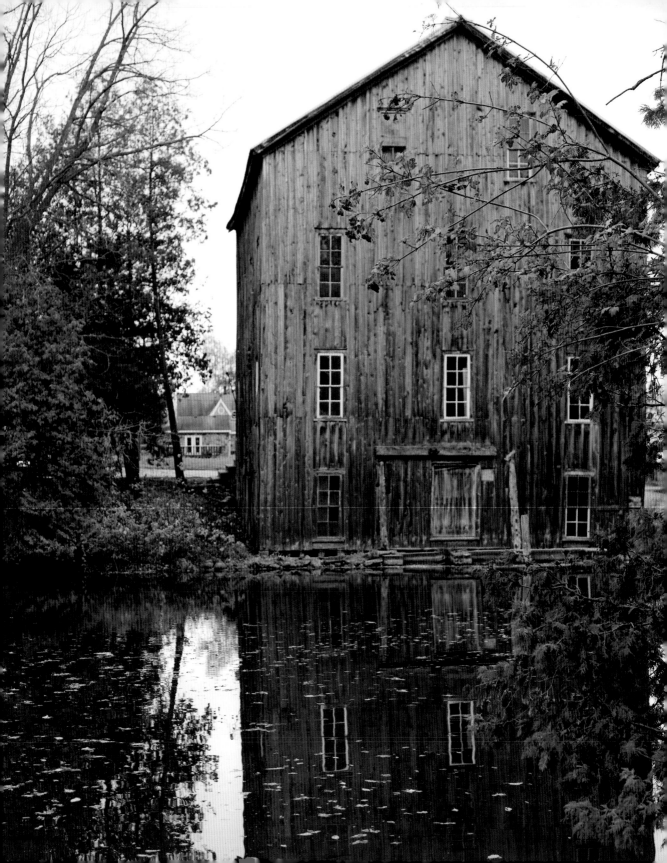

Neustadt Mill

A quick look at the somewhat chaotic, bright yellow exterior and you'd never know that this building is one of the best places in Western Ontario to see loads of vintage gristmill equipment. Built in 1856 by David Winkler, the building is a perfect setting for its current use as an antique shop. As the visitor explores the three floors of antiques and collectibles, they can view equipment such as the old scale, a chopper, the turbine, and lots of lineshafting. The owners recently created a small art gallery by cutting into old garner bins constructed of stacked 2 by 4's. It took two weeks to cut through the 2 by 4s! Neustadt is a quaint little village with a number of old stone buildings, located 10 km south of Hanover on Grey Rd 10.

Traverston Mill

The Traverston Mill (c.1870) is set in a gorgeous wooded setting beside the Rocky Saugeen River, just downstream of an old one-lane iron bridge. At one time part of a (slightly) more bustling community known as Waverly, the mill eventually ceased operations in 1955 and is now just one of a handful of buildings remaining. It is now used as a private residence and can only be viewed from the bridge. From Durham, drive north to Grey Rd 12 and turn right. Follow the road for 9 km, turn right on Traverston Rd, and drive 2 km to the tiny community. It is not open to the public.

Traverston Mill

Bibliography

Angus, James T., 1998. *Mills and Mill Villages of Severn Township.* Severn Publications Ltd.

Brown, Howard Morton, 1984. *Lanark Legacy. Nineteenth Century Glimpses of an Ontario Town.* Perth: Howard Morton Brown.

Brown, Ron, 1999. *Disappearing Ontario.* Toronto: Polar Bear Press.

Cooper, W. Stephen, 1988. *Watermills of Ontario, Quebec and Maritime Canada.* Toronto: McGraw-Hill Ryerson Ltd.

Denis, Leo G. and Arthur V. White, 1911. *Water Powers of Canada.* Ottawa: The Mortimer Co. Ltd

Fox, William, Bill Brooks and Janice Tyrwhitt, 1976. *The Mill.* Toronto: McLelland and Stewart.

Gordon, Michael, 2005. *Rock Watching. Adventures Above and Below Ontario.* Erin: Boston Mills Press.

Harris, Mark and George Fischer, 2003. *Waterfalls of Ontario.* Toronto: Firefly Books.

Heritage Cambridge, 1978. *Our Heritage in Stone.* Cambridge, ON: Heritage Cambridge.

Hewitt, Kenneth, 1995. *Elora Gorge. A Visitor's Guide.* Erin: Boston Mills Press.

Lawton, Jerry and Mikal Lawton, 2000. *Waterfalls. The Niagara Escarpment.* Erin: Boston Mills Press.

Legget, Robert, 1972. *Rideau Waterway.* Toronto: University of Toronto Press.

Leung, Felicity L., 1981. *Grist and Flour Mills in Ontario.* Ottawa: Minister of Supply and Services Canada.

McIlwraith, Thomas E., 1997. *Looking for Old Ontario.* Toronto: University of Toronto Press.

Mika, Nick and Helma, 1987. *Historic Mills of Ontario.* Belleville: Mika Publishing Company.

Priamo, Carol, 1976. *Mills of Canada.* Toronto: McGraw-Hill Ryerson.

Rempel, John I., 1980. *Building With Wood.* London: University of Toronto Press.

Reynolds, John, 1970. *Windmills and Watermills.* London: Hugh Evelyn Limited.

Scott, David E., 1993. *Ontario Place Names.* Toronto: Whitecap Books.

Szuck, Maryanne, 2005. *Mills in Ontario (Mills Open to the Public).* St. Thomas: Unpublished Booklet for the Society for the Preservation of Old Mills.

Various, 2006. Millstone News. Semi-Annual Newsletter of the Society for the Preservation of Old Mills. St. Thomas: Unpublished Periodical.

(Right) Armstrong Mills

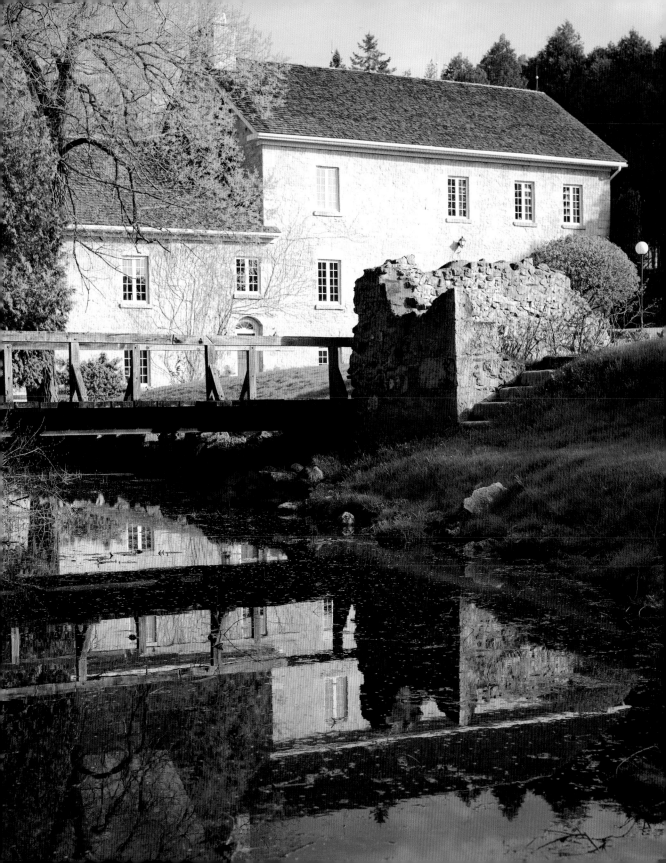

Index